Norma J. Carder
Reno NV
2004

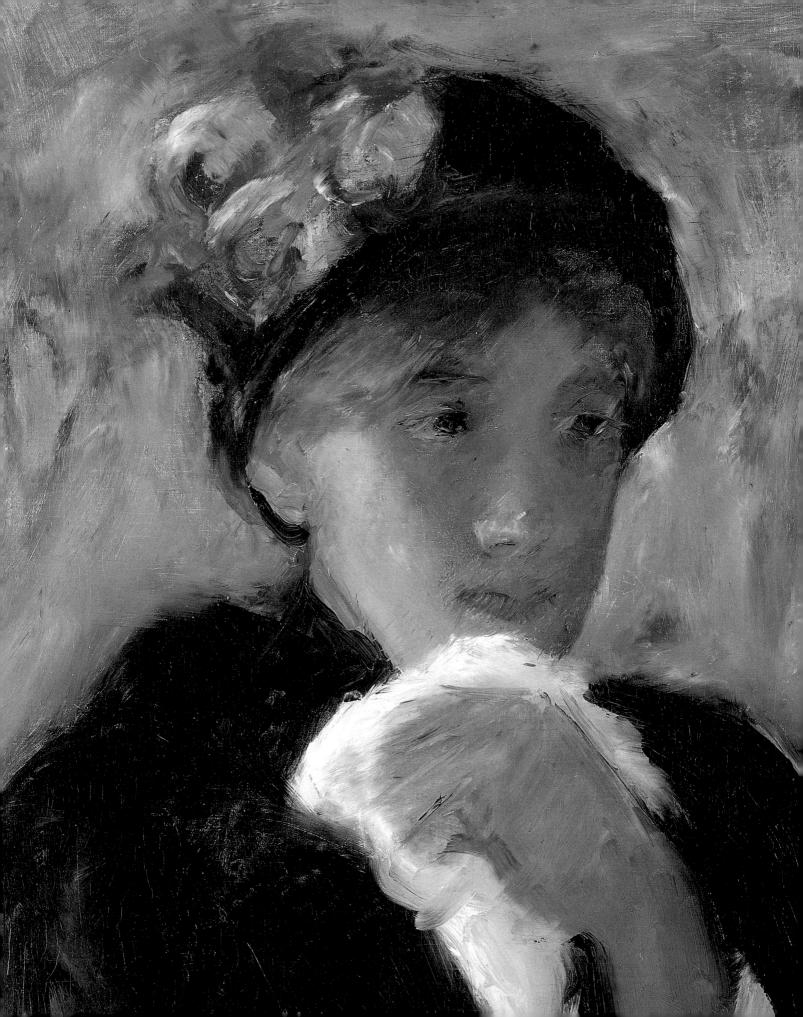

The Janice H. Levin Collection of French Art

Richard Shone

THE METROPOLITAN MUSEUM OF ART

YALE UNIVERSITY PRESS

This publication is issued in conjunction with the exhibition "A Very Private Collection: Janice H. Levin's Impressionist Pictures," held at The Metropolitan Museum of Art, New York, from November 19, 2002, to February 9, 2003.

The exhibition and its accompanying catalogue are made possible by The Philip and Janice Levin Foundation.

Published by The Metropolitan Museum of Art, New York

John P. O'Neill, Editor in Chief
Jennifer Bernstein, Editor
Tsang Seymour Design, Design
Sally VanDevanter, Production

Photography of works in the exhibition is by Bruce Schwarz of the Photograph Studio, The Metropolitan Museum of Art, New York.

Typeset in Enigma by Tsang Seymour Design
Separations by Professional Graphics Inc., Rockford, Illinois
Printed by Brizzolis Arte en Gráficas, Madrid
Bound by Encuadernación Ramos, S.A., Madrid
Printing and binding coordinated by Ediciones El Viso, S.A., Madrid

On the jacket: Camille Pissarro, *Outskirts of Pontoise* (cat. no. 5), detail. Frontispiece: Mary Cassatt, *Young Woman Holding a Handkerchief to Her Chin* (cat. no. 17), detail. Back of jacket: Claude Monet, *Chrysanthemums* (cat. no. 16)

CIP data is available from the Library of Congress.
ISBN 1-58839-029-2 (The Metropolitan Museum of Art)
ISBN 0-300-09774-3 (Yale University Press)

Contents

Director's Foreword

PHILIPPE DE MONTEBELLO
Director,
The Metropolitan Museum of Art

In the many director's forewords, speeches, and other remarks I am called upon to deliver ex officio, I often find it fitting to mention the Metropolitan Museum's encyclopedic holdings of more than two million objects from five millennia of recorded time and nearly every square mile of the earth's surface. Indeed, that breadth is one of the greatest strengths of this museum, and it is one of the prime reasons that our exceedingly generous patrons are moved to donate still more objects and sometimes even the funds for their installation in galleries of the requisite elegance and amplitude. Such donors agree to part with precious, often beloved works of art in order that they be shared with the wider public in a setting that permits of their interaction and resonance not only with works of their own periods but also those periods that came before and after—not only of their own regions but those of other countries, continents, and civilizations.

The decision to share with the public at large in exactly the fashion described above was a clear motive for Janice H. Levin, a most generous patron of the Museum, whose death in 2001 deprived us of a longtime friend and dynamic presence among our Honorary Trustees. In the late 1960s, Mrs. Levin and her husband, Philip J. Levin, began acquiring paintings and some sculptures from a vital period in French art history: the 1870s, when Impressionism hit its classic stride, and the 1880s, when particular Impressionists sought to reinvent their practice, in whole or in part, to suit their individual goals. Monet, Pissarro, Degas, and Renoir all entered the Levins' collection in the space of three or four years. Before Mr. Levin died, in 1971, they had also evinced their interest in the 1890s and even the early twentieth century, with purchases of work by the Nabi painters Vuillard and Bonnard. Subsequently, in Mrs. Levin's thirty years as a widow, active philanthropist, and thriving businesswoman, she stayed mostly within this artistic territory, which suited her taste so perfectly, though she did occasionally find a Modigliani or a Giacometti that seemed to cry out for inclusion in her collection.

In 1991, Mrs. Levin pledged three works that she and her late husband had owned since the early 1970s—a canvas each by Pissarro and Sisley and a pastel by Degas—to the Metropolitan Museum. At the same time, she pledged $3 million to the renovation of the Nineteenth-Century European Paintings and Sculpture Galleries,

and five years later she committed an additional $2 million to be directed toward the Museum's endowment for special exhibitions of nineteenth- and twentieth-century European art. I hardly need express how grateful we were at the time of those gifts, and how grateful we remain, for her generosity—though it is a pleasure to express just that, and to welcome with great enthusiasm the opportunity to exhibit her entire collection now, under the auspices of The Philip and Janice Levin Foundation. What we are showing here is truly a "private" collection in the strictest sense of the word: it was assembled for private enjoyment, and it reflects the taste and lifestyle of a specific couple, and then of a single individual. As such, it is fascinating to behold.

Gary Tinterow, Engelhard Curator of 19th-Century European Painting, and Rebecca A. Rabinow, Assistant Research Curator, have organized the exhibition of Mrs. Levin's collection at the Metropolitan Museum. Richard Shone, an editor at *The Burlington Magazine* in London, has written the informative and sprightly text, and Asher Miller has provided editorial assistance. I wish to thank them all and to acknowledge the pleasure of working with the Directors of the Levin Foundation— Adam K. Levin, Director and Foundation President; William A. Farber, Director; and Paul Skwiersky, Director—as well as with Jan Farber, Curator of the Levin Collection, to make this tribute to Mrs. Levin a reality.

A Tribute

Adam K. Levin

Director and President,

The Philip and Janice Levin Foundation

For Philip and Janice Levin, it was always about collaboration. They built a real estate empire together. They built a world-renowned art collection together. They built a beautiful life together. He was the creator. She was the manager. As she was fond of saying, "I was warmed by the glow of his shadow."

On August 3, 1971, he died.

My mother could easily have continued to live under the glow and protection of my father's shadow for the rest of her life. She could have been a caretaker. However, she opted to come out into her own sunlight and become a creator and empire builder in her own right.

Over the next thirty years, she built a reputation as a tough, fair, and brilliant businesswoman. She used their resources to build on his philanthropic endeavors and went far beyond his vision. She even exceeded her own expectations. When she gave, she never simply wrote a check and then sat in the background. She demanded to participate in the planning and the implementation of the projects she supported. She was "value-added" all the way. She became both the quarterback and the cheerleader. And she never gave anonymously. Her philosophy was simple: "If you want me to do it and I decide to do it, never forget that I did it and make damn sure the world knows about it!"

She was committed to the collaborative effort as a vehicle for the enhancement of understanding and achievement of individual potential. She worked tirelessly to bring people out from under the shadows of prejudice and obscurity into the light of positive interaction and the glory of individual accomplishment.

It wasn't all sunlight for my mother, however. She struggled continuously with her own clouds. She lost three husbands, two children, and one grandchild—way more than one person should have to bear in a lifetime. But she dealt with misfortune in her characteristically ebullient style. As she would say time and again, "Sadness is to be borne alone, but joy is to be shared." And joyously share she did.

As a result of her hands-on generosity, thousands of worthy students received the necessary financial assistance to graduate from the School of Law and Mason Gross School of the Arts at Rutgers University. Tens of thousands of Jewish

and Arab children have studied and performed together at the Philip and Janice Levin Music Center in Tel Aviv–Haifa and throughout the world. Millions have experienced the extraordinary talents of the musicians, dancers, and actors of Lincoln Center for the Performing Arts. Tens of millions of art lovers have swooned to some of the greatest works of Impressionism at The Metropolitan Museum of Art and the National Gallery of Art. Over one hundred million viewers have been exposed to the timeless productions of WNET and the Public Broadcasting System.

In the spirit of Monet's breathtakingly beautiful *Garden at Argenteuil,* she worked with the Central Park Conservancy to transform a simple field into the lovely playground it is today, where hundreds of thousands of children from around the world come to play with their peers. Collaborating with the Friends of Art and Preservation in Embassies, she turned a lawn at Winfield House, the official residence of the United States Ambassador to the Court of St. James's, into a splendid sculpture garden.

My mother had a continuing love affair with her art. She loved the process of collecting and building the profile of her collection. Some days, she would simply float about her home staring at each painting, thankful that she had the good fortune to acquire such treasures and the opportunity to experience such beauty alone, as well as the option to share her joy with the world.

Janice Levin had a great deal in common with her paintings: she was elegant and graceful, a study in color, different from every perspective, and her personality was something to be experienced at least once in a lifetime and was clearly unforgettable. As many of her beneficiaries readily attest, an hour with her could certainly change your life, or at least give you a new viewpoint.

On behalf of the Philip and Janice Levin Foundation and the Levin family, I want to express our appreciation to The Metropolitan Museum of Art for providing the opportunity to honor my mother's legacy and continue her lifelong commitment to sharing that which brought her joy—her beloved collection.

THE JANICE H. LEVIN COLLECTION OF FRENCH ART

From Corot to Giacometti

THE PRIVATE EYE OF JANICE H. LEVIN

Opposite: Detail, cat. no. 26 (Édouard Vuillard, *Arthur Fontaine Reading in His Salon*)

One of my most curious and memorable experiences over many years of visiting private collections took place a few months ago. It was to see a collection that was no longer there. The apartment was still furnished with all the luxurious trappings one might expect from a home in the Pierre, the hotel on Fifth Avenue, with its expansive views of Central Park. I felt as if I were trespassing in the rooms of someone who had perhaps gone away on a long vacation. The vases were there, but without their customary profusion of flowers. Bowls for hors d'oeuvres were empty; ashtrays were clean; magazines and newspapers were in tidy piles; and there was a welcome drink from the kind people who showed me around. But where the pictures had been on the walls—on the pink silk of the dining room or the bold yellow-and-blue upholstery of the bedroom—there were now only rectangles of a slightly darker shade. And the empty pedestals in the sitting room cried out for sculpture. What made my visit all the more odd was that I knew, at first hand, all the paintings and drawings—had indeed that very morning been examining each one. My hosts, who had been well acquainted not only with the collector but also with the exact disposition of the works throughout the apartment, had only to point to a space and say, "That is where the Derain was," or "There was Vuillard's woman in a

Figure 1

View through the sitting room and into the drawing room of Janice H. Levin's apartment in the Hotel Pierre, New York, showing (from left to right) works by Picasso, Modigliani, Cassatt, Degas, Vuillard, and Giacometti

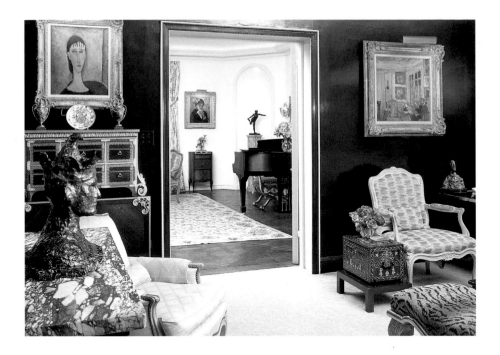

hat," or to tell me where Sisley's summer meadow had hung or the Giacometti bust had stood, and an image immediately surfaced in my mind's eye of the effect each work would have had in that particular spot. Not long before, I had been looking at the works on utilitarian storage racks at the Metropolitan Museum, and my visit to the somewhat ghostly apartment was intended to give me some idea of the pieces as a complete and personal collection.

Here was an assemblage of works, mostly by household names, bought by Philip and Janice Levin entirely for their pleasure, to be lived with and enjoyed from day to day. Acquiring works to decorate the rooms one lives in is perhaps the oldest answer given to the question of why people collect. In the case of the Levins, this was certainly true, but they also invested wisely. There are only a few areas of collecting that never lose their cachet or dip in value, and French art of the later nineteenth century has possibly been the most secure of all. It was only after Philip Levin had become wealthy from real estate development that he and his wife began to buy works of art for their home. As Janice Levin freely admitted, she did not care for contemporary art, and the couple's first purchases went straight to the heart of the collection—paintings by

Renoir and Monet. At first, moving into a highly competitive field, they were naturally cautious and bought selectively with the wise counsel of two leading New York dealers, Sam Salz and Richard Feigen. They had made some headway—Monet's spectacular *Garden in Argenteuil*, for example, was already theirs (cat. no. 4)—when Philip Levin died unexpectedly in 1971.

For the thirty years of her widowhood, Janice Levin continued to buy, increasing the scope of her collection in period, style, and subject. Although the field of French art on which she concentrated could hardly be called adventurous, she bought works that, while not difficult or demanding, are unusual or offbeat and that often reveal their qualities only after some familiarity. If she was going to spend a great deal of money on an object, she wanted something to live with that was easy on the senses. But she was not content with filling her walls with charming *petits riens*, nor was she going for the most obviously "pretty" of Impressionist works. Although the general temper of the works is sunny and celebratory, that is only part of the story.

The early Pissarro (cat. no. 5), for example, is not the most seductive of his Pontoise paintings: it has a rather melancholy note to it, which, nevertheless, is highly characteristic. It serves as an entirely appropriate foil to the radiant landscapes of Renoir and Sisley. The two early Bonnards (cat. nos. 29 and 30) also show a darker side to this artist—a sense of being caught up in a transitory moment of inexplicable significance. While another collector might have gone for a later Van Dongen in sumptuous Fauvist color, Janice Levin chose an early work (cat. no. 33) with a strong Parisian flavor, trimmed with humor. So, too, with the Toulouse-Lautrec (cat. no. 24), a painting made when the young artist had probably never set foot in the Moulin Rouge. And André Derain might have been represented here with an enticing view of the harbor at Collioure, all cobalt blue and chrome yellow, whereas we see him instead as the earnest student of Cézanne, but no less compelling for that (cat. no. 34).

While Mrs. Levin wanted her pictures, which were individually lit and spaciously hung, to hold their own in her rooms, she did not want them to be overwhelming. As far as subject matter was concerned, she had her preferences. Figures predominate—from the vivid close-up heads by Cassatt and Modigliani and the sculptures by Picasso and Giacometti to

people in interiors going about their daily life, such as Degas's business-men conferring in the Paris stock exchange, Pissarro's women at work in an orchard, and Berthe Morisot's daughter perhaps doing lessons at a table. Still life and the nude (represented by just two examples each) were not especially to her taste—Vuillard's model modestly undressing before assuming a pose in the studio (cat. no. 28) shows only her naked back to the viewer ("I don't lend myself to what I call bathroom scenes," Janice Levin commented; "This is undressed enough for me"). And her Renoir bather turns shyly aside as she dries herself (cat. no. 14).

There are also some notable idiosyncrasies, touches of personal taste that only a complete exhibition of the collection might disclose. For example, it cannot be solely attributable to the fashion of the age that so many hats are represented, forming a virtual index to late-nineteenth- and early-twentieth-century headgear. We move from the elaborate headdress of Corot's young girl (cat. no. 1) and Ernest May's professional top hat in the Degas pastel (cat. no. 8) to the bedecked sun hats in Renoir's country outing (cat. no. 22); from the man's straw boater in the Toulouse-Lautrec to the velvety street wear of Bonnard's young woman and the pointed cap of the jester in the sculpture by Picasso (cat. no. 35). Women predominate in the paintings. Men are few, but it is worth noting that two of them were wealthy and remarkable men of the world who were also at the forefront of avant-garde culture—the financier Ernest May, an enthusiastic collector of works by the Impressionists, and, in one of the Vuillards (cat. no. 26), Arthur Fontaine, a patron and friend of writers and artists such as Odilon Redon, Maurice Denis, André Gide, and Vuillard himself.

As we study the works, moving from one to another, further connections become apparent. The importance of the Normandy countryside and its coastline is one such thread, connecting one of the older painters in the collection, Eugène Boudin, to one of the more recent, Pierre Bonnard. Well before the advent of Impressionism, Boudin had claimed the new holiday resorts of Normandy as his subject matter, and here he has dashed down two sparkling snapshots of groups on the beach at Trouville (cat. nos. 2, 3). Forty years later, when Bonnard was ensconced as a younger neighbor of Monet's near Giverny, he painted his verdant landscape featuring the Seine in the Normandy countryside (cat. no. 32). As for the

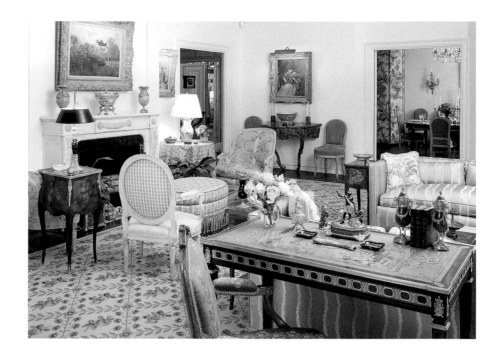

Impressionists, in the 1880s they grew restless with Paris and its country
suburbs, which were increasingly encroached upon by the ever-expanding
capital. Sooner or later, all of them moved from the city or spent long
periods in rural retreats, especially in the summer months. Monet and
Pissarro went, respectively, to the small Normandy towns of Giverny and
Pontoise; Renoir eventually settled at Cagnes in the South; and Sisley
retired to the provincial quiet of Moret-sur-Loing, on the edge of the forest
of Fontainebleau. But there are works here by all four depicting Normandy,
the great lung to the north of Paris, with its intense agriculture, water-
ways, ports, and seaside resorts. Renoir's painting dates from the period of
his close friendship with a patron, Paul Bérard, whose country house was
near the coast; Sisley's was made on a visit to his loyal patron François
Depeaux, near Rouen.

There is no formal portraiture here, in the manner of Sargent, for
example—though, again, many people are depicted. Usually, they are
caught off guard or in a momentary attitude, which is highly representative
of the changes undergone by portraiture in the later nineteenth century.
Even including Degas's highly informal portrayal of Ernest May, Vuillard's
treatment of Arthur Fontaine is perhaps the most extreme example of this

newfound sense of relaxation: the commissioning sitter is pushed to the
very edge of the canvas, where he becomes just one more object among his
furniture and pictures. Bonnard's young girl at a window is scarcely there
at all, until one peers into his weave of somber colors. And Mary Cassatt's
young model is seen with a handkerchief to her face (cat. no. 17), a common
enough human gesture but one rarely seen in European art.

Something of this informality and unpretentiousness reflected
Janice Levin's own character. Although she lived luxuriously, her collection
was neither showy nor obviously self-advertising. Her life was too busy
and her understanding of life too realistic for that. She had many interests
and was the benefactor of numerous charities and organizations con-
cerned with the arts. Dance was her particular passion (reflected here in
three works by Degas), but she was an encourager on all fronts. Her name
is firmly associated with The Metropolitan Museum of Art and Lincoln
Center for the Performing Arts in New York and with the Philip and Janice

Levin Music Center in Tel Aviv–Haifa, as well as with various benefactions to help young performers and students in the musical theater. Her days were socially and professionally full, and her collection was not the outcome of a single-minded pursuit. It is not a scholarly collection in the sense that, although French Impressionism is its focus, she did not feel obliged to represent all its associates in all their phases, ticking off their names as a philatelist ticks off countries. Nor did she feel, when acquiring early-twentieth-century works, that she needed to amplify the narrative by adding Post-Impressionist and Pointillist pictures from the intermediary period. What she bought pleased her as a beautiful ensemble rather than as a textbook. Thus, toward the end of her life, she jumped forward in time because she fell in love with the Giacometti bust of his brother Diego (cat. no. 37) and knew it would settle in well with its adopted family.

Inevitably in this as in all collections, certain works rise above the rest. The five that Janice Levin gave before her death to three major museums—Degas's pastel *À la Bourse,* the Sisley landscape, and Pissarro's *Outskirts of Pontoise* to the Metropolitan Museum; the Monet of Pourville to the Museum of Modern Art; and the Monet of his garden at Argenteuil to the National Gallery of Art—unquestionably deserve top billing. The Degas, in particular, shows the artist at his most acutely urban, its unusual composition articulated through his cynically affectionate eye. And in the Monet of the cliffs at Pourville (cat. no. 15), we find the painter in a mood of bold pictorial invention clothed in a celebration of nature. In the presence of such works, it would perhaps be too easy to overlook the interest and charm of the more modest ones. But the Morisot pastel view of Paris is a rare and lovely drawing (cat. no. 18), and the Van Dongen oil sketch shows this uneven painter in all the mischievous high spirits of his youth. It might be worth adding here that the four Renoirs in this collection deserve patient study. Although his fame is undiminished, the critical reputation of this great figure is not, today, as secure as it once was. His particular kind of innocent hedonism is invariably greeted with a skeptical, even cynical eye. But Renoir is no innocent, and a painting such as *Landscape with Figures* (cat. no. 22), for all its notes of tender relaxation, is built on compositional foundations as solid as a rock.

Nearly all the works in this collection have long provenances traced back to the best-known dealers and estates for such works. The

name of the great supporter of the Impressionists Paul Durand-Ruel, for example, frequently occurs. For my own part, as a writer familiar with the reception of Impressionism and Post-Impressionism in Britain, I have rue-fully noted that two Levin works were shown at the famous Impressionist exhibition organized by Durand-Ruel in London in 1905, whence, from a show of masterpieces, absolutely nothing sold. Even at that comparatively late date, the British, unlike the Americans, were still holding back from such daring acquisitions, much to the impoverishment of their national collections. The tide turned in the 1920s, and I am glad to note the name of Percy Moore Turner in the provenance of both the Degas pastel of a dancer and the Derain still life. This London dealer did as much as anyone to fire the interest of collectors of modern French art in just the kind of works that would have tempted Philip and Janice Levin.

The gradual building up of an art collection such as the Levins' involves numerous factors. Money, of course, is essential; patience, too, plays its part, as Balzac brilliantly described in his novel centered on a collection, *Cousin Pons.* Also, I think, what has to be present is a sense of being a *collector,* rather than simply someone who buys haphazardly from time to time. A strong conviction in one's own taste and a sure feel for how the works will look together and relate to one another are also vital ingredients. Janice Levin had all these qualities—and one more. She enjoyed the works she owned, and it is that enjoyment, first and foremost, that is conveyed in her interviews and through the memories of her friends. She cherished each work she owned and savored its individual personality. Although she was reluctant to lend to exhibitions—for she liked her collection around her, especially in her last years—she did occasionally agree to a temporary separation. She knew the importance a work might have for a particular show and the pleasure and interest it would contribute. Now, it is our turn to experience the full panoply. We can finally appreciate the entire span, from Corot and Boudin to Picasso and Giacometti, delighting in individual works along the way. We are fortunate both to encounter often reproduced but seldom seen paintings and to come across others that are almost completely unknown. But we should remember above all that they are, as assembled here, the fruits of Janice Levin's formidable capacity to enjoy.

CATALOGUE

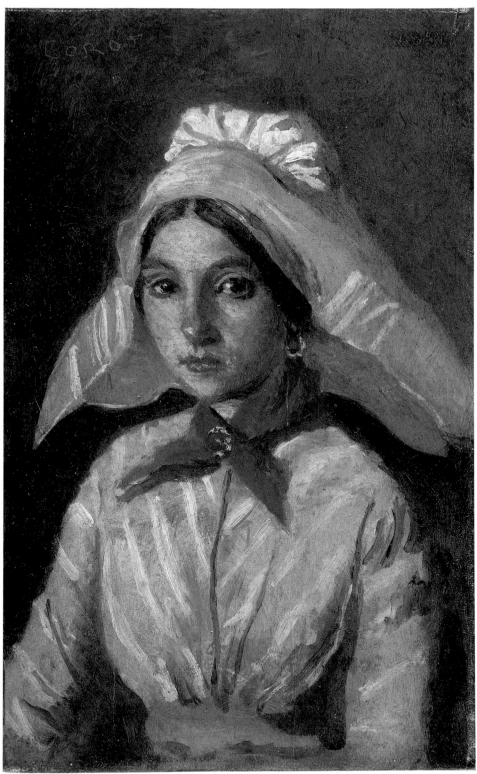

1.

Camille Corot (1796–1875)

1. *Portrait of a Girl*, ca. 1841

1. CAMILLE COROT

Portrait of a Girl, ca. 1841

Oil on paper laid down on cradled panel,
9¾ x 6 in. (24.7 x 15.3 cm)

Signed (upper left) *COROT*; dated
(upper right) *184[?]1*

PROVENANCE Alfred Daber, Paris; Florence J.
Gould (d. 1985); her sale, Sotheby's, New York,
April 24, 1985, no. 10 (color ill.); purchased at that
sale by Janice H. Levin, New York; The Philip and
Janice Levin Foundation, 2001.

REFERENCE Schoeller and Dieterle 1948,
pp. 12 (no. 6), 13 (ill.).

The predominant focus of the Janice H. Levin Collection is, unmistakably, on French art of the last decades of the nineteenth century and the early years of the twentieth. Beyond this concentration, however, it reaches back to Corot and forward to Giacometti. That it begins with a little portrait by the former establishes the main thrust of the collection, in which images of people are prevalent, in both paintings and sculpture. The Corot may seem a modest stepping-stone into the age of Impressionism, and even a little willful in that it is a portrait rather than the kind of landscape by Corot that was admired by Monet, Sisley, and Pissarro. In his lifetime, Corot's portraits and figures were much less well known; many went straight into private hands once they had been painted, and Corot often presented such works to the sitter's family. His achievements as a painter of the human figure were not really revealed until the early twentieth century, when some of his later portraits of female models made their mark on artists such as Georges Braque and André Derain (Derain happened to own one of the most beautiful of the early portraits, *Louise Harduin in Mourning* of 1831; Sterling and Francine Clark Art Institute, Williamstown, Mass.). But Corot's influence as a landscapist on the Impressionist generation was second to none. Camille Pissarro, for example, styled himself *élève de Corot* when he exhibited landscapes at the Paris Salons of 1864 and 1865; the works reflected the fact that after settling in Paris in the 1850s, he had sought the older artist's advice. Even in portraiture, Pissarro owed some debt to Corot, as can be seen in a comparison of the present work with Pissarro's 1872 painting of his daughter, Jeanne (Yale University Art Gallery, New Haven; fig. 4). In addition, Berthe Morisot's parents were friendly with Corot, and he played a crucial role in her early development. Much of Sisley's work, especially his choice of subject matter, is unthinkable without Corot's example. And Degas, whose private collection included seven of the artist's works, thought that Corot's figure paintings excelled even his landscapes.

Corot's engaging early portraits show his obvious rapport with children and young people. As sitters, they suited his candid and generous character, and very young children were persuaded to pose for him partly because he did not require absolute stillness from his models. His style in these works is one of artful simplicity and unlabored execution. His most sustained series portrays his nieces, the daughters

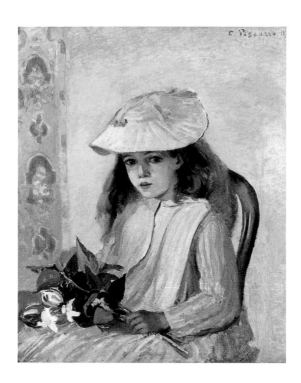

of his sister Annette-Octavie Sennegon, with whom the painter shared the Corot family's country property at Ville-d'Avray, outside Paris. The finest of this group is that of the youngest of the girls, Louise-Claire Sennegon, a picture unusual in the series for its landscape background (1837; Musée du Louvre, Paris); but it is entirely characteristic in that the sitter directly confronts the viewer with an uncorrupted charm of expression. Not all of Corot's portraits are of named individuals, however. In his early years in Italy, he drew and painted local people and made studies of peasants in regional costume and familiar attitudes that contributed to the figures in his landscapes. In his sketchbooks, there are drawings of French working girls and servants in which Corot took evident delight in the often elaborate hats and coiffures of his period. The present painting may well belong to this early phase: nothing is known of the large-eyed, attentively serious girl, perhaps in her mid-teens, beautifully caught between adolescence and adulthood and wearing her extraordinary hat without self-consciousness. The overall palette is clear and subdued, offset by the red kerchief (and its sharp, dark shadow), the paint applied lightly on the paper. If a date of about 1841 is correct (the inscription on the painting is partly illegible), then it is one of the last of Corot's portraits in his early manner. Thereafter, he dressed his models in less contemporary, often exotic clothes and gave them the air and attitude of more timeless figures, representative of poetic mood rather than the human immediacy that results from vivid and direct observation, as seen here.

Eugène Boudin (1824–1898)

2. *Trouville: The Nanny,* 1885

3. *Crinolines on the Beach, Trouville,* 1889

The Impressionist movement, based on the superlative achievements in landscape painting of Monet, Renoir, Sisley, and Pissarro in the 1870s, drew into its orbit a great many painters during the run of its eight exhibitions, from 1874 to 1886. Some of the participating artists now appear to have had little more in common with the leading figures (whom, in fact, they outnumbered) than a desire for independence from the official French system of exhibitions. Several are now obscure or forgotten or went their separate ways. Personal ties and friendships were often responsible for their inclusion in the exhibitions, which changed in cast and content depending on the chief organizers for each show. At the start, there had been a hope that some older artists whose work was sympathetic to that of the group would express their solidarity by exhibiting alongside them. But Corot and Courbet, for example, refused, as did Manet. There was one painter from the previous generation, however, who did accept an invitation to show at the first Impressionist exhibition (1874), having gained admittance with his stylistic innovations and contemporary subject matter. This was Eugène Boudin, who had already won a modest reputation and attracted a circle of collectors when the protagonists of the Impressionist movement were still studying at the Atelier Gleyre and elsewhere in Paris, and when the word Impressionist had not even been coined.

Claude Monet was the one primarily responsible for Boudin's invitation to exhibit. They had met in Le Havre in 1858, when Monet was eighteen years old and devoting himself to caricature, as well as making his first attempts at landscape. Boudin pointed out the delights of open-air painting, particularly on the Normandy coast (see fig. 7), where Boudin, born in Honfleur, chiefly worked in the summers. Monet always acknowledged the older artist's counsel and encouragement: in 1920, for example, he wrote to the critic Gustave Geffroy, "I owe everything to Boudin and am grateful to him for my success." Without this vital link to one of the great modern movements, Boudin's place in art history might be somewhat diminished, though not one of "oblivion," as he himself modestly suggested toward the end of his life. Measured by Impressionist standards of varied handling and audacious color, Boudin can indeed seem a little disappointing. But nothing can deprive him of his status as a *petit maître* of enduring charm, an innovator within his own generation. His numerous paintings of beaches, harbors, and ports on the Channel coast around the Seine

2. EUGÈNE BOUDIN
Trouville: The Nanny, 1885
Oil on panel, 5½ x 9 in. (14 x 22.8 cm)
Signed (lower right) *Boudin*; dated (lower left) 85

PROVENANCE Possibly Boudin sale, Hôtel Drouot,
Paris, April 19, 1888, no. 8, probably bought in;
Galerie Durand-Ruel, Paris (stock no. 483), pur-
chased from the artist June 6, 1890, for 200 francs;
purchased from that dealer by Monsieur Devilder,
Roubaix, France, April 2, 1914; Wildenstein and Co.,
New York; Jack Lasdon, New York, as of 1968; sale,
Parke-Bernet, New York, October 19, 1977, no. 29A
(color ill.), for $45,000; Richard L. Feigen and Co.,
New York (stock no. 16091-C); purchased from that
dealer by Janice H. Levin, New York, October 20,
1977; The Philip and Janice Levin Foundation, 2001.

EXHIBITIONS Paris 1889, no. 72; Mulhouse 1931,
no. 27; Paris 1965, no. 70.

REFERENCES Jean-Aubry and Schmit 1968, pp. 156
(color ill.), 239 (no. 156, as "coll. Jack Lasdon, New
York"); Schmit 1973, vol. 2, p. 240 (no. 1931, ill.), and
possibly vol. 3, p. xxiii (under no. 8); Schmit 1984,
p. 165, no. 1931.

3. EUGÈNE BOUDIN
Crinolines on the Beach, Trouville, 1889
Oil on panel, 5½ x 9 in. (14 x 22.8 cm)
Signed (lower right) *E. Boudin*; inscribed (lower left)
Trouville 89.

PROVENANCE Richard Green, London (stock no.
RH 2785); purchased from that dealer by Janice H.
Levin, New York, October 19, 1998; The Philip and
Janice Levin Foundation, 2001.

REFERENCE To be included in the third supple-
ment to the catalogue raisonné in preparation by
Robert Schmit, Paris

estuary may sometimes seem repetitive, a narrow repertory multiplied for commercial purposes and by an ingrained habit of painting what he knew. But to look into these usually small works, often on panel (as are the two shown here), and to savor their fresh color and brushwork, is to understand the regard in which Boudin was held by Monet and his colleagues. Émile Zola wrote admiringly of Boudin's *Jetty at Le Havre* in a review of the 1868 Salon: "There I see the artist's exquisite originality, his large silver-gray skies, his little figures so fine and witty of touch. There is a rare accuracy of observation in the details and attitudes of these figures on the edge of the vast expanse."

Boudin's career falls into three phases. His early work is dominated by the influence of the seventeenth-century Dutch artists he admired and copied—the coastal views of Adriaen van de Velde and Aelbert Cuyp and the landscapes of Jacob van Ruisdael—paying particular attention to their huge skies, reflected light, and hori-zontal format. In the 1860s, alongside views of ports and harbors, he developed his most famous subject matter—fashionable crowds on the beach at Trouville, the bur-geoning resort southeast of Honfleur (see fig. 6). Finally, the wide skies and coastlines in some of his later beach scenes and landscapes are treated with an increasing free-dom of touch that makes them his finest works. The Trouville paintings started appearing in 1862, then regularly through that decade and on into the 1870s, but they began to be far less numerous thereafter, particularly the large, finished works made from on-the-spot studies. The two small paintings being considered here belong to the 1880s, late in Boudin's career, when such contemporary subject matter was no longer such a hotly debated topic. Twenty years earlier, however, it had been this strik-ing note of modernity—the "bathing machines" (changing booths), parasols, and crinolines—that attracted the attention of such acute commentators as Baudelaire and Zola. At the same time, Boudin was admired for the effects of light sparkling off the sea and animating the leisurely crowds as they protect themselves against the Channel breeze. His compositions, though virtually free of anecdote or event, were fully realized, with the figures arranged in groups along a syncopated horizontal band, providing color and movement between the sky, which often takes up two-thirds of the canvas, and the narrow foreground of sand.

Each of these two late studies, obviously made in situ, concentrates on a single group of related figures, with a swarm of more sketchily indicated vacationers behind them. In *Trouville: The Nanny* (cat. no. 2), Boudin is looking up the beach past the striped sunshades to the large awnings on the promenade. In the other painting, he faces toward the sea, with a bathing machine at left and figures standing to the right, perhaps looking out at passing boats. Boudin's color range is gentler, more tempered, in these works than in the elaborate, often brilliantly hued paintings of the 1860s. Surprisingly, blacks predominate among the women's clothes and hats, offset by

2.

3.

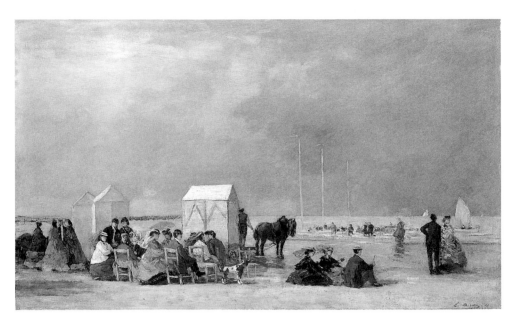

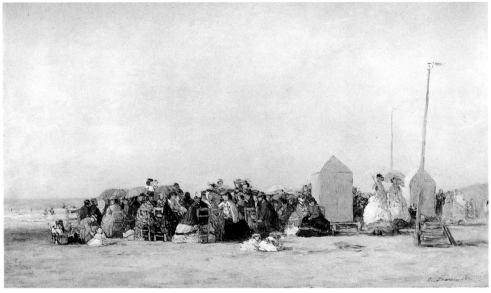

Figure 5
Eugène Boudin. *Bathing Time at Deauville*, 1865.
Oil on wood, 13⅝ x 22⅝ in. (34.7 x 57.5 cm).
National Gallery of Art, Washington, D.C.,
Collection of Mr. and Mrs. Paul Mellon (1983.1.8)

Figure 6
Eugène Boudin. *The Beach, Trouville*, 1865. Oil
on wood panel, 13⅝ x 22⅝ in. (34.5 x 57.5 cm).
Toledo Museum of Art, Purchased with funds
from the Libbey Endowment, Gift of Edward
Drummond Libbey (1951.372)

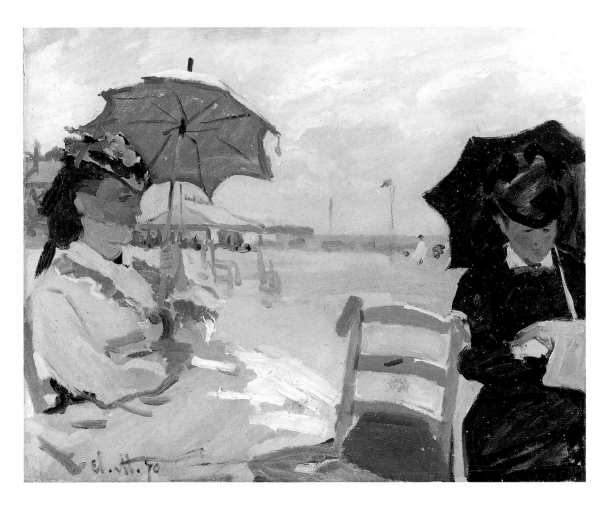

Figure 7
Claude Monet. *The Beach at Trouville,* 1870. Oil on
canvas, 14¾ x 18 in. (37.5 x 45.7 cm). The National
Gallery, London (NG3951)

touches of red and modulated whites. Gossip and possibly needlework occupy the
central group in *Crinolines* (cat. no. 3); in the other scene, the nanny, in a white apron
at the right, appears less mindful of the children than does the central figure, prob-
ably their mother or grandmother. Boudin gives us no narrative situation; all is pure
vision, deft in tone and contemplative in mood—two small glimpses of life entirely
taken up with the pleasures of the moment.

Claude Monet (1840–1926)

4. *The Artist's Garden in Argenteuil (A Corner of the Garden with Dahlias),* 1873

Nearly all the leading Impressionists painted gardens, which range in type from humble village vegetable plots to the flower gardens of rented suburban houses to Renoir's extensive property in Cagnes and Gustave Caillebotte's manicured rose beds at Petit-Gennevilliers. There are, too, Pissarro's panoramic views of the Tuileries gardens in Paris and Alfred Sisley's desolate garden under snow at Veneux-Nadon. But it was Monet who made the subject his own, painting every kind of public and private garden from the 1860s to the 1920s. The theme was relatively new in French art and coincided with the growing national taste for bourgeois flower gardens, as opposed to the royal and aristocratic parks and ornamental gardens of the eighteenth century. Monet was a passionate devotee of gardening (something he shared with his friend Caillebotte), and even in his often financially precarious early years he turned the gardens of his rented properties at Argenteuil into exuberant oases. He filled beds and borders with the stock herbaceous plants known for their bright colors, strong growth, and continuous seasonal flowering—roses, chrysanthemums, dahlias, nasturtium, salvia, and pelargonium—and favored blossoming bushes such as vibernum, fuchsia, and lilac. It was only later, on his own property at Giverny, that he began to cultivate the more exotic and expensive species of iris, poppy, peony, and, of course, nymphaea—his celebrated water lilies.

The present work was painted in the garden of the first of Monet's two rented houses in Argenteuil, the small Seine-side town to which he and his family had moved in December 1871. Number 2, rue Pierre Guienne, had both formal areas and less cultivated ones, at both the front and the back of the house: here, we are at the back, with a side or rear view of a newly built villa beyond the dividing garden fence. A third of the canvas is taken up by a profusion of red, yellow, and white dahlias. But are we in Monet's garden or looking across at his neighbor's? Are the dahlias the result of Monet's green thumb, or has he appropriated them from next door? These questions arise because of the existence of Renoir's well-known canvas of 1873 *Monet Painting in His Garden at Argenteuil* (Wadsworth Atheneum, Hartford; fig. 10), obviously executed at the same moment and showing the same house (at the left) as appears in the center of Monet's work, as well as the same configuration of dahlias. But Renoir depicts a wooden fence, parallel to the picture plane, that confines the flowers to the neighboring garden. Did

4. CLAUDE MONET

The Artist's Garden in Argenteuil (A Corner of the Garden with Dahlias), 1873
Oil on canvas, 24⅛ x 32½ in. (61.3 x 82.5 cm)
Signed and dated (lower left) *Claude Monet. 73*
National Gallery of Art, Washington, D.C., Gift of Janice H. Levin, in Honor of the 50th Anniversary of the National Gallery of Art (1991.27.1)

PROVENANCE Galerie Durand-Ruel, Paris, purchased from the artist December 1873 (as *Les Dahlias*); [Monsieur?] Baroux; purchased from him by Galerie Durand-Ruel, Paris (stock no. 3961), December 11, 1896; at Galerien Thannhauser, Berlin, 1928; Sam Salz, Inc., New York; Mr. and Mrs. David O. Selznick, New York; private collection (possibly Durand-Ruel), Paris, by 1949; possibly Galerie Durand-Ruel, Paris, by 1959; Sam Salz, Inc., New York, 1965; Mr. and Mrs. Konrad H. Matthaei, New York, ca. 1966; purchased from them by Richard L. Feigen and Co., New York, September 28, 1970; purchased from that dealer by Mr. and Mrs. Philip Levin, New York, September 28, 1970; given by Janice H. Levin to the National Gallery of Art, Washington, D.C., 1991.

EXHIBITIONS Paris 1899, no. 2; London 1905, no. 149; Berlin 1905, no. 13; Weimar 1905, no. 3; Vienna 1910, no. 29; London 1914, no. 49; Paris 1924, no. 42; Paris 1928, no. 12; Berlin 1928, pp. 8 (no. 19), 29 (ill.); Basel 1949b, p. 25 (no. 79, as "private collection, Paris"); Paris 1959b, no. 9; New York 1966, no. 116; New York 1968a, p. 26 (no. 117); New York 1968b, p. 16 (no. 117); New York 1971, p. 1 (no. 1); Chicago 1975, pp. 29, 89 (no. 35, ill.); New York 1982, no. 6; Washington, D.C., 1991, pp. 166, 167 (cat. entry by Charles S. Moffett, color ill.); Chicago 1995 [no. 32], pp. 55 (color ill.), 231 (under "April 6 or 10–May 1899"), 237 (under "January–February and April–May 1905"), 242 (under "May 1910"), 254 (under "January 4–18, 1924"); Washington, D.C., Hartford 2000, pp. 92 (no. 20), 93 (color ill.), 94–95 (color dtl.).

REFERENCES Geffroy 1922, opp. p. 72 (ill.), p. 263; Adhémar 1950, pl. 4; Rewald 1973, p. 284 (ill.), cf. p. 285 (ill.); Tucker 1982, pp. 122–23 (fig. 23, color), 143, 145, 185; Gordon and Forge 1983, p. 200 (color ill.); Wildenstein 1974–91, vol. 1 (1840–1881, *Peintures*), pp. 236 (no. 286), [237] (ill.); Tucker 1995, pp. 86, 87 (pl. 94, color); Wildenstein 1996, vol. 2 (*Nos. 1–968*; trans. Josephine Bacon), p. 122 (no. 286, ill.); Ottawa, Chicago, Fort Worth 1997–98, pp. 122 (under no. 14), 278 (nn. 8–10), 279 (fig. 133).

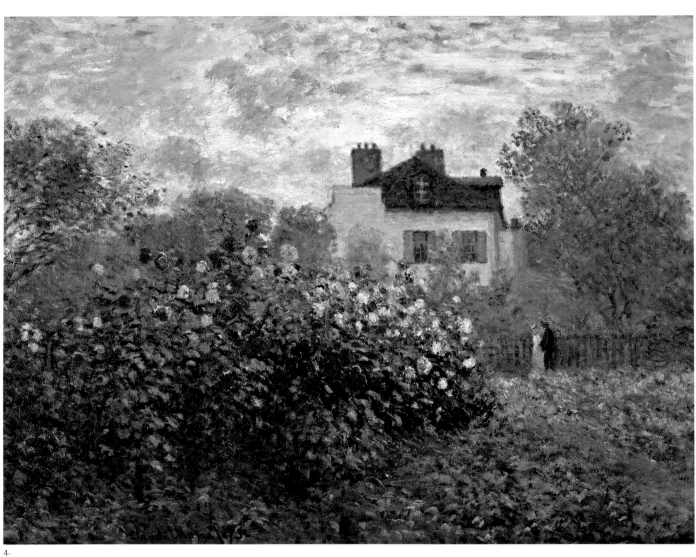

4.

Figure 8
Claude Monet. *The Artist's House at Argenteuil*, 1873.
Oil on canvas, 23¼ x 28⅞ in. (60.2 x 73.3 cm). The
Art Institute of Chicago, Mr. and Mrs. Martin A.
Ryerson Collection (1933.1153)

Monet simply omit this feature from his own work (as Paul Hayes Tucker has suggested)[1] to give the scene a less suburban, more open feeling? Perhaps Renoir was aware of his friend's strategy—that of Monet the would-be landowner—and decided to give us both the topographical truth (he also includes other encroaching new houses that Monet carefully eschews) and a sly observation about his friend's character. Whatever the circumstances, the two kindred paintings—Monet's carrying a note of autumnal melancholy, Renoir's a more genial impression of the everyday—are an example of the close accord between the two artists, not only in their painterly freedom but at a moment when discussions were under way to form an exhibiting society, soon to be called the Société Anonyme des Artistes Peintres, Sculpteurs, Graveurs, Etc., which would lead to the first Impressionist exhibition of 1874.

1. Tucker 1982, p. 143.

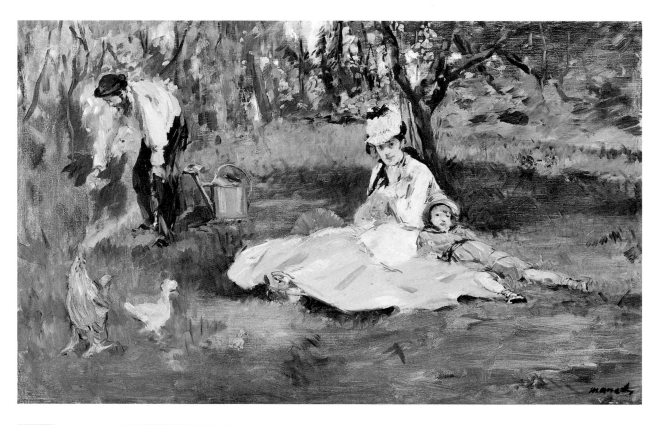

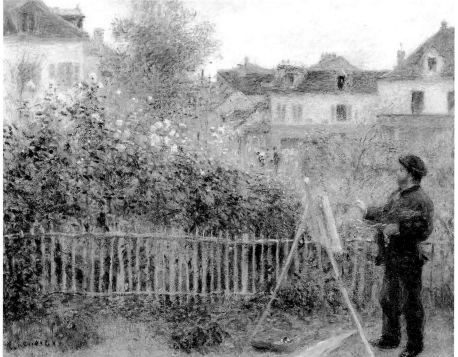

Figure 9
Édouard Manet. *The Monet Family in Their Garden at Argenteuil*, 1874. Oil on canvas, 24 x 39¼ in. (61 x 99.7 cm). The Metropolitan Museum of Art, New York, Bequest of Joan Whitney Payson, 1975 (1976.201.14)

Figure 10
Pierre-Auguste Renoir. *Monet Painting in His Garden at Argenteuil*, 1873. Oil on canvas, 18⅜ x 23½ in. (46.7 x 59.7 cm). Wadsworth Atheneum, Hartford, Bequest of Anne Parrish Titzell (1957.614)

Camille Pissarro (1830–1903)

5. *Outskirts of Pontoise,* or *La Côte des Grouettes,* ca. 1878

5. CAMILLE PISSARRO
Outskirts of Pontoise, or *La Côte des Grouettes,* ca. 1878
Oil on canvas, 29⅛ x 23⅝ in. (74 x 60 cm)
The Metropolitan Museum of Art, New York,
Gift of Janice H. Levin, 1991 (1991.277.2)

PROVENANCE Galerie Durand-Ruel, Paris, and
Durand-Ruel, New York (stock no. 754), purchased
from the artist January 14, 1881, for 440 francs;
Durand-Ruel until after 1888; Catholina Lambert,
Paterson, N.J.; purchased from him by Durand-
Ruel, New York, April 14, 1899, for $500; Durand-
Ruel, New York (stock no. 2194), 1899–1916;
purchased by Galerie Durand-Ruel, Paris (stock
no. 10828), January 25, 1916; purchased from that
dealer by Max Bollag, Zürich, 1920, for 14,400
francs; private collection until 1922; sale of that
collection, American Art Galleries, New York,
February 16, 1922, no. 52; purchased at that sale
by Durand-Ruel, New York, and Knoedler and
Co., New York, for $2,000; Knoedler share sold to
Durand-Ruel, New York (stock no. 4720), 1925;
purchased by Galerie Durand-Ruel, Paris (stock
no. 12753), May 31, 1927; purchased from that dealer
by Sam Salz, Inc., New York, December 15, 1967, for
4,000 francs; purchased from that dealer by Mr.
and Mrs. Philip Levin, New York, January 1971;
given by Janice H. Levin to The Metropolitan
Museum of Art, New York, 1991.

EXHIBITIONS Zürich 1917, no. 157; New York 1923,
no. 21; Paris 1956, no. 34; Bern 1957, p. 14 (no. 50,
as "Privatbesitz Paris" [though the painting was,
according to Durand-Ruel, part of the dealer's
inventory in 1957]); Paris 1962, no. 16; New York
1971, p. 1 (no. 3); Fort Lauderdale 2000, p. 57 (no. 26,
color ill.).

REFERENCES Pissarro and Venturi 1989, vol. 1,
p. 146 (no. 465), vol. 2, pl. 95 (fig. 465); Brettell 1990,
p. 213 (under n. 32); Tinterow 1992, p. 46 (color ill.);
Anon. 1994, p. 94 (under "États-Unis").

Among the celebrated villages and small towns that recur throughout the early history of Impressionism—Argenteuil, Louveciennes, Voisins, and Bougival, all by or near the river Seine, west of Paris—the small Normandy town of Pontoise, between Paris and Rouen, occupies a special place. It is most closely associated with Pissarro, who lived there in the late 1860s and returned to make his home there from 1872 to 1882. Some of his finest landscapes from the period of the early Impressionist exhibitions were inspired by the town and the nearby hamlet of L'Hermitage. During his second residence, he was visited in Pontoise by his contemporary Paul Cézanne and by the younger artist Paul Gauguin, both of whom benefited from his wise encouragement at crucial moments in their development.

Pissarro found in Pontoise and its environs exactly the kind of motifs to which he was most attracted. He never cared for the dramatic scenery that enthralled Monet, and the landscape that kept Sisley at Moret-sur-Loing for twenty years was perhaps too quiet even for Pissarro. He liked busy rural life amid the gentle contrasts of cultivated fields, wooded slopes, and village outskirts, animated by the presence of local people and farmworkers. In the 1870s Pissarro's compositional devices became more varied and adventurous. One of his great earlier views of Pontoise from his first period there, *Jallais Hill, Pontoise* of 1867 (The Metropolitan Museum of Art, New York; fig. 11), presages such innovations but, in its broad sweep of country, reminds us more of Corot than of the individual voice of Pissarro in the 1870s. During his next, decade-long stay, he began to depict hillside houses seen through a dense palisade of tree trunks (*Côte des Boeufs, Pontoise,* 1877; The National Gallery, London) and to contrast plunging and rising viewpoints in ways encouraged by the vertiginous slopes of Pontoise (*Climbing Path, Pontoise,* 1875; Brooklyn Museum of Art).

In this intimate late-summer or early-fall landscape of about 1878, we find Pissarro in a gentler mode. Most striking is the placing of the tall, thin tree trunk almost at dead center of the canvas, which entailed subtle changes of perspectival weight to either side of it in order to prevent too simplistic a composition. At the left, the eye moves rapidly from the foreground of undergrowth and brambles to the distant horizon across the valley, with the houses in between beautifully diminishing in tone and detail. At the right, the varied brushstrokes suggest the recession of trees

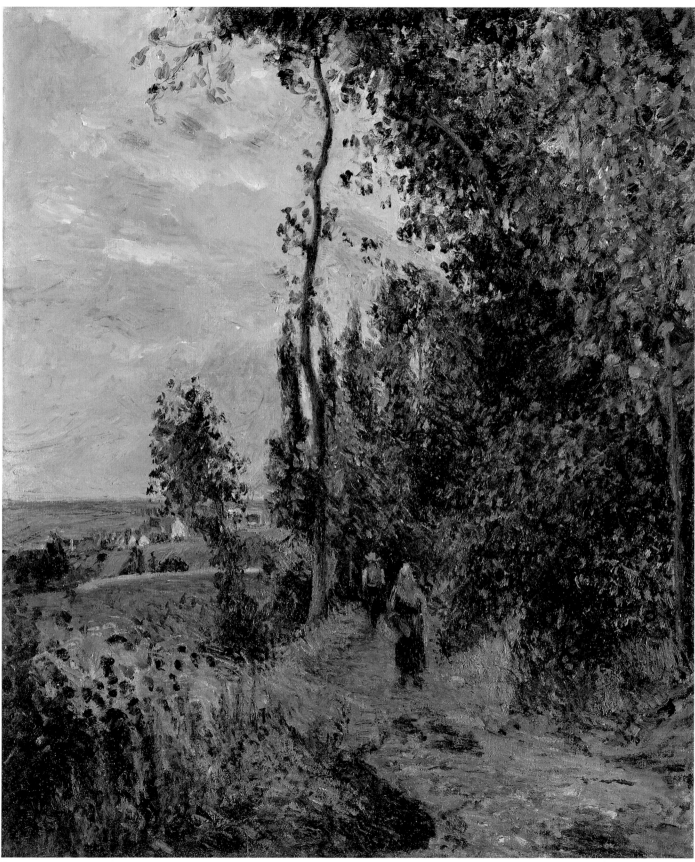

5.

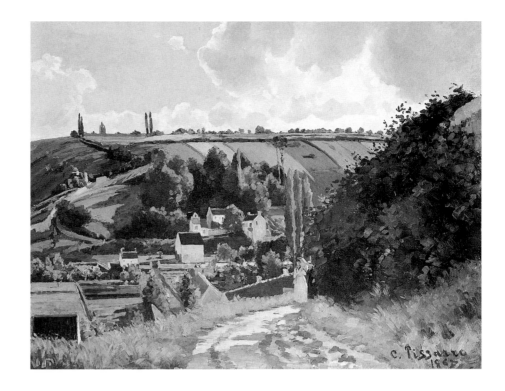

alongside the path—from individually detailed leaves toward the finer, more matted texture of the foliage at center. On the path, two villagers, having perhaps exchanged a few words, walk away from each other, curiously adding to the painting's sense of solitude. All this is carried through with unforced simplicity of effect; Pissarro never pushes the emotional pace of his work, never adds a dramatic or sentimental touch. But through this concentrated absorption in the scene before him, something of *l'automne et ses tristesses,* in the painter's own phrase, is conveyed.

The fall and spring seem to have been Pissarro's favorite seasons, certainly in the 1870s, for he found the full green of summer too monotonous and the glare of sunlight too blatant. Among the Impressionists, Pissarro and Sisley are the great chroniclers of autumnal change, from the first hint of brown and yellow among the trees to the last leaves left on the branches as winter takes hold. But where Sisley injects his work with an English poetry of melancholy solitude, as though bereft at the passing of high summer (the season he depicts in his Sahurs landscape, cat. no. 21), Pissarro's rural sentiments are more philosophical. He enjoys the colors of the fall but accepts the change as an inevitable part of the annual cycle.

Camille Pissarro (1830–1903)

6. *Peasant Woman Digging*, 1883

7. *Apple Gatherers*, 1891

6. CAMILLE PISSARRO
Peasant Woman Digging, 1883
Oil on canvas, 18 x 15 in. (45.7 x 38.1 cm)
Signed and dated (lower right) *C. Pissarro / 1883*

PROVENANCE Galerie Durand-Ruel, Paris (stock
no. 3021 through 1884, stock no. 1412 in 1891 and
thereafter), purchased from the artist September 6,
1883, for 500 francs; Paul-Marie-Joseph Durand-
Ruel (1831–1922), Paris (inv. no. A.I.239); Sam Salz,
Inc., New York; purchased from that dealer by Mr.
and Mrs. Philip Levin, New York, after April 1968–
by August 1971; The Philip and Janice Levin
Foundation, 2001.

EXHIBITIONS London 1905, no. 191; Fort Lauder-
dale 2000, p. 65 (no. 35, color ill.).

REFERENCE Pissarro and Venturi 1989, vol. 1,
p. 169 (no. 618), vol. 2, pl. 128 (fig. 618).

It is only in the last two decades or so that scholarly and interpretive attention has been directed toward Pissarro's considerable body of work depicting the human figure in the landscape. Of course, villagers and farmhands are a constant presence in his landscapes of the 1870s (as seen in *Outskirts of Pontoise*, cat. no. 5). But by the early 1880s Pissarro had begun to close in on such figures—making them the focus of the landscape rather than subordinate to it—and to show his country people, in more specific detail, pursuing the habitual, seasonal tasks of rural and agricultural life.

Like his Impressionist colleagues, especially Monet, Renoir, Morisot, and Sisley, Pissarro had experienced frustration with certain aspects of his work as it had developed up to about 1880. He was impatient with Impressionism's tendency to dissolve form and promote an unstructured handling of paint. In midcareer he set about an overhaul of his technical procedures as well as of his subject matter, which would come to a head later in the 1880s with the influence of the principles of Pointillism as formulated by the much younger Georges Seurat (1859–1891). But even before that, his painting had begun to be more tightly constructed and spatially various, with surfaces consisting of a weave of short brushstrokes. Concurrently, his subjects reflected his growing reverence for Degas's figure drawings and his renewed interest in scenes of agricultural labor by Jean-François Millet (1814–1875). At intervals during the decade, this concentration on the figure, involving numerous studies and drawings, culminated in substantial compositions such as *The Harvest* (1882; Bridgestone Museum of Art, Tokyo), *Apple Picking* (1886; Ohara Museum of Art, Kurashiki), *Apple Picking at Éragny-sur-Epte* (1888; Dallas Museum of Art; fig. 12), and *The Gleaners* (1889; Kunstmuseum Basel; fig. 13). But perhaps more immediately seductive than these are his modestly scaled paintings of single figures or pairs laboring in the fields or tending kitchen gardens, as seen in the two present works.

Living in the agricultural landscape of Normandy around Pontoise and, from 1884, after a brief period at Osny, in the village of Éragny, which would be his home until his death, Pissarro could observe every kind of rural and domestic task—from household chores such as sweeping the yard and washing dishes to the tending of livestock, digging, hoeing, planting, and harvesting. For the most part, the farming in Pissarro's immediate area tended to be on a small scale, with an emphasis on the production of

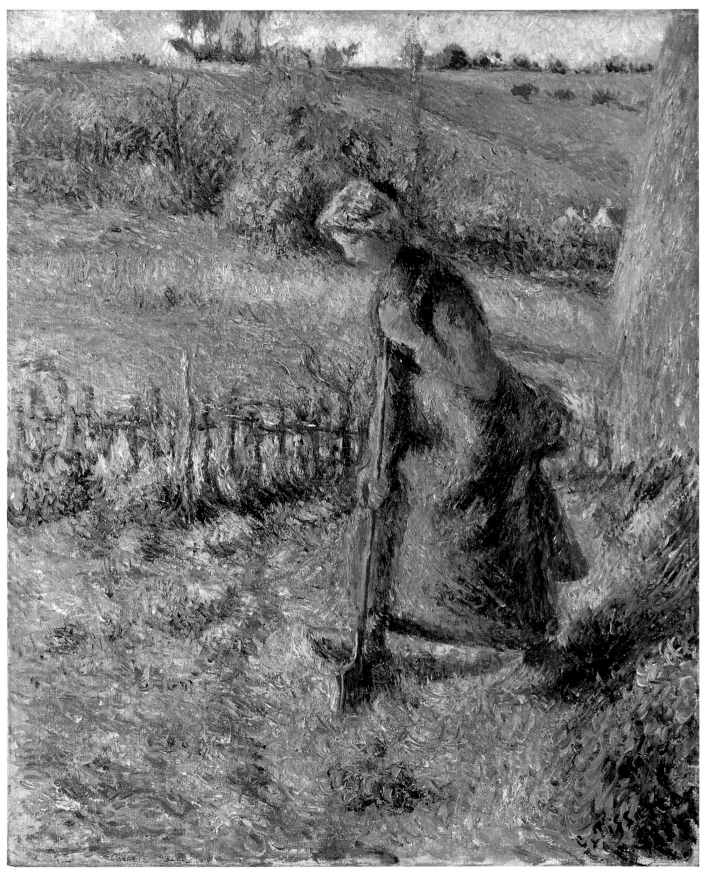

6.

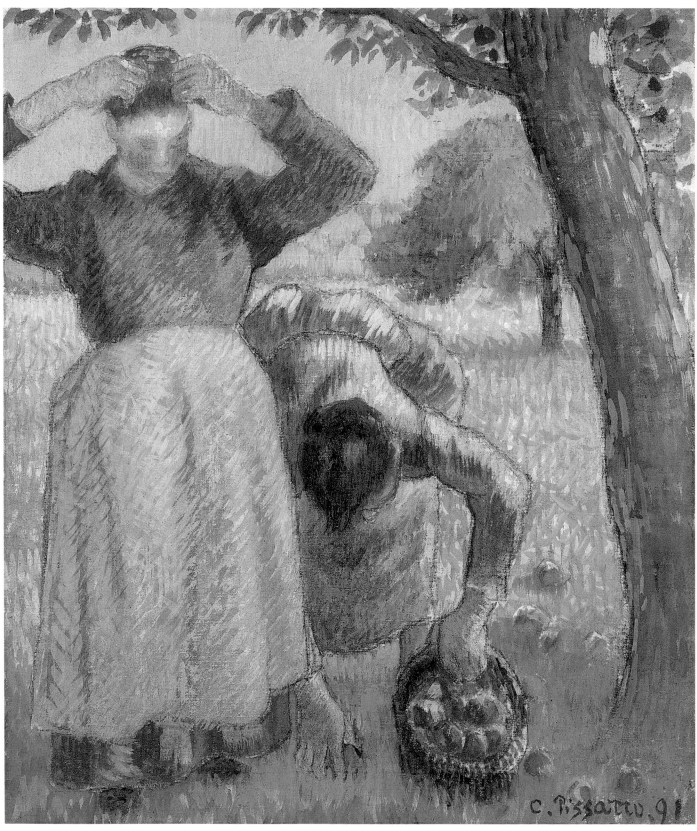

7.

7. CAMILLE PISSARRO

Apple Gatherers, 1891

Gouache on silk on paper, 10¼ x 8⅝ in.
(26 x 21.9 cm)

Signed and dated (lower right) *C. PISSARRO '91*

PROVENANCE Galerie Durand-Ruel, Paris (stock
no. 2033), purchased from the artist February 24,
1892, for 400 francs; purchased from that dealer
by Potter Palmer, April 29, 1892; purchased from
him by Durand-Ruel, New York (stock no. 996),
December 5, 1892; purchased from that dealer by
Mrs. John Jay Borland, March 6, 1897; her sale,
Parke-Bernet, New York, January 17–18, 1945, no. 38
(ill.), for $1,750; sale, Sotheby's, New York, May 11,
1984, no. 2 (color ill.); purchased at that sale by
Janice H. Levin, New York; The Philip and Janice
Levin Foundation, 2001.

EXHIBITION Fort Lauderdale 2000, p. 72
(no. 43, color ill.).

Figure 12
Camille Pissarro. *Apple Picking at Éragny-sur-Epte*,
1888. Oil on canvas, 23 x 28½ in. (58.4 x 72.4 cm).
Dallas Museum of Art, Munger Fund (1955.17.M)

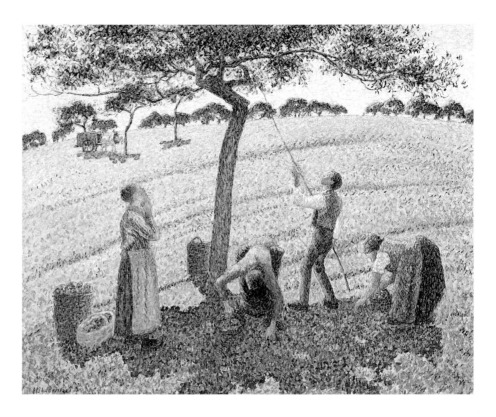

vegetables and fruit. The quotidian intimacy of his depictions of peasant life is balanced
by a metaphorical charge that is subtly poetic rather than sentimental or dogmatic. He
suggests the binding regime of the yearly rural cycle without idealizing his figures or
demeaning them. Hard work is present but so, too, are moments of rest, of a neighborly
chat among women in the fields who manage yet to keep a watchful eye on a venture-
some child or on a cow that might be straying too far from sight.

 The young woman shown on page 29 in the 1883 oil is related to an 1881 paint-
ing of a woman, seen from behind, digging in a vegetable garden, or *potager*, at Pontoise
(Nieson Shak Collection, Scotch Plains, N.J.). But she reappears over the following years
in several guises, notably in *Peasant Woman Digging* (1882; private collection), where
her posture is close to that in the present work; and, a decade later, in *Two Young Peasant
Women* of 1892 (The Metropolitan Museum of Art, New York; fig. 14), where she talks
with a companion as they both rest from their work. This repetition of certain figures,
their roles and tasks transformed, is a constant feature of Pissarro's figurative scenes.
A woman gleaning in the fields becomes an apple picker in one work and a bathing
nude in another. Many of these single-figure paintings are suffused with Pissarro's
obvious sympathy for the country people among whom he lived. The young women—
men are much rarer—are shown absorbed in their work or temporarily resting in
reflective or introspective moods. A spade or hoe or brush takes their weight and

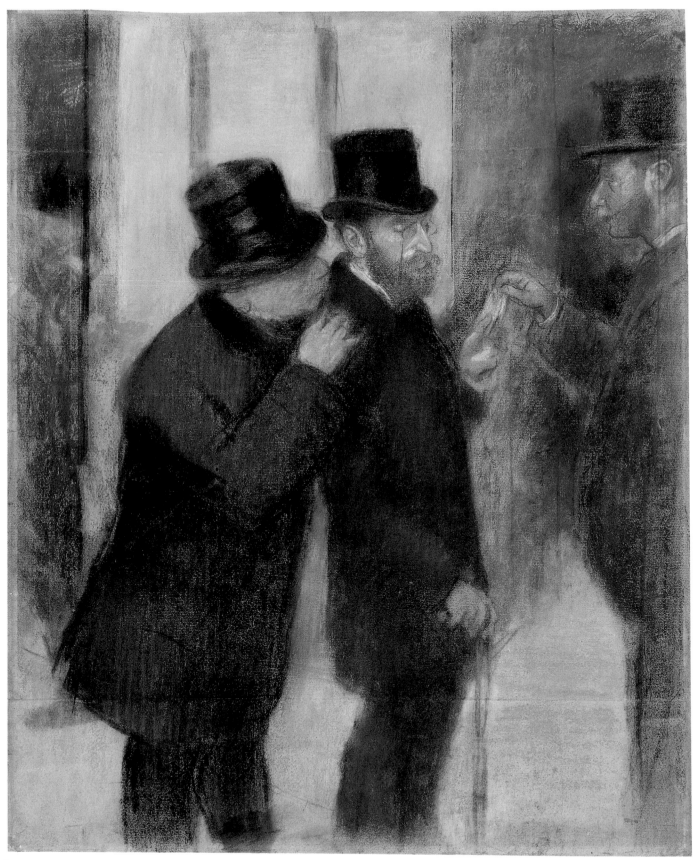

8.

Edgar Degas (1834–1917)

8. À la Bourse (Portraits in the Stock Exchange), ca. 1878–79

8. EDGAR DEGAS

À la Bourse (Portraits in the Stock Exchange), ca. 1878–79
Pastel on three sheets of paper, pieced and laid
down on canvas, 28⅜ x 22⅞ in. (72.1 x 58.1 cm)
The Metropolitan Museum of Art, New York, Gift of
Janice H. Levin, 1991 (1991.277.1)

PROVENANCE The sitter, Ernest May, Paris (d.
1925), purchased from the artist; by inheritance to
his son, Jacques-Ernest May, Paris, until 1946;
Rosenberg and Steibel, New York; Norton Simon
(1907–1993), Pasadena, until 1971; his sale, Parke-
Bernet, New York, May 5, 1971, no. 36; purchased at
that sale by Mr. and Mrs. Philip Levin, New York;
given by Janice H. Levin to The Metropolitan
Museum of Art, New York, 1991.

EXHIBITIONS Paris 1931, no. 128; New York 1978,
no. 13 (color ill.); Paris, Ottawa, New York 1988–89,
p. 317 (under no. 203), cf. p. 318 (nn. 8–9), exhibited
hors catalogue (New York only).

REFERENCES Lemoisne 1946–49, vol. 2, pp. 212
(no. 392), 213 (ill.); Russoli and Minervino 1970,
pp. 105 (no. 398, ill.), 108 (under no. 454); Loyrette
1991, p. 418; Tinterow 1992, p. 45 (color ill.); Anon.
1994, p. 94 (under "États-Unis"); Berson 1996, p. 34
(under no. 2-38).

The fusion of contemporary subject matter and progressive style in the work of Manet, Degas, and others associated with the Impressionist movement runs parallel to the great innovations in nineteenth-century French literature at the hands of Émile Zola, Guy de Maupassant, Gustave Flaubert, and the Goncourt brothers. The points of contact have been exhaustively explored, and hardly a novel published between, say, 1860 and 1890 has not been searched in order to discover some visual or narrative coincidence with the work of the artists of the period. Yet for the most part, these artists—the Impressionists and their close colleagues—remained miraculously free from the anecdotal thrust and the moral, social, and political agendas of many of their non-Impressionist contemporaries, both within France and without, especially in Great Britain.

During the second half of the century, Degas took as his raw material a huge range of everyday occurrences and events—anything, indeed, that human beings could be seen doing in a social context—and extracted a visual content that always illuminated life in a way well beyond its documentary or mere illustrative value. ("In a single brush-stroke we [painters] can say more than a writer in a whole volume," Degas remarked discouragingly to his young writer friend Daniel Halévy.) There are few works (*Le Viol,* or *The Rape,* is one notorious exception) in his prolific oeuvre as a painter, sculptor, and draftsman about which it would be reasonable to ask, "What is happening here? What is the situation?" This does not deny, of course, the high human content and profound implications of his vision of modern society. But words and commentary are left at the threshold when we enter the complex visual eloquence of a work by Degas. That we use, in connection with Degas's line, such words as *witty* and *caressing* and *mordant,* even *cruel,* is testimony to his supreme draftsmanship rather than to his gifts as a commentator or novelist manqué.

Edmond Duranty, the subject of one of Degas's greatest portraits (1879; Burrell Collection, Glasgow), was an early apologist for contemporary art and for Degas in particular. In his 1876 pamphlet *La Nouvelle Peinture,* Duranty traced the rise through the 1860s and early 1870s of modern subject matter in art: "The painter had to be dragged away from his skylight, from his cloister where his only contact is with Heaven, and brought back into the world of men," and likewise he had to learn that

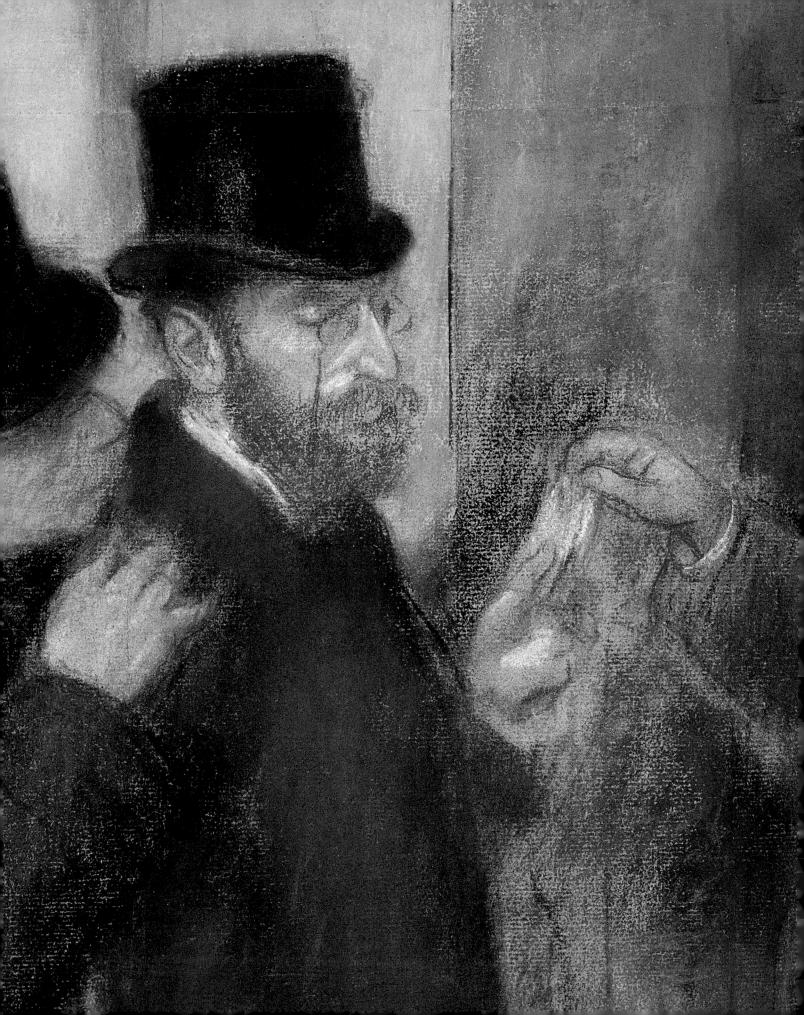

Figure 16

Edgar Degas. *Portraits at the Stock Exchange*, 1878–79. Oil on canvas, 39⅜ x 32¼ in. (100 x 82 cm). Musée d'Orsay, Paris

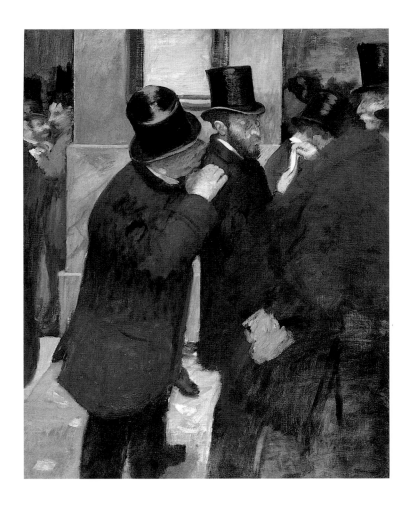

Opposite: Detail, cat. no. 8

"our lives are passed in rooms or in the street, and that rooms and the street have their own particular laws of light and expression." [1]

Nothing could be more representative of this embrace of new subject matter than the present pastel, a preparatory study for the well-known painting of the same title in the Musée d'Orsay, Paris (see fig. 16). [2] Two men are momentarily reading a financial note or memorandum handed to the central figure by an employee, at right, in the Paris stock exchange (La Bourse). They are wearing the sober business clothes of their day; their features are humdrum but concentrated; and their activity takes place entirely within the confidential purlieus of their work. It might well be a pivotal scene in a novel by Zola, such as *L'Argent* (as Theodore Reff has suggested), or even in one by Anthony Trollope, such as *The Way We Live Now*. Degas makes no comment on the action (though in the subsequent oil painting he introduces a slightly sinister or, at least, critical note with the Daumier-like figures in the background, barely present at far left in the pastel). All the work's significance relies on observed gesture and the meaningful dialogue of the central figures, drawn in subtle blues and blacks.

Figure 17

Edgar Degas. *Portraits of Friends in the Wings (Ludovic Halévy and Albert Cavé Backstage at the Opéra)*, 1879. Pastel (and distemper?) on paper, 31⅛ x 21⅝ in. (79 x 55 cm). Musée du Louvre, Paris (RF 31140)

The bearded man wearing a pince-nez is Ernest May (1845–1925), a Jewish financier and adventurous collector who bought works by Monet, Pissarro, and Sisley (in 1923 he gave to the Louvre a triptych of early landscapes, one by each of these artists) as well as by Degas himself. May commissioned portraits of his wife and their young son (an 1880 chalk-and-pastel head of the homely Madame May is in an American private collection). Here, May is seen looking older than his thirty-three or thirty-four years, already a seasoned figure in the financial world. Peering over his shoulder is a colleague identified as a Monsieur Bolâtre, whose obscured face lends force to the finer detail of May's features; the latter's intent expression, however, gives nothing away of his reaction to the proffered document.

The chief departures from the pastel in the painting include Degas's enlargement of the lower part of the picture, where he introduces Bolâtre's left foot and thus suggests a higher angle of vision than that of the pastel; the unresolved introduction of two passing businessmen seen from the side, at right; and, on the floor, a scattering of white memoranda like the one Ernest May is studying. May bequeathed the painting to the Louvre,[3] and the pastel remained with his descendants until 1946.

1. The French original of Duranty's pamphlet is reprinted in Charles S. Moffett, ed., *The New Painting: Impressionism 1874–1886* (Oxford, 1986), pp. 477–84.

2. Works in pastel comparable in date and subject to *À la Bourse* include *Portraits of Friends in the Wings* of 1879 (Musée d'Orsay, Paris; fig. 17) and *At the Louvre* of ca. 1879 (private collection), Degas's celebrated view of the American artist Mary Cassatt, seen from behind and leaning on her umbrella.

3. The painting was shown at the Jeu de Paume from 1947 and transferred to the Musée d'Orsay in 1986.

Edgar Degas (1834–1917)

9. *Kneeling Dancer*, ca. 1880–85

The development of the motif of dancers in Degas's work is complex and ranges from stage performances seen from the audience's viewpoint to intimate close-ups of dancers in rehearsal to dense groups of figures dissolving into one another in a kaleidoscope of color and movement. In his earliest treatments of the theme, from about 1871 to 1874, his interest focused on the rehearsal room and the stage, with the dancers shown singly or in groups, defining the space across the canvas. Such works were based on modeling sessions with dancers in the artist's studio and, for the setting, regular visits to the Paris Opéra. In the 1880s Degas was granted access to the backstage rooms of the Opéra during working hours and thus became a familiar of its corridors, changing areas, and salons for practice and rehearsal (see fig. 18). Here, he could observe in more detail the dancers resting, yawning, tying their shoes—sometimes with mothers or chaperones in attendance. No male dancers appear, but Degas has left us memorable images of the dance masters, such as Jules Perrot (in *The Dance Class* of 1874; The Metropolitan Museum of Art, New York) and Louis Mérante (in the famous *Dance Class at the Opéra* of 1872; Musée d'Orsay, Paris).

Degas never prettified or idealized his dancers. His anxiety to record every aspect of a figure's movements and gestures forbade any tampering with the truth as he saw it. But he did edit in order to concentrate on what he felt was visually most important. Pastel was his preferred medium, because it allowed him to suggest mood through color while admitting of rapid work and sure handling, as against the slower aspects of oil paint and the inherent liquidity of watercolor. It enabled him both to catch transitory movement and to alter his drawing when necessary. In the present pastel, he has used color abstemiously, focusing instead on the long line of tension between face and hand formed by the slender arm just resting on the dancer's tulle skirt. It is unclear whether, in fact, she is kneeling or making a forward movement (her other arm is presumably stretched out to the side or the back to maintain her balance and grace of posture). Briefly suggested below the line of the skirt is what appears to be the figure's right leg, bent at the knee; the left leg is probably extended out behind her as for a curtain call or curtsy. The facial expression is unusually fully realized—a recognizable portrait—and shows the effort needed to hold a difficult pose by a dancer who appears somewhat older than Degas's usual models.

9.

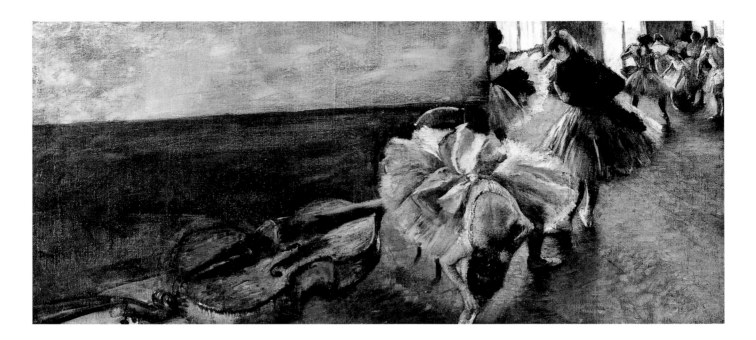

9. EDGAR DEGAS
Kneeling Dancer, ca. 1880–85
Pastel on paper laid down on board, 19¼ x 12¾ in.
(48.9 x 32.4 cm)

PROVENANCE Madame Grandjean; purchased from
her by Galerie Durand-Ruel, Paris (stock no. 11416),
February 7, 1919; purchased by Durand-Ruel, New
York (stock no. 4507), November 11 or December 20,
1920; purchased from that dealer by Percy Moore
Turner, London, October 15, 1926; probably his sale
(as "English collector"), Hôtel Drouot, Paris, May 29,
1929, no. 26 (ill.); purchased at that sale by Kojano-
vicz, Zürich; Dr. Fritz Nathan, by 1954; Sam Salz, Inc.,
New York; Mr. and Mrs. Sydney M. Shoenberg, Saint
Louis, by 1966; E. V. Thaw and Co., New York; private
collection, Chicago; William Beadleston Gallery,
New York, 1991; purchased from that dealer by Dr.
and Mrs. Robert Nowinski, New York, 1991; Richard
L. Feigen and Co., New York (stock no. 19874-D);
purchased from that dealer by Janice H. Levin, New
York, November 19, 1996; The Philip and Janice Levin
Foundation, 2001.

EXHIBITIONS Saint Louis, Philadelphia, Minne-
apolis 1967, pp. 180, 181 (fig. 117), 182 (no. 117);
Roslyn Harbor, Princeton 1992–93, pp. 22, 23
(color ill.).

REFERENCES Lemoisne 1946–49, vol. 2, pp. 350
(no. 616), 351 (fig. 616); Longstreet 1964.

Figure 18
Edgar Degas. *Dancers in the Rehearsal Room with a
Double Bass,* ca. 1882–85. Oil on canvas, 15⅜ x
35¼ in. (39.1 x 89.5 cm). The Metropolitan Museum
of Art, New York, H. O. Havemeyer Collection,
Bequest of Mrs. H. O. Havemeyer, 1929 (29.100.127)

There are no indications on this drawing that Degas subsequently used it
for a painting—no plumb lines or grid—and it does not appear to relate to any later
canvas. What is chiefly remarkable about it is a sense of parallel effort—Degas's in his
attempt to capture a fleeting position and expression (most obvious in the earlier
version of the right hand, still visible on the sheet), and the dancer's in her own physi-
cal achievement. The charm of spontaneity was, in fact, the result of long, perspiring
practice, and it was Degas's aim to express the latter rather than the former. In his innu-
merable later paintings and drawings of dancers, it is comparatively rare to see them
on stage. He preferred to depict all the behind-the-scenes activity that goes into the
final performance, to the point that such persistent work becomes almost symbolic
of his own hard-won creativity.

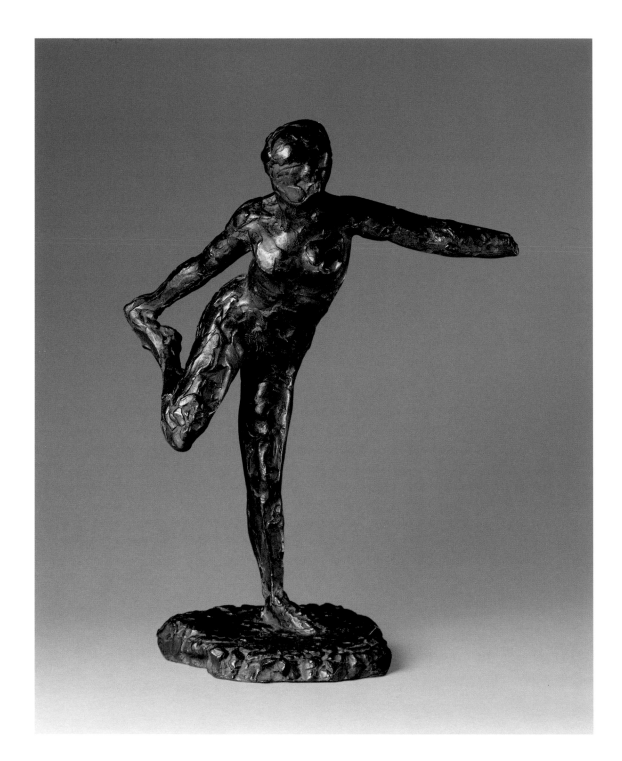

10.

Edgar Degas (1834–1917)

10. *Dancer Holding Her Right Leg with Her Right Hand,* cast 1919–21
after wax original of ca. 1882–95

11. *Dancer Putting on a Stocking,* cast 1919–21 after wax-and-wire
original of ca. 1896–1911

10. EDGAR DEGAS

Dancer Holding Her Right Leg with Her Right Hand,
cast 1919–21 after wax original of ca. 1882–95
Patinated bronze, h. 19½ in. (49.5 cm)
Incised signature (on base) *Degas*; embossed
stamp of the founder (on base) A. A. Hébrard,
Paris; bronze/cast number (on base) *68 / Q*

PROVENANCE Possibly Gaston Bernheim de
Villers; Sam Salz, Inc., New York (stock no. 622);
purchased from that dealer by Mr. and Mrs. Philip
Levin, New York, April 23, 1968; The Philip and
Janice Levin Foundation, 2001.

REFERENCES This cast: Pingeot 1991, p. 167 (no.
30, as "Q," under *Archives Hébrard,* ill.). Other casts:
Rewald 1944, pp. 27 (no. 62), 128 (ill.); Rewald 1956,
p. 155 (no. 62, fig. 21); Florence, Verona 1986, pp. 165
(pl. 68, color), 188 (cat. no. 68, exh. no. 68, ill.);
Pingeot 1991, pp. 130 (ill.), 131 (ill.).

Degas belongs to the great tradition in France of painter-sculptors, a line that goes back to Gericault and Daumier, includes Renoir and Gauguin as well as Degas (there are also extant sculptures by Morisot and Bonnard), and reaches a climax with the massive achievements of Matisse, Picasso, and Giacometti. The innovative work on canvas or paper of such artists can be transferred, at certain moments, into equally new and refreshing three-dimensional objects, invariably based on the nude female figure or the portrait head (as we see in Picasso's *Head of a Jester,* cat. no. 35). Renoir's contribution to this tradition is astonishing, for it belongs to his later years, when arthritis incapacitated his hands and the sculptures were carried out to his design by studio assistants. His great bronze goddesses belong to the era of another painter-sculptor, Aristide Maillol (1861–1944), and Antoine Bourdelle (1861–1929). Degas's sculpture, on the other hand—rooted in the real world of dancers, bathers, and the racecourse—has more affinity, in its concern with movement and modeled texture, with the work of his contemporary Auguste Rodin (both artists died in 1917).

The history of Degas's sculptural activity is elusive, fragmentary, and dotted with unanswered questions. Even the date of his first sculptures has never been securely established; only two or three of the seventy or more works can be assigned a reasonably accurate date. Such was the poor condition of many of his wax originals when found in his studio after his death that subsequent restoration, before casting was carried out in 1919–21, gives some of the works a collaborative status. Degas's friend Walter Sickert wrote in a preface to the catalogue for the first full showing in England of Degas's sculptural oeuvre in 1923 that the works owed their existence to Degas and to "his pious, wise and effectual friend, the founder, Adrien A. Hébrard."[1] Alas, about seventy more sculptures, broken and incomplete, had been deemed uncastable and were destroyed, unrecorded.

The two bronze figures of dancers in this collection are relatively late in date and show a freedom of modeling that contrasts with the tighter, more detailed surfaces

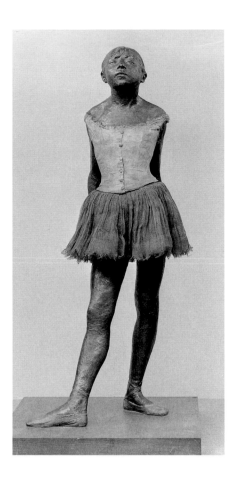

11. EDGAR DEGAS

Dancer Putting on a Stocking, cast 1919–21 after
wax-and-wire original of ca. 1896–1911
Patinated bronze, h. 18¼ in. (46.4 cm)
Incised signature (on base) *Degas*; embossed
stamp of the founder (on base) A. A. Hébrard,
Paris; bronze/cast number (on base) 29 / G

PROVENANCE Possibly Gaston Bernheim de
Villers; Sam Salz, Inc., New York; purchased from
that dealer by Mr. and Mrs. Philip Levin, New York,
April 23, 1968; The Philip and Janice Levin Foun-
dation, 2001.

REFERENCES This cast: Pingeot 1991, p. 158–59
(no. 14, as "G," under *Archives Hébrard,* ill.). Other
casts: Rewald 1944, pp. 26 (no. 56), 121 (ill.); Rewald
1956, p. 154 (no. 56), pl. 74; Florence, Verona 1986,
pp. 128 (pl. 29, color), 188 (cat. no. 29, exh. no. 14,
ill.); Pingeot 1991, pp. 128 (ill.), 129 (ill.).

of Degas's earlier sculptures. The very earliest are of horses and belong to the late 1860s;
the most celebrated is *The Little Fourteen-Year-Old Dancer* (ca. 1880; fig. 19), the only sculp-
ture the artist exhibited in his lifetime, at the sixth Impressionist exhibition in 1881. At
the time, its realism was considered ugly and repulsive and contrary to all the idealizing
tendencies expected of sculpture that found favor with the public. We do not know if
Degas was cowed by the excessively harsh reactions to the work (it is doubtful that he
would have taken any notice), but he never again exhibited his sculpture. Though its
results were witnessed by only a few friends and visitors to his studio, sculpting be-
came a legendary part of his creative activity—an unseen output that further reinforced
Degas's reputation for secrecy. Yet even if Degas's sculpture had been limited solely
to the 1881 dancer—wearing a real muslin tutu—he would still retain his place as an
important contributor to the modernization of sculptural practice in the late nineteenth
century.

For the most part, Degas's sculptures imply movement. His horses walk,
trot, gallop, and rear, some without touching the ground (see fig. 20). The late figures
of women at their toilette—washing and drying themselves or doing their hair,
in complex, momentary poses of self-absorption—exhibit a seeming rapidity of

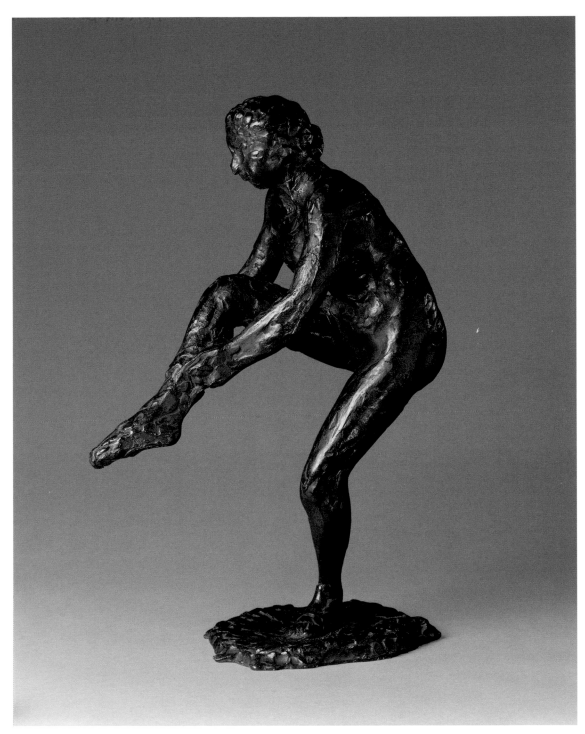

11.

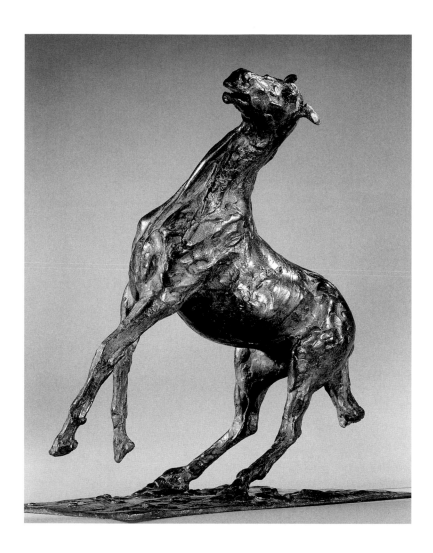

Figure 20
Edgar Degas. *Rearing Horse*, 1888–90. Bronze,
h. 12⅛ in. (30.8 cm). The Metropolitan Museum
of Art, New York, H. O. Havemeyer Collection,
Bequest of Mrs. H. O. Havemeyer, 1929 (29.100.426)

modeling and a roughness of surface. Remarkably, Degas depicts an activity such as drying oneself after a bath without giving the figure a towel to hold, but he was not averse to modeling an armchair, for example, for a figure to sit on, or including a small *objet trouvé* to stand in for a bathtub. What the figures have in common is an absence of physical detail: their faces are barely delineated, and their hands and feet are left undefined. In this way, Degas moves toward the synoptic abstraction of Cézanne's bathers. Nevertheless, his figures live vividly in the present; they may be a little dumpy and certainly are not alluring in the manner of a Rodin or a Renoir, but they go about their everyday activities with physical zest.

Degas's dancers, which form the largest category within his sculptural output, tend to be nude and engaged in balletic action. Sometimes on one leg, they execute recognizable choreographic positions (see fig. 21); in repose, standing on both legs, they intimate a future movement. Here, in *Dancer Holding Her Right Leg* (cat. no. 10), the figure is obviously exercising or warming up, her tense but not awkward position

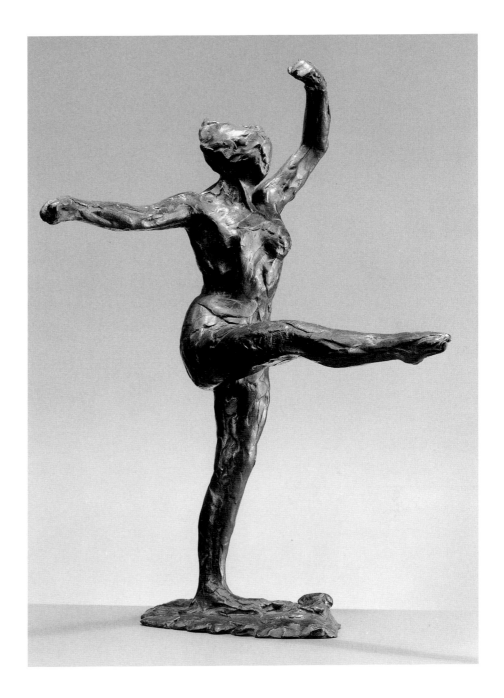

entailing a sure distribution of weight, instinctively maintained. In the other work (cat. no. 11), the position is even more precarious, for the arms are kept close together in order to pull on the stocking, rather than being held outward to maintain a balanced stance on one leg. At the same time, both figures are beautifully observed "in the round," showing a circular elasticity of movement and a contained sculptural form that only great sculpture achieves.

1. *Catalogue of an Exhibition of the Works in Sculpture of Edgar Degas* (London, Leicester Galleries, February–March 1923), p. 5.

Pierre-Auguste Renoir (1841–1919)

12. *Gondola, Venice*, 1881

12. PIERRE-AUGUSTE RENOIR
Gondola, Venice, 1881
Oil on canvas, 25 x 29½ in. (63.5 x 74.9 cm)
Signed (lower left) *Renoir*

PROVENANCE Galerie Durand-Ruel, Paris, purchased from the artist, 1881; Max Silberberg, Breslau; his sale, Galerie Georges Petit, Paris, June 9, 1932, no. 27; purchased at that sale by Dr. Hirschmann, Amsterdam, for 180,000 francs; Siegfried Kramarsky (1893–1961), Amsterdam, then New York in 1940; his son Werner H. Kramarsky, New York, by 1958; purchased from him by Richard L. Feigen and Co., New York (stock no. 14971-D), December 19, 1970; purchased from that dealer by Mr. and Mrs. Philip Levin, New York, December 19, 1970; The Philip and Janice Levin Foundation, 2001.

EXHIBITIONS Paris 1899, no. 80; Liège 1909; Paris 1922a, no. 77; Paris 1933a, p. 30 (no. 65), pl. 40; Paris 1933b, pl. 39; Amsterdam 1938, p. 116 (no. 215); New York 1941, pp. 142–43 (no. 39), 61 (ill.); New York 1950, pp. 41 (no. 34), 53 (ill.); New York 1958a, p. 46 (no. 32, ill.); New York 1958b, p. 10 (no. 116); New York 1960c; New York 1969, no. 42 (ill.); New York 1971, p. 1 (no. 4). Possibly two additional, unidentified exhibitions, the second per label affixed to reverse: Ambroise Vollard, Paris; Städelsches Kunstinstitut, Frankfurt (as lent by S. Kramarsky).

REFERENCES Duret 1906, p. 102 (ill.); Vollard 1918, vol. 1, p. 13 (no. 51, ill.); Vollard 1919, opp. p. 128 (ill.); Meier-Graefe 1929, p. 155 (fig. 140); Duret 1924, pl. 16 (as *Le Grand Canal, Venise*); Scheffler 1931, pp. 12 (ill.), 14; Thieme-Becker 1907–50, vol. 28 (1934), p. 170 (under "Renoir," entry by W. Grohmann); Wilenski 1940, p. 62; Rouart 1985, p. 67 (ill.); Drucker 1944, pl. 73; Barnes and de Mazia 1935, pp. 77 (n.), 79 (n.), 81 (n.), 157, 383 (n.), 454 (no. 125); Rewald 1973, p. 460 (ill.); Perruchot 1964, p. 174; Schneider 1967, p. 28; White 1969, fig. 11, pp. 343, 345 (no. 3); Fosca 1970, p. 161 (color ill.).

Venice has always bristled with painters, but in the later decades of the nineteenth century an unprecedented stream of artists was attracted to the city. Paintings and prints of the canals and palaces were highly marketable, as were genre scenes featuring Venetian costume and picturesque local trades. Édouard Manet was accompanied there by James Tissot in 1874, and in 1879 James McNeill Whistler made his celebrated commissioned series of Venetian etchings. John Singer Sargent had two highly productive stays in 1880 and 1882, overlapping with, among others, the English painters Luke Fildes and William Logsdail. Alongside such better-known visitors, a great international ruck of painters recorded, in sentimental and sometimes garish works, every aspect of La Serenissima. The annual Salons and Academy exhibitions were awash with gondolas, bridges, girls in shawls, and sunsets over the lagoon.

Renoir's trip to Italy in the fall of 1881 was his first, and until earlier that year he had never been outside his native France. In the spring he had spent six weeks in North Africa, following the example of Eugène Delacroix, and in September or early October he began his extensive Italian tour. A measure of financial prosperity gained through portrait commissions and purchases of his work by his attentive dealer, Paul Durand-Ruel, made possible this long sojourn abroad. Italy proved fruitful both in terms of the number of paintings produced and in the visual stimuli Renoir found in Venice, Rome, and Naples—namely, a variety of Italian old masters, especially Veronese, Tiepolo, and Raphael, as well as the Roman frescoes from Pompeii, which he greatly admired in the museum in Naples.

In Venice, Renoir was not unaware that he was only one of innumerable artists tackling the city's famous sights and views. As he wrote with his habitual sarcastic humor, "I did the Doge's Palace as seen from San Giorgio across the canal, it had never been done before, I think. We were at least six in line." It is not known where Renoir stayed, or even what the dates of his arrival and departure may have been; nor do we know whether or not he had traveled there alone. For many years it was thought that his entire Italian trip had been accomplished solo, and indeed, he mentions no companion in his letters to friends in France. But we do now know that his mistress Aline Charigot (1859–1915), later his wife, was with him certainly in the latter part of his journey.[1] In any case, he obviously set to work soon after settling there, and he seems

12.

Figure 22
Pierre-Auguste Renoir. *The Piazza San Marco, Venice,*
1881. Oil on canvas, 25¾ x 32 in. (65.4 x 81.3 cm).
The Minneapolis Institute of Arts, The John R. Van
Derlip Fund (51.19)

to have completed some canvases for exhibition in Paris while he was still abroad (two paintings entitled *Vue de Venise* were included in the seventh Impressionist exhibition in March 1882) and begun others that he would finish once he had returned. He varied a diet of open-air painting with portraits of Venetian girls and used a sketchbook to record his immediate impressions as he toured the city. One of his finest Venetian paintings happens to have one of the most clichéd subjects—San Marco in front of its piazza (The Minneapolis Institute of Arts; see fig. 22). He described that work as an *ébauche*, or first stage of a painting, when he included it, signed, a decade later in his 1892 retrospective at Durand-Ruel. The present painting seems to comprise the view toward the Dogana, or customs house, at top left from either the Giudecca or the island of San Giorgio Maggiore; Renoir was apparently positioned on a quayside near a seated young woman. His raised viewpoint allows us to see into the gondola, where two female tourists are being ferried by a gondolier in the habitual striped top, dark jacket, and brimmed hat. The rapidity of Renoir's attack on the view can be observed in the

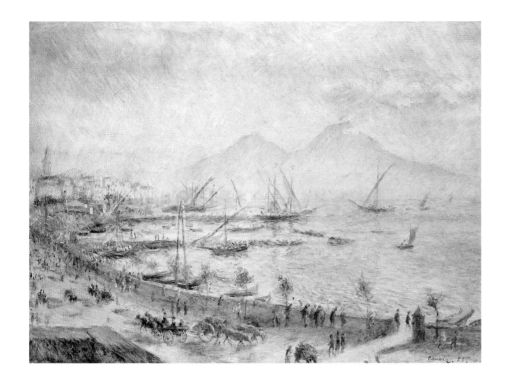

Figure 23
Pierre-Auguste Renoir. *The Bay of Naples*, 1881.
Oil on canvas, 23½ x 32 in. (59.7 x 81.3 cm). The Metropolitan Museum of Art, New York, Bequest of Julia W. Emmons, 1956 (56.135.8)

Figure 24
Édouard Manet. *The Grand Canal, Venice*, 1875. Oil on canvas, 23⅛ x 28⅛ in. (58.7 x 71.4 cm). Shelburne Museum, Shelburne, Vt.

varied, even turbulent brushwork, both broadly and thinly applied, and perhaps, too, in the unresolved suggestion of the weight of the passing gondola on the water. Nevertheless, *Gondola, Venice* achieves a spirited "impression" akin to Manet's Venetian paintings of 1874 (see fig. 24).

At first, Renoir's experience of Italy was colored by his somewhat cynical attitude toward being in a country other than France, especially one inundated with the works of the great Renaissance masters. But as he traveled farther south, becoming more accustomed to the light and to his new surroundings, he painted with more confidence (particularly in a complex view such as *The Bay of Naples* of 1881; The Metropolitan Museum of Art, New York; fig. 23). And it was in the South, under the impact of Raphael and the Pompeiian frescoes, that his conception of the nude figure out of doors was crucially recast (see cat. no. 14).

1. According to a reported conversation in *Growing Up with the Impressionists: The Diary of Julie Manet* (London, 1987), translated by Rosalind de Boland Roberts and Jane Roberts, entry for September 19, 1895, p. 67.

13.

Pierre-Auguste Renoir (1841–1919)

13. *Country Landscape (Blanche Pierson's Cottage, Pourville)*, 1882

13. PIERRE-AUGUSTE RENOIR
Country Landscape (Blanche Pierson's Cottage,
Pourville), 1882
Oil on canvas, 21½ x 25½ in. (54.6 x 64.7 cm)
Signed (lower left) *Renoir*

PROVENANCE Galerie Durand-Ruel, Paris (stock
no. 1238), purchased from the artist August 25,
1891, for 1,000 francs; Paul-Marie-Joseph Durand-
Ruel (1831–1922), Paris (inv. no. A.I.297); Sam Salz,
Inc., New York, possibly ca. 1965; purchased from
that dealer by Mr. and Mrs. Philip Levin, New York,
April 23, 1968; The Philip and Janice Levin Foun-
dation, 2001.

EXHIBITIONS Paris 1892, no. 32; Paris 1908, no. 59;
Paris 1933c, no. 29; London 1950b, no. 265; Paris
1958, no. 20; New York 1968a, p. 36 (no. 181), New
York 1968b, p. 22 (no. 181).

REFERENCE Meier-Graefe 1929, p. 159 (fig. 154).

Although the human figure was at the center of Renoir's art—from the sober portraits of his early years to the family scenes and bathing groups of his last—landscape was a constant preoccupation. The combination of figures and outdoor settings, particularly gardens and riverbanks, prompted a continuing quest for harmonious integration, particularly when Renoir took more and more to working in the studio from models and drawn studies. In the 1870s the majority of his landscapes had been painted out of doors, sometimes alongside his friend Monet or Sisley, in the village suburbs of Paris such as Louveciennes, Argenteuil, Châtou, and Bougival. The best-known of these are his views of La Grenouillère, the popular boating and bathing spot on the Île de Croissy. Pure landscapes are relatively rare in Renoir's work, although he obviously delighted in countryside that was empty of the usual signs of human life, such as the Provençal landscapes he painted when visiting Paul Cézanne in Aix-en-Provence and L'Estaque in 1881: "Here I have the true countryside at my doorstep," he wrote to a friend. More usually, however, Renoir animated his scenes with small figures, glimpses of sailboats, and, as in this painting, children and animals. But whereas colleagues such as Pissarro and Sisley tended to include in their landscapes figures indigenous to the working and agricultural communities where they painted, Renoir's figures are often vacationers or people finding leisure and refreshment on a day's excursion to the country. This is particularly true, of course, of his beach scenes and views of the Normandy coast and the Channel Islands.

Although from humble origins himself, Renoir enjoyed a well-heeled bourgeois life and, from the late 1870s onward, was a regular guest at literary and musical salons in Paris and at the country houses of his rich patrons. He was by no means socially ambitious, but he knew that the more enlightened members of the upper bourgeoisie could provide him with portrait commissions and contacts. It was while staying with a patron who became a cherished, lifelong friend that the present work was painted. Between 1879 and 1885 Renoir paid almost annual summer visits, sometimes for several weeks, to the Château de Wargemont near Dieppe. This was the summer home of Paul Bérard (1833–1905), an embassy secretary and ex-banker who commissioned decorative panels from Renoir for rooms in the château, as well as a sizable group of portraits of Bérard, his wife, Marguerite, their four children, and other

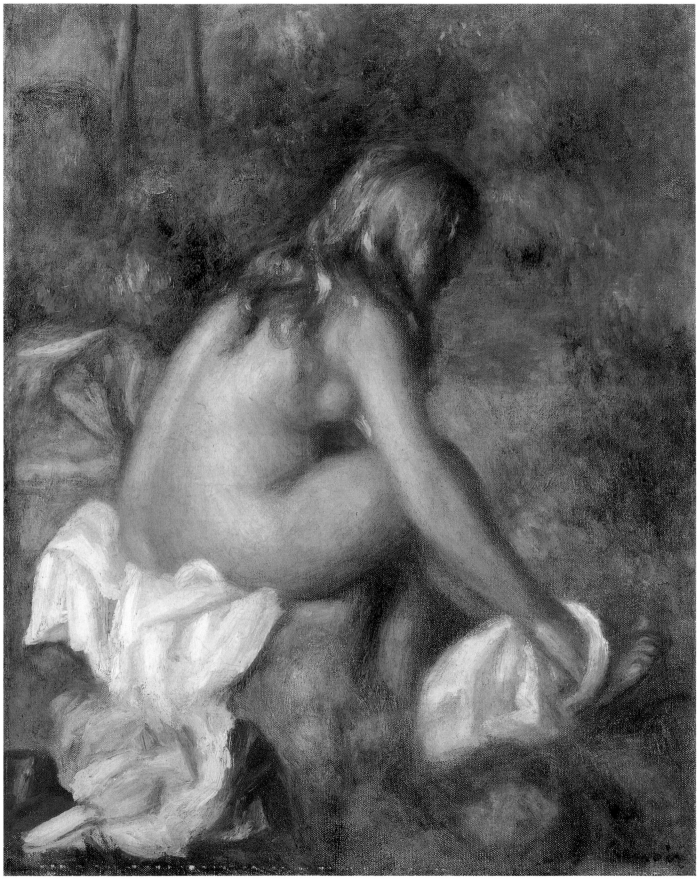

14.

14. PIERRE-AUGUSTE RENOIR
Seated Female Nude, or *After the Bathe*, ca. 1895
Oil on canvas, 16 x 12½ in. (40.6 x 31.7 cm)
Signed (lower right) *Renoir*

PROVENANCE Galerie Durand-Ruel, Paris (stock
no. 4462), purchased from the artist November
24, 1897, for 500 francs; Paul-Marie-Joseph Durand-
Ruel (1831–1922), Paris (inv. no. A.I.327); Durand-
Ruel family, Paris; Jean d'Alayer de Costemore
d'Arc, Paris, acquired by descent through the
Durand-Ruel family; purchased from him by
Sam Salz, Inc., New York; purchased from that
dealer by Mr. and Mrs. Philip Levin, New York,
after April 1968–by August 1971; The Philip and
Janice Levin Foundation, 2001.

EXHIBITION Paris 1920, no. 34 (as dated 1895).

REFERENCE Daulte 1971, no. 420 (under "1882,"
ill. opp.).

Figure 26
Pierre-Auguste Renoir. *Young Girl Bathing*, 1892.
Oil on canvas, 32⅛ x 25⅝ in. (81.5 x 65 cm). The
Metropolitan Museum of Art, Robert Lehman
Collection, 1975 (1975.1.199)

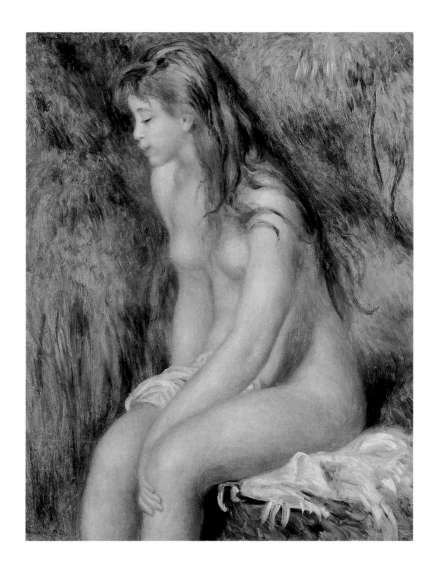

seem lit from within. Like a cat quietly cleaning itself, she is totally absorbed in her
activity, completely disengaged from the viewer and oblivious to interruption.

In Renoir's earlier series of nudes, from the 1880s (such as *Blonde Bather*, 1881;
Sterling and Francine Clark Art Institute, Williamstown, Mass.), the seated figures,
painted in the studio, seem somewhat disconnected from their settings; there is little
attempt at a unifying outdoor daylight, and the relation of figure to ground is some-
times awkward. But as Renoir's investigation of the motif continued, he gradually
made a virtue of this apparent dislocation. The figures become more abstracted from
the world, inhabitants of an arcadian vision that, fully aware of sensual delights,
nevertheless transcends everyday reality. The works of the 1890s are forerunners of
Renoir's pagan goddesses and nymphs, which found their fullest expression in the
Paris *Bathers*, completed shortly before the artist's death. That magnificent summary

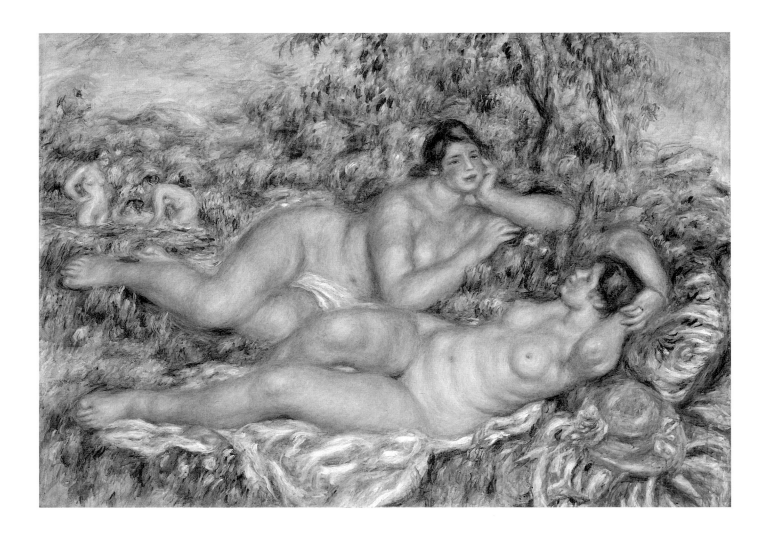

Figure 27
Pierre-Auguste Renoir. *The Bathers*, 1918–19.
Oil on canvas, 43¼ x 63 in. (110 x 160 cm). Musée
d'Orsay, Paris

of the theme that had haunted Renoir for nearly forty years depicts two monumental,
reclining figures in the ripe southern sun, in a picture that pulsates with heat and
color. The modest, sylvan bather of the present work, while still retaining echoes of
the posed studio model, is a move toward that synthesis of the quotidian and the
classic that was a distinctly French tradition, established by Watteau and Boucher and
continued in the following century by Manet and Renoir.

Opposite: Detail, cat. no. 14

Claude Monet (1840–1926)

15. *On the Cliff at Pourville, Clear Weather*, 1882

15. CLAUDE MONET

On the Cliff at Pourville, Clear Weather, 1882
Oil on canvas, 25½ x 31¾ in. (64.8 x 80.6 cm)
Signed and dated (lower right) *Claude Monet 82*
The Museum of Modern Art, New York, Bequest
of Janice H. Levin (371.91)

PROVENANCE Possibly Galerie Durand-Ruel, Paris,
purchased from the artist April or, more likely,
October 1882; possibly Monsieur Charpentier, by
1883; Jean-Baptiste Faure (1830–1914), Paris; pur-
chased from him by Galerie Durand-Ruel, Paris,
January 1, 1893, for 15,000 francs; Jean d'Alayer de
Costemore d'Arc, Paris, possibly acquired by de-
scent through the Durand-Ruel family; Sam Salz,
Inc., New York; purchased from that dealer by Mr.
and Mrs. Philip Levin, New York, December 3, 1969;
bequeathed by Janice H. Levin to the Museum of
Modern Art, New York, 1991/2001.

EXHIBITIONS Paris 1883, no. 23 (as "coll. M.
Charpentier"); London 1905, no. 140; Manchester
1907–8, no. 74; Paris 1908, no. 39 (as *Falaises*); London
1914, no. 46; Paris 1928, no. 33 (as *Sur la falaise*); Berlin
1928, p. 9 (no. 32); Paris 1940–41, no. 29; New York
1971, p. 1 (no. 1); Chicago 1975, no. 54 (ill.); New York
1999–2000, pp. 56, 57 (n. 4), 64 (pl. 28, color).

REFERENCES Duret 1904, p. [241] (as *Felsen bei
Dieppe*, ill.); Malingue 1943, pp. 102 (ill.), 147 (as
"Collection Durand-Ruel"); Callen 1971, p. 356 (no.
465); Rewald 1973, p. 510 (as *Cliffs at Dieppe*, ill.);
Wildenstein 1974–91, vol. 2 (1882–1886, *Peintures*),
pp. 76 (no. 756), [77] (ill.); Wildenstein 1996, vol. 2
(*Nos. 1–968*; trans. Josephine Bacon), pp. 282
(fig. 756), 283 (no. 756).

It was in the early 1880s, on the coast of Normandy, that Monet developed his distinc-
tive and often dramatic approach to marine painting. In the previous decade his depic-
tions of water had been confined to the river Seine (at Argenteuil and elsewhere), the
canals and ports of Holland (1871), and the busy harbor of Le Havre (1873). But in 1880,
when Monet was in his fortieth year, a brief visit to the coast refired his enthusiasm,
dormant since the 1860s, for the sea. The following year he painted at the Petites Dalles,
and in 1882 he spent two periods at Pourville, a fishing village and growing resort just
west of Dieppe. For his first stay (late winter and early spring) he was alone, and he
wrote glowing letters to his dealer, Paul Durand-Ruel, and to his future wife, Alice
Hoschedé, extolling the beauty of the coast, with its white chalk cliffs, rocky inlets,
and bays. Alice agreed to Monet's plan of renting a house at Pourville for the whole
summer, and the two households—Alice and her children and Monet and his two
young sons (his first wife, Camille, had died in 1879)—decamped in mid-June to the
Villa Juliette, on the cliffs above the English Channel, and stayed until early October.

Immediately noticeable in the present work—painted, or at least begun,
during the second visit to Pourville—are the near absence of sky, the almost heart-
stoppingly vertiginous viewpoint Monet has adopted, and the close, textural weave of
color defining the cliff-top turf and the calm dazzle of the Channel below. Another
view in this series, painted from exactly the same spot (Nationalmuseum, Stockholm;
fig. 28), shows the boats on much choppier water and the ground in momentary
shadow. Here, the refulgent sea, dotted with white sailboats, suggests a perfect sum-
mer's day; the gleaming expanse puts one in mind of some of the passages of shim-
mering orchestration in Claude Debussy's *La Mer*. Monet shows one of the many dry
valleys that slope toward the cliff's edge, providing both a sinuous contour that
bisects the picture plane and a precipitous perspective suggesting that the viewer of
this scene is raised, untethered, high above the grassy land below. This sensation is
evoked in Guy de Maupassant's short story "Miss Harriet" (1884), in which a painter,
partly based on the author's encounters with Monet, walks along the cliffs looking
at the boats out at sea.

On a material level, Monet found acclaim and financial reward for his
extensive series of marine paintings (many finished in his studio, once his visit to

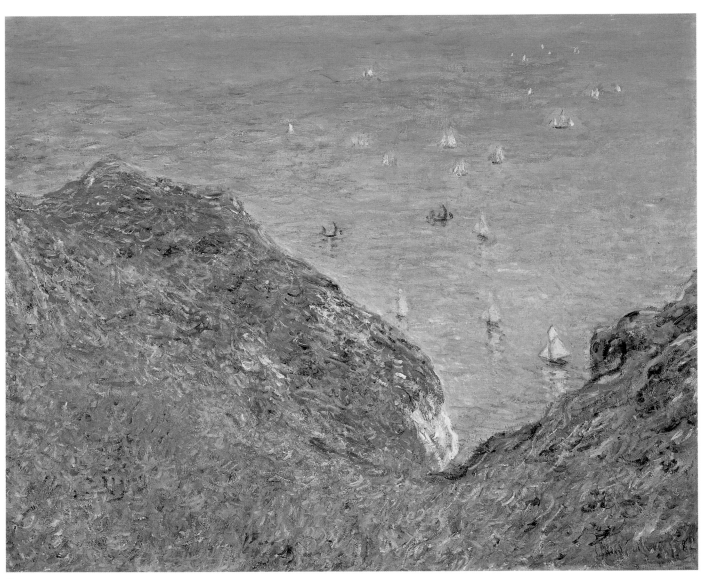

15.

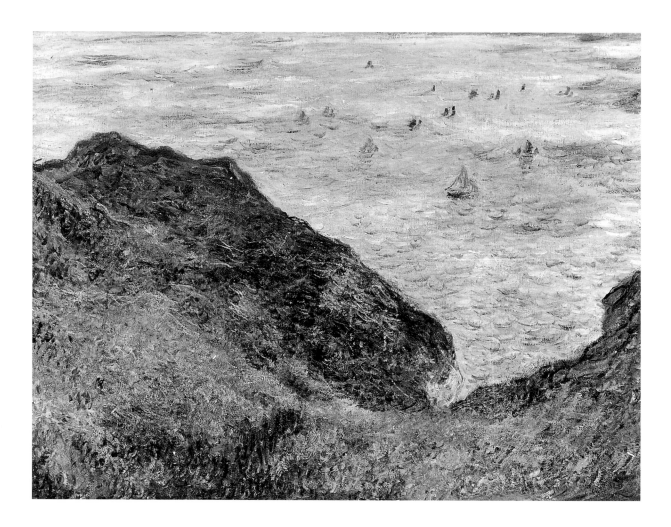

Figure 28
Claude Monet. *View over the Sea*, 1882. Oil on canvas,
25¼ x 32¼ in. (64 x 82 cm). Nationalmuseum,
Stockholm (NM 2122).

Pourville was over): from this year alone about ninety are recorded, and many were
sold to Durand-Ruel. It is little wonder that from then on, until 1886, Monet returned
to the coast annually, basing himself at Étretat, farther west than Pourville, and
exploring every nuance of weather, all times of day, and the sea in all its moods.

Opposite: Detail, cat. no. 15

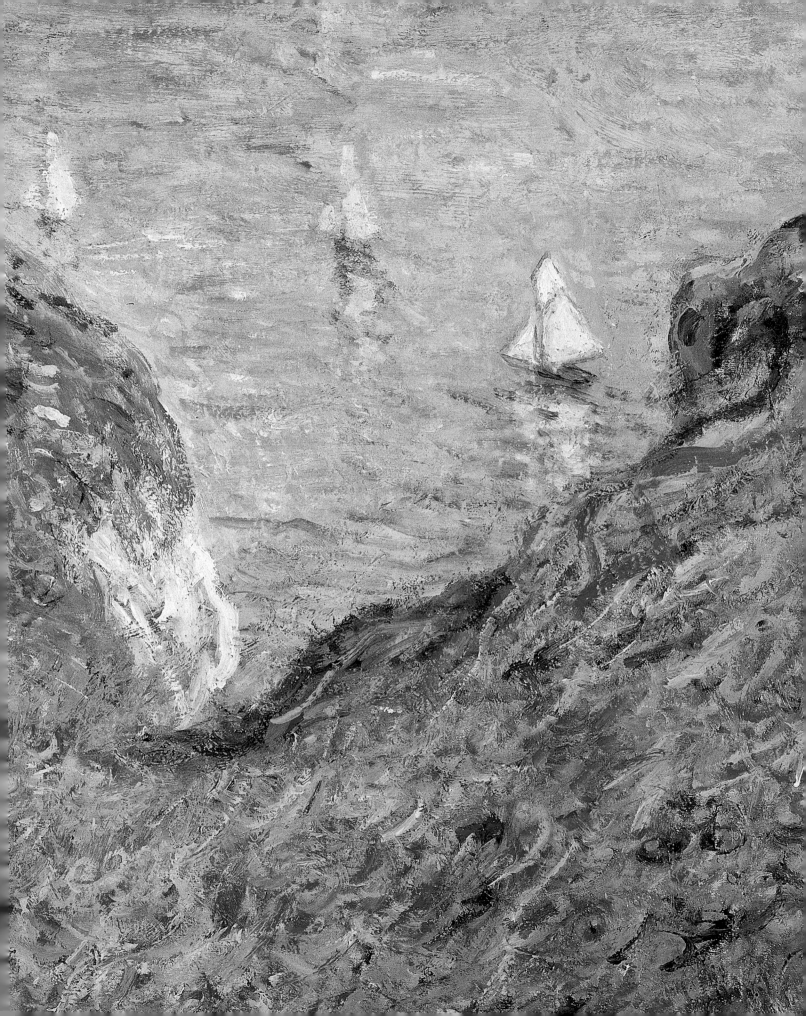

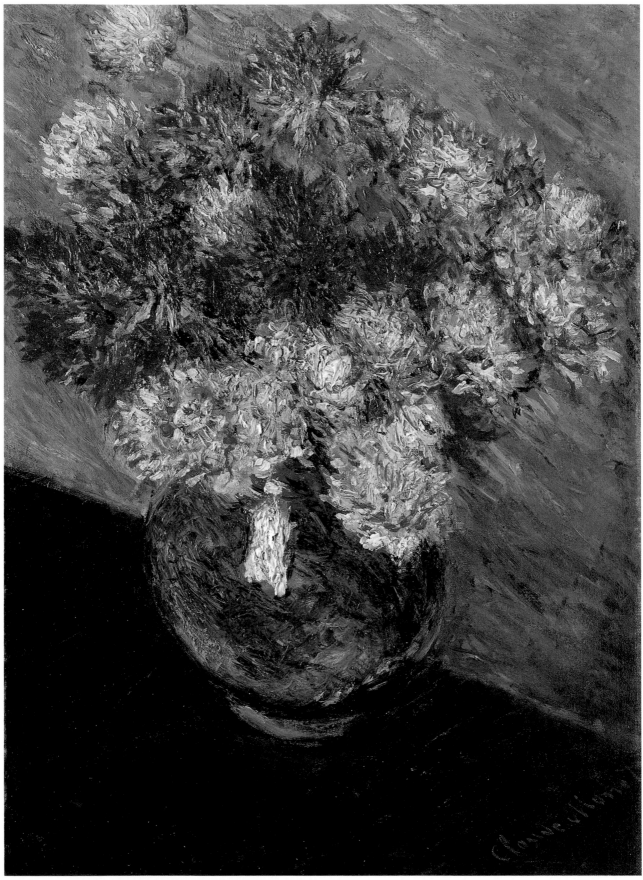

16.

Claude Monet (1840–1926)

16. *Chrysanthemums*, 1882–85

16. CLAUDE MONET
Chrysanthemums, 1882–85
Oil on canvas, 20 x 15 in. (50.8 x 38.1 cm)
Signed (lower right) *Claude Monet*

PROVENANCE Paul-Marie-Joseph Durand-Ruel (1831–1922), Paris (inv. no. A.I.182), commissioned from the artist; his son, Georges-Marie-Jean-Hugues Durand-Ruel (1866–1931), Paris, ca. 1922; possibly his niece Thérèse de Montfort, née Aude (per label affixed to reverse); Sam Salz, Inc., New York; purchased from that dealer by Janice H. Levin, New York, June 4, 1976; The Philip and Janice Levin Foundation, 2001.

EXHIBITION Paris 1970, no. 34 (ill.).

REFERENCES Lecomte 1892, pp. 196–98; Wildenstein 1974–85, vol. 2 (1882–1886, *Peintures*), pp. 138, 146 (no. 947, ill.), 147 (ill.); Wildenstein 1996, vol. 2 (*Nos. 1–968*; trans. Josephine Bacon), pp. 344, 352 (fig. 947), 353 (no. 947, ill.).

Although Monet had occasionally painted still lifes earlier in his career, it was not until about 1878 and the following four or five years that they make a more persistent appearance in his work. If he seems to have preferred to paint flowers in their natural setting (see cat. no. 4), he was not, of course, unaware of the allure of indoor flower pieces to collectors who may have found his landscapes and figure compositions uncongenial or too stylistically advanced for their taste. It is no coincidence that still life becomes more prominent from 1878 to 1883 (when more than twenty flower pieces are recorded; see fig. 30)—a period that still saw Monet comparatively impoverished, partly through his ingrained habit of spending more than he earned, often with considerable extravagance. At one time or another, all the Impressionist painters undertook still life, usually of flowers, fruit, or dead game. Even that congenial landscapist Alfred Sisley painted the occasional still life, and Camille Pissarro attempted, from time to time, to capture the charm of bunches of cut flowers.

The present work originally belonged to a highly unusual decorative scheme carried out by Monet between 1882 and 1885. The dealer Paul Durand-Ruel commissioned the artist to paint panels for the six doors of the salon in his apartment at 35, rue de Rome, Paris. Each door had six panels—two principal vertical ones, two small horizontals (at door-handle level), and two lower verticals. It was for one of the latter that *Chrysanthemums* was painted, forming a contrasting pair with a depiction of a potted white azalea. The thirty-six canvases were painted by Monet in his studio over a considerable period of time, then fixed in place on the salon doors (see fig. 29). They were easily removable and were later transferred to Durand-Ruel's son's home in the rue Jouffroy, from where they were eventually sold.

Here, Monet goes straight to the point—a simple green vase filled with nothing but pink and red chrysanthemums, placed on an obliquely angled tabletop. There are none of the usual accessories of fruit or cloth, no variety of bloom, no patterned wall to offset the natural arrangement of the flowers, which are closely confined by three edges of the canvas (a compositional device shared with the exuberant *Bouquet of Sunflowers* of 1881 in The Metropolitan Museum of Art, New York). The work appears to have been painted with some rapidity, a brisk pace detectable in the short, thick, spiky brushstrokes of the multipetalled chrysanthemums and the raked texture, from

Mary Cassatt (1844–1926)

17. *Young Woman Holding a Handkerchief to Her Chin,* ca. 1880–83

17. MARY CASSATT

Young Woman Holding a Handkerchief to Her Chin,
ca. 1880–83

Oil on canvas, 21½ x 18¾ in. (54.6 x 47.6 cm)

Signed (lower center) *Mary Cassatt*; signed and titled
(on top stretcher bar) *Mary Cassatt La femme au
mouchoir*; signed and titled (on center horizontal
stretcher bar) <u>*Mary Cassatt*</u> *La femme au mouchoir*

PROVENANCE Ambroise Vollard (1867–1939),
acquired from the artist; Monsieur Martin, Paris;
with Schoneman Galleries, Inc., New York, spring
1961; private collection, New York; Établissement
Mondart, Zürich; purchased from that dealer by
Janice H. Levin, New York, November 5, 1983; The
Philip and Janice Levin Foundation, 2001.

EXHIBITION Paris 1950.

REFERENCE Breeskin 1970, p. 85 (no. 149, ill.).

For many decades, the American-born painter Mary Cassatt was regarded as an inter-esting but minor figure associated with the Impressionist movement through her friendship with Degas and her contributions to Impressionist exhibitions from 1879 onward. A somewhat paradoxical picture of her prevailed for most of the last century. Cassatt had mined a narrow seam of subject matter—young motherhood—in her art, while herself remaining resolutely childless; she appeared neither quite French nor quite American; and she was a woman who had participated in an almost exclusively male revolution. The feminist rereading of art history changed this limited view, and she is now as unlikely to be omitted from even a cursory account of Impressionism as, say, Lee Krasner is to be left out of an account of Abstract Expressionism. Cassatt is surely one of the few women artists whose true stature has been revealed by such a revisionist approach.

Well versed in the major schools of European painting (she studied and copied the old masters in Paris, Parma, Spain, and the Netherlands), Cassatt quickly forged a refined but essentially conservative style of genre painting. Settling in Paris in the 1870s, she came under the influence of Manet, Renoir, and, above all, Degas, whose protégée she became after he visited her studio in 1877. Like him, she was entranced by Japanese prints and looked, too, to photography to add a sharp tang of contemporane-ity to her painting. Degas's influence is most apparent in her theater scenes (though the example of Renoir was also important) and in her acute and shapely draftsman-ship. Soon, the theme of women and small children became predominant in her art, although other aspects of women's lives extend her range and sympathies. Consistent with that of Degas, Cassatt's view of women was essentially detached, and though she was never as ruthless as he in her portrayal of them, there is a chastity to her vision that sometimes strikes a distinctly chilly note (just as, conversely, Renoir may seem to linger too warmly over the charms of some of his models).

This painterly head-and-shoulders, with its broad brushwork and confident juxtaposition of blues and pinks, may come as a surprise to those who are accustomed to Cassatt's more refined approach to line and color and who momentarily forget the stunning yellows and blues of her famous *Boating Party* of 1893–94 (National Gallery of Art, Washington, D.C.; fig. 32). The painting dates to relatively early in her career, about

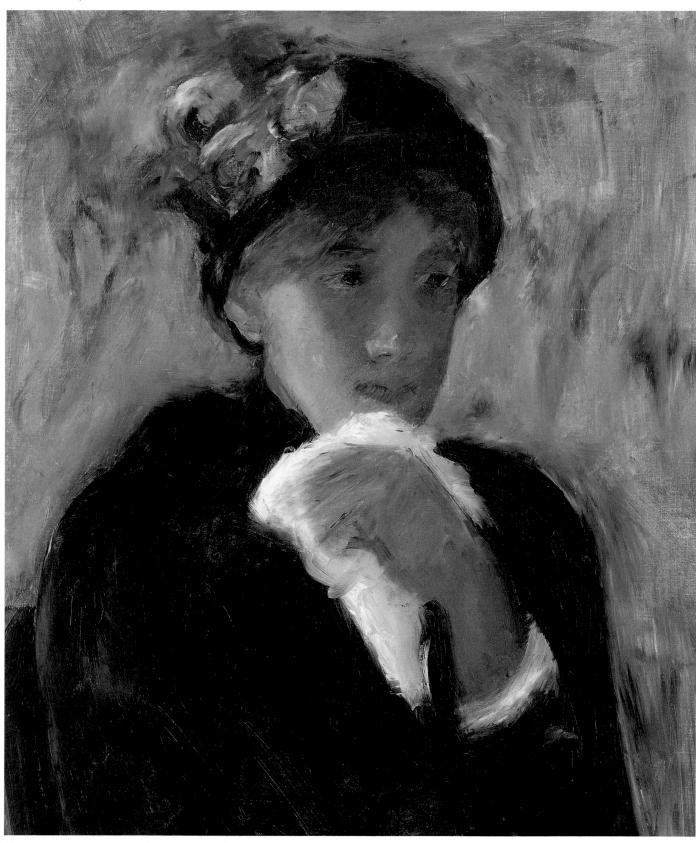

17.

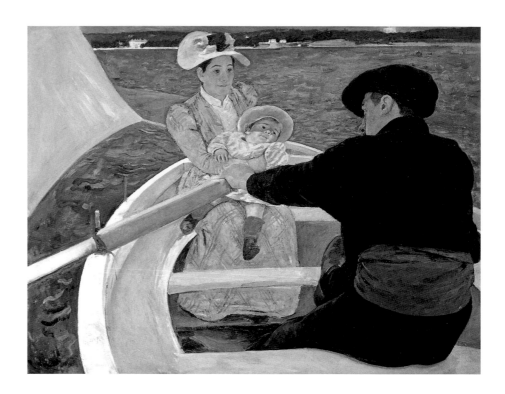

Figure 32
Mary Cassatt. *The Boating Party,* 1893–94.
Oil on canvas, 35⅛ x 46⅛ in. (90 x 117.3 cm).
National Gallery of Art, Washington, D.C.,
Chester Dale Collection (1963.10.94)

1880 to 1883. The young woman has not been identified, though she was almost certainly a member of Cassatt's family or close circle of friends in Paris, rather than a professional model. She bears some resemblance to the figure in the 1883 painting *Young Woman in Black* (The Peabody Art Collection, Maryland State Archives; fig. 33). The triangularity of the white handkerchief that she holds toward her face echoes the shape of her head beneath its close-fitting, flower-emblazoned hat. Her expression is reflective, even somewhat embarrassed—maybe she *did* have a cold when Cassatt painted her—and the depiction has some of the demure charm of Renoir's early portraits of young women. The red underpainting—a technique Cassatt borrowed from the old masters, particularly Rubens, whose work she studied closely in Antwerp—gives a particular warmth and vitality to the work. But, as also with *Young Woman in Black,* the example of Velázquez, whom Cassatt discovered and copied in Madrid, informs the portrait's sensitivity and color harmonies.

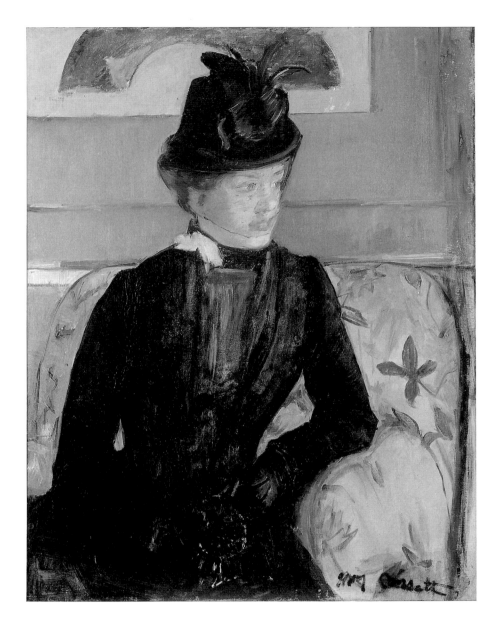

Figure 33
Mary Cassatt. *Young Woman in Black*, 1883. Oil on
canvas, 31¾ x 25⅜ in. (80.6 x 64.6 cm). The Peabody
Art Collection, Maryland State Archives

18.

Berthe Morisot (1841–1895)

18. *Corner of Paris, Seen from Passy,* ca. 1872–73

18. BERTHE MORISOT
Corner of Paris, Seen from Passy, ca. 1872–73
Pastel on paper, 10⅝ x 13¾ in. (27 x 34.9 cm)
Signed (lower left) *Berthe Morisot*

PROVENANCE Madame Soustiel, Paris, by 1961;
Jean-Claude Bellier; purchased from him by
Richard L. Feigen and Co., New York (stock no.
17484-D), June 26, 1986; purchased from that dealer
by Janice H. Levin, New York, June 27, 1986; The
Philip and Janice Levin Foundation, 2001.

EXHIBITIONS Paris 1896, p. 34 (no. 217); Paris 1941,
no. 122; Paris 1961, p. 11 (no. 107, as "coll. Mme
Soustiel, Paris"); Washington, D.C., Fort Worth,
South Hadley 1987–88, pp. 57, 63 (pl. 22, color), 218
(no. 22).

REFERENCES Bataille and Wildenstein 1961, p. 51
(no. 421), fig. 411; Lille, Martigny 2002, p. 126 (under
no. 13).

Berthe Morisot spent most of her life at successive addresses in Passy, once a village with grand villas overlooking the river Seine but, in the nineteenth century, rapidly becoming a built-up, well-to-do suburb to the west of the center of Paris. Passy is now separated from the river by the Palais de Chaillot, but that site was occupied in the 1870s by the Palais de Trocadéro and its gardens, built for the Exposition Universelle of 1867. The Morisot family home in the rue Franklin afforded views down the slopes of Passy to the Trocadéro, the Seine—crossed here by the Pont d'Iéna—and the whole of Paris spread out beyond. Morisot painted and drew aspects of this view on several occasions, sometimes from the gardens, sometimes from her home; most notable are *View of Paris from the Trocadéro* of about 1871–72 (Santa Barbara Museum of Art; fig. 34) and, from about the same time, *Woman and Child on the Balcony* (private collection), which includes the gleaming dome of the Hôtel des Invalides on the horizon (a related watercolor study is in the Art Institute of Chicago; fig. 35). For the present pastel, she appears to have gone some way northwest to the wooded edge of the Trocadéro in order to show the Quai de Passy and the Pont de l'Alma, the next bridge downstream from the Pont d'Iéna.

It was from this secluded neighborhood that the Morisot family witnessed the Siege of Paris and the impact on the capital of the Commune established during and

Figure 34
Berthe Morisot. *View of Paris from the Trocadéro,*
1871–72. Oil on canvas, 18⅛ x 32⅛ in. (46 x 81.6 cm).
Santa Barbara Museum of Art, Gift of Mrs. Hugh N.
Kirkland (1974.21.2)

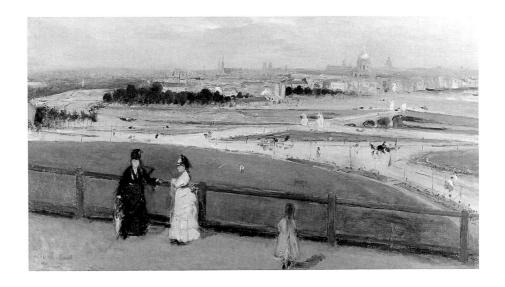

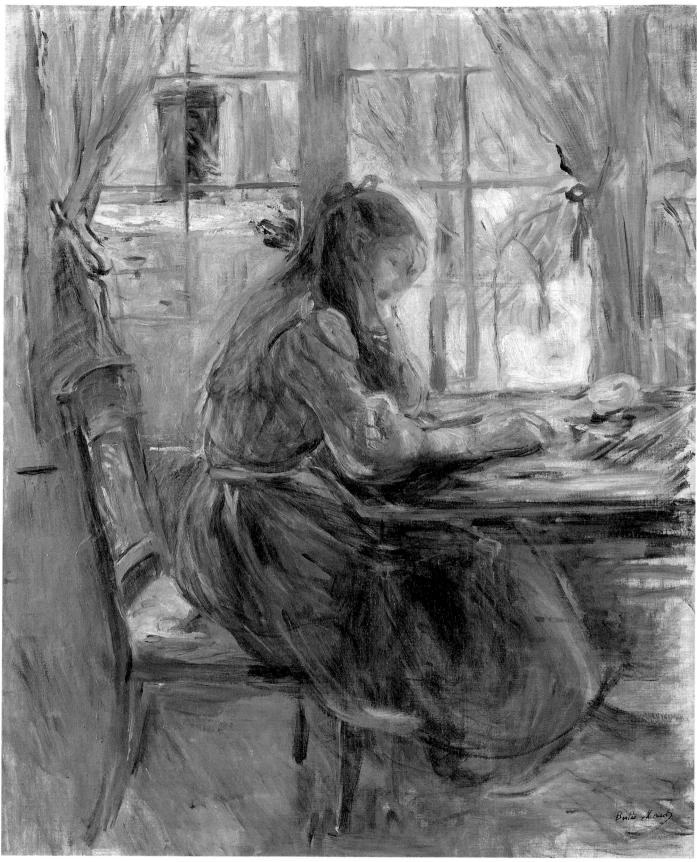

19.

19. BERTHE MORISOT

Girl at the Window (Julie at the Table), 1891
Oil on canvas, 23¼ x 19¼ in. (59 x 48.9 cm)
Atelier stamp (lower right) *Berthe Morisot*

PROVENANCE Ernest Rouart (1874–1942) and Julie
Rouart, née Manet (1878–1966; the artist's daugh-
ter; also the sitter), Paris, presumably by 1895; pur-
chased from Julie Rouart by the Toledo [Ohio]
Museum of Art (acc. no. 1955.36), 1955; deacces-
sioned by that institution to Sam Salz, Inc., New
York, by exchange, 1957; Monsieur Rosensaft,
Montreux, by spring 1958; Mr. and Mrs. Josef
Rosensaft, New York, by 1960; Mr. and Mrs. Philip
Levin, New York, after April 1968–by August 1971;
The Philip and Janice Levin Foundation, 2001.

EXHIBITIONS Paris 1896, p. 23 (no. 59); Paris 1907,
no. 15; Paris 1912b, no. 52; Copenhagen 1914, p. 38
(no. 155); Paris 1929, no. 87; London 1930, no. 44;
Paris 1941, no. 90; Copenhagen 1949, no. 39; London
1950a, no. 41; Geneva 1951, no. 9; Toronto, Montreal,
Washington, D.C., San Francisco, Portland 1952–54,
no. 18, pl. 16; New York 1953, no. 11 (ill.); New Haven
1956, no. 86; The Hague 1957, no. 59; Dieppe 1957,
no. 41; Vevey 1958, no. 18, pl. 10; Paris 1959a, no. 98;
New York 1960a, no. 52 (ill.); Vevey 1961, no. 18, pl. 10;
New York 1968a, p. 29 (no. 136); New York 1968b, p. 18
(no. 136); Washington, D.C., Fort Worth, South
Hadley 1987–88, pp. 158, 160–[61] (pl. 94, color), 222
(no. 94).

REFERENCES Angoulvent 1933, p. 144 (no. 514, as
dated 1891–92); Rouart 1954, pl. 53; Anon. 1956, p. 73;
Daulte 1959b, p. [370] (ill.); Daulte 1959c, pp. 78–79
(color ill.); Boston, New York, San Francisco, Minne-
apolis 1960–61, pp. 174, 175 (ill.); Bataille and Wilden-
stein 1961, p. 41 (no. 267), fig. 285; Huisman 1962,
p. 49 (ill.); Clairet et al. 1997, p. 247 (no. 271, ill.).

Figure 36
Berthe Morisot. *Girl Writing*, 1891. Charcoal on
paper, 7½ x 4¾ in. (19 x 12 cm). Musée Marmottan
Monet, Paris (6066)

Berthe Morisot (1841–1895)

20. *Young Woman on a Sofa*, 1893

20. BERTHE MORISOT
Young Woman on a Sofa, 1893
Oil on canvas, 25¼ x 31½ in. (64 x 80 cm)
Atelier stamp (lower left) *Berthe Morisot*

PROVENANCE The artist's estate, 1895; purchased
from the artist's family by Durand-Ruel, Paris,
1898; possibly Buret collection (prior to Vollard?),
per Bataille-Wildenstein 1961; Ambroise Vollard
(1867–1939), Paris, by 1933; Jean d'Alayer de Coste-
more d'Arc, Paris; Sam Salz, Inc., New York; pur-
chased from that dealer by Mr. and Mrs. Philip
Levin, New York, April 23, 1968; The Philip and
Janice Levin Foundation, 2001.

EXHIBITIONS Paris 1912a; possibly New York 1921;
London 1936, no. 9; Paris 1952; New York 1968a,
p. 28 (no. 134); New York 1968b, p. 17 (no. 134);
Washington, D.C., Fort Worth, South Hadley
1987–88, pp. 163 (pl. 96, color), 164, 222 (no. 96).

REFERENCES Angoulvent 1933, possibly p. 147
(no. 568, as "*Sur la chaise longue,* Collection Vol-
lard"); Bataille and Wildenstein 1961, no. 340,
fig. 339; Higonnet 1992, pp. 242 (fig. 103), 243;
Clairet et al. 1997, p. 282 (no. 343, ill.).

Women and girls in interiors or in the countryside are the predominant subjects of Morisot's work. They are seen in a variety of activities familiar from the upper-middle-class world that was Morisot's domain. Indoors, they wash and dress and do their hair; they read, draw, sew; children are kept entertained by nursemaids. In parks and gardens, they boat and skate, play croquet, or chase butterflies. Young women dress for the opera or theater, but chastely; only in her later years did Morisot attempt the nude female figure. Men, on the other hand, are infrequent intruders on this realm of self-contained domesticity (Morisot's images of her husband, Eugène, are comparatively few, although they affirm his centrality in the household). A hushed, conspiratorial air envelops the works, especially those of Morisot's more retiring later years. Only Renoir, of her contemporaries, can approach this level of female intimacy, but whereas for him it is often mediated by an erotic impulse, for Morisot it suggests instead a wary sensuousness that emanates from her figures' self-absorption.

The model for this painting may well have been Jeanne Fourmanoir, who posed for Morisot on several occasions and also for Renoir. She is seen here in Morisot's temporary apartment at 10, rue Weber, rented while her own quarters in the rue de Villejust were let. The picture appears to be a large study for a smaller painting, *Young Girl Reclining* (or *On the Chaise Longue*; private collection), also of 1893, which shows the model full length, down to her shiny shoes. The room is the same, though more elaborately depicted, with its complement of tables, pictures, and plants; and the girl wears the same light dress. In the present work, she rests on an Empire chaise longue (its swan's-head ornamentation is visible at the lower left) with her hair let down. Her mood is reflective and relaxed, suggesting that the painting may have been carried out during, rather than before, the sittings for the other, more fully realized work. Morisot is often at her most winning when directly evoking such fleeting moments—a maid seen through the dining-room doorway, a girl adjusting her petticoat in a mirror or dressing, perhaps after a morning's modeling. Similar in subject and mood is a fully developed pastel on canvas, *Daydreaming*, of 1877 (The Nelson-Atkins Museum of Art, Kansas City, Mo.; fig. 37)—a comparison that perfectly highlights Morisot's stylistic progress during the intervening years.

20.

Figure 37

Berthe Morisot. *Daydreaming*, 1877. Pastel on canvas, 19¾ x 24 in. (50.2 x 61 cm). The Nelson-Atkins Museum of Art, Kansas City, Mo., Purchase, acquired through the generosity of an anonymous donor (F79-47)

Like all the major figures of the Impressionist group—a group to which Morisot was professionally and socially central—she had her own solutions to the dissatisfactions she felt about the direction of her work in the 1880s. In her case, there was the danger of a certain incoherence of surface, a disappearance of linear structure, and an overall milky tonality as she attempted the transitory effects of light coming through a window or passing over a landscape. She began to strengthen her line, amplify her forms, and define contours more clearly. This newfound direction can be observed here, for example, in the definition of the girl's right arm and the generally less broken application of paint. At the same time, the subject matter is highly characteristic of Morisot's later period: a note of withdrawal, even solitariness, is sounded, in contrast to her earlier portrayals of women in more socially various situations.

Alfred Sisley (1839–1899)

21. *A Corner of the Meadow at Sahurs, Normandy, Morning Sun*, 1894

In the last twenty years of his life, Alfred Sisley rarely stirred from the vicinity of Moret-sur-Loing, a small riverside town on the edge of the forest of Fontainebleau. Except for visits to Paris, he made only three known excursions from Moret. There was an abortive trip to England and the Isle of Wight in 1881, when his paints and canvases failed to arrive from France and he was too poor to purchase any supplies locally. At the end of his life he again went to England before settling for two months in Wales, where he married Eugénie Lescouezec, his longtime companion and the mother of his two children, and where he painted some invigorating coastal land-scapes. This visit was partly financed by one of his few patrons, an industrialist and collector from Normandy named François Depeaux. It was to Depeaux's estate at Le Mesnil-Esnard, near Rouen, that Sisley went in 1894 and there that he produced a group of landscapes of which the present work is an example.

Almost from the start of his career, Sisley had worked in series, whether in the rural outskirts of Paris at Louveciennes and Marly or by the rivers Loing and Seine at Moret. The same motif is seen in different light, under different weather conditions, and in all seasons. He was never as ambitious or single-minded in this practice as was his friend Claude Monet, but when such groups of Sisleys are viewed together they often provide a cumulative effect of great subtlety and gently shifting perceptions. The most celebrated is his extensive group of paintings of the church at Moret, carried out in 1893–94, and it was perhaps as a rest from his long concentration on the church series that Sisley accepted Depeaux's invitation to paint in Normandy. He was evidently attracted to the present motif—a wide meadow bordered by bushes and high, slim trees (possibly overgrown with parasitical mistletoe) close to the Seine at Sahurs, with the wooded slopes of La Bouille in the background. Two closely related views, one in the Musée des Beaux-Arts, Rouen (fig. 38), complete the relaxed, sunny triumvirate devoted to this gentle countryside south of Rouen.

In the 1880s and 1890s Sisley was constantly experimenting, not so much with new subject matter (though this happened later, on his visit to the Welsh coast, with that unprecedented group of marine paintings) but with an increased variety in his handling of paint within a single picture. Grass and foliage are treated in different ways, whether near or far, as are the expanses of sky. Here, in contrast to the rapidly

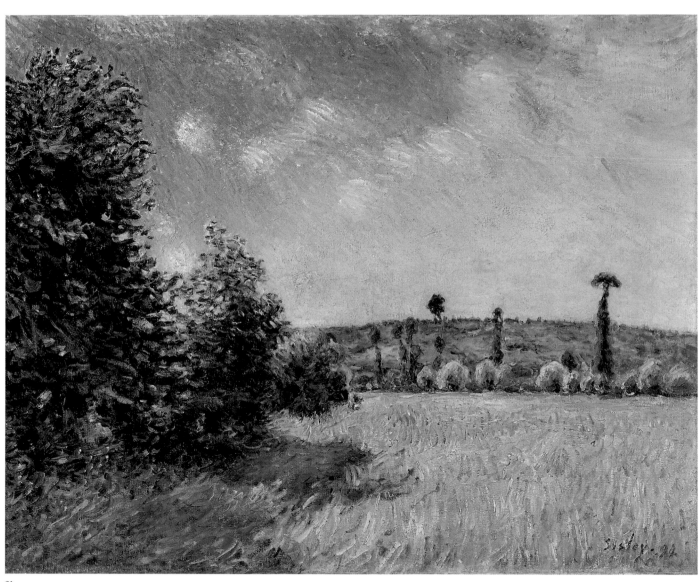

21.

21. ALFRED SISLEY

A Corner of the Meadow at Sahurs, Normandy, Morning Sun, 1894

Oil on canvas, 28¾ x 36¼ in. (73 x 92.1 cm)

Signed and dated (lower right) *Sisley 94*

The Metropolitan Museum of Art, New York, Gift of Janice H. Levin, 1991 (1991.277.3)

PROVENANCE François Depeaux, Rouen, by 1901; his sale, Hôtel Drouot, Paris, April 25, 1901, as *Un Coin de prairie en Normandie*; bought in for Depeaux by Durand-Ruel, Paris; Depeaux sale, Galerie Georges Petit, Paris, May 31, 1906, no. 50; purchased at that sale by Galerie Durand-Ruel, Paris (stock no. P8191), for 3,960 francs; purchased from that dealer by Monsieur Longuet, Paris, June 19, 1923, for 45,000 francs; his sale, Hôtel Drouot, Paris, March 3, 1933, no. 84; purchased at that sale by Durand-Ruel, New York (stock no. 5207), for 21,000 francs; Durand-Ruel, New York, until at least 1949; Jean d'Alayer de Costemore d'Arc, Paris, by 1959; Sam Salz, Inc., New York; purchased from that dealer by Mr. and Mrs. Philip Levin, New York, after April 1968–by June 1971; given by Janice H. Levin to The Metropolitan Museum of Art, New York, 1991.

EXHIBITIONS Manchester 1907–8, p. 37 (no. 179); Paris 1914, no. 33; Venice 1938; New York 1971, p. 1 (no. 6); London, Paris, Baltimore 1992–93, pp. 250 (no. 72), [251] (color ill.), and French ed., pp. 258 (no. 72), [259] (color ill.); Ferrara, Madrid, Lyons 2002–3, pp. 228–29 (no. 45, color ill.).

REFERENCES Daulte 1959a, no. 825 (ill.); Tinterow 1992, p. 47 (color ill.).

Figure 38

Alfred Sisley. *Path at the Water's Edge, Sahurs, Evening,* 1894. Oil on canvas, 32⅛ x 39⅝ in. (81.5 x 100.5 cm). Musée des Beaux-Arts, Rouen, Donation François Depeaux, 1909 (909.1.50)

notated bushes at the left, short, soft brushstrokes carefully evoke the disappearing clouds of an early summer's morning; in another view (*The Hills of La Bouille*; private collection), a heavier impasto conveys a more sultry, overcast sky above a meadow rendered in thickly painted, parallel strokes. Sometimes this effort toward variety led him to an overlabored surface, too desiccated for the often lush summer motifs that he preferred. At other times, this diversity of mark making lends the work a spatial agility with no loss of freshness. In *A Corner of the Meadow at Sahurs,* we find Sisley, in his maturity, bringing to the scene something of the surprise and purity that characterize his classic Impressionist landscapes of the 1870s.

Pierre-Auguste Renoir (1841–1919)

22. *Landscape with Figures*, 1891

22. PIERRE-AUGUSTE RENOIR
Landscape with Figures, 1891
Oil on canvas, 25⅝ x 31⅞ in. (65.1 x 80.9 cm)
Signed (lower right) *Renoir*

PROVENANCE The artist's studio, upon his death;
Alphonse Bellier, Paris, possibly acquired from
the artist's heirs; Durand-Ruel, New York (stock
no. 8026); James Wood Johnson, New York, by 1961;
Sam Salz, Inc., New York; Mr. and Mrs. Konrad H.
Matthaei, New York; acquired from them by
Richard L. Feigen and Co., New York (stock no.
14963-D), September 28, 1970; purchased from that
dealer by Mr. and Mrs. Philip Levin, New York,
September 28, 1970; The Philip and Janice Levin
Foundation, 2001.

EXHIBITIONS Paris 1933a, p. 43 (no. 100), pl. 51
(as *Paysage de Cagnes avec trois personnages*); Paris
1933b, pl. 50; New York 1946–47, no. 6 (ill.); New
York 1961, p. 8 (no. 79, as lent by James Wood
Johnson); New York 1968a, p. 37 (no. 185); New York
1968b, p. 22 (no. 185); New York 1971, p. 1 (no. 5).

REFERENCES Barnes and de Mazia 1935, p. 461
(no. 209, as "*Cagnes Landscape with Three Figures*,
ca. 1893"); Frost 1944, p. [26] (color ill.); Bernheim-
Jeune 1989, p. 230 (no. 42, as *Beaulieu, femmes et
garçonnet*), pl. 18 (fig. 42).

A certain amount of confusion and mythmaking has long surrounded the identifi-
cation of the setting and three figures of this painting. It has been variously described
as having been painted at Cagnes-sur-Mer and at Beaulieu but was correctly assigned
to Tamaris-sur-Mer in the 1933 exhibition devoted to Renoir at the Musée de l'Orange-
rie, Paris—a conclusion subsequently overlooked. In recent years, the small boy
reclining in the grass has been identified as the artist's son Jean, later the great film
director. In fact, it is his older brother, Pierre, the first child of Renoir and Aline Chari-
got, who was born in March 1885 (Jean was not born until 1894). It has also been sug-
gested that the seated woman facing the viewer is Renoir's famous model Gabrielle
Renard, a relative of Madame Renoir's. But Gabrielle did not enter the Renoir house-
hold until 1894, some months before Jean's birth, when she was only about fifteen
years old. The woman in profile is almost certainly Aline Charigot, Madame Renoir
(see fig. 39); the woman in full face thus may be a family servant or a guest at the
rented house where the Renoirs were staying in Tamaris.

Already by 1891 Renoir's health was showing ominous signs of decline, and
he frequently went in search of winter warmth to the south of France, either renting
a house or sharing one with friends. In the hotter summer months, he was invariably
on the coast or in his wife's native village of Essoyes. This was the pattern of his life
until he acquired Les Colettes at Cagnes-sur-Mer in 1907, although he continued to
keep a flat and a studio in Paris. In 1891 he and his wife and son were in the South from
February to April, sharing a house in Tamaris, a seaside village and resort close to the
naval town of Toulon, with the Franco-Polish writer and critic Teodor de Wyzewa, a
great admirer of Renoir's work.

Somewhere on the outskirts of Tamaris, a little walking party has stopped
to rest in the shade. The foreground and figures are dappled in afternoon sun; the lake
and villas beyond (their shutters closed against the glare) are uniformly lit. Three pine
trees provide dark verticals, spatial markers against the gently receding horizontals of
path, grass, water, distant landscape, and sky. The two women are talking, perhaps; the
boy, head propped on his elbow, idly listens.

Renoir's reputation for demotic hedonism, his delight in obvious charms and
idyllic commonplaces, have frequently prevented a full appreciation of the subtleties

22.

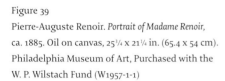

Figure 39
Pierre-Auguste Renoir. *Portrait of Madame Renoir,*
ca. 1885. Oil on canvas, 25¾ x 21¼ in. (65.4 x 54 cm).
Philadelphia Museum of Art, Purchased with the
W. P. Wilstach Fund (W1957-1-1)

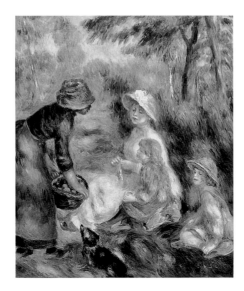

Figure 40
Pierre-Auguste Renoir. *The Apple Seller,* ca. 1890.
Oil on canvas, 25⅞ x 21½ in. (65.7 x 54.5 cm).
Cleveland Museum of Art, Bequest of Leonard C.
Hanna Jr. (1958.47)

and discretion of his art. The present painting combines complete naturalness of subject with rigorous composition—like a scene in a novel by Colette. The canvas flickers with rhythmic echoes and correspondences of color, clothing the firmest of structures. The dark trunks of the pines are unobtrusively related to the silvery ones of the tamarisk bushes by the lake; the houses are disposed in perfect relation to the figures; the colors of the women's clothes are picked up in the varied warm tones along the trunk of the central tree.

Throughout the 1880s, Renoir had struggled with the integration of figures and an outdoor setting. There had been a measure of dislocation between the model, painted in the light of the studio, and the surrounding garden or landscape, based on studies made out of doors. With the gradual tightening of his style during that decade and a closer attention to tone, at one remove from the more naturalistic palette of earlier years, he achieved both the integration he sought and a more unified overall texture. Paintings of the early 1890s such as *The Apple Seller* (Cleveland Museum of Art; fig. 40) and the present work paved the way for Renoir's great outdoor figures and nudes of the 1900s, such as his *Washerwomen* of about 1912 (The Metropolitan Museum of Art, New York).

Pierre-Auguste Renoir (1841–1919)

23. *Woman with a Guitar,* ca. 1896–97

In the latter half of the 1890s, Renoir made a group of closely related paintings of a young female model sitting in the artist's studio holding a guitar. The most fully realized is *Woman Playing the Guitar* of 1896–97 (fig. 41), which Renoir sold to the Musée des Beaux-Arts, Lyons, in 1901; two others were acquired by his dealer, Paul Durand-Ruel, in 1897. The Lyons painting shares its studio setting with the present work, and the young guitarist, a model called Germaine, sits on the same low, red-upholstered chair in both. In contrast to the white dress with pink bows of the Lyons painting, however, here she wears a pink skirt and green ruffled top. The whole series is notable for Renoir's gentle concentration on the model's face and for the rich rhythmic correspondences subtly deployed throughout, as in the interplay of curves from figure to instrument; in this example, the round curl of the woman's chignon is even echoed in the dark aperture of the guitar. The greens, reds, pinks, and light browns make for a warm but subdued harmony reflective of the music such a guitarist might have been playing (though the model, of course, may not have been able to manage a single note). It is thought that Renoir was inspired to carry out this group of works by memories of a seductive Spanish performer he had seen at the Folies-Bergère. A number of preliminary charcoal drawings exist in which he sought the most suitable pose for the guitarist. By early 1897 the paintings were well under way, as Julie Manet (see cat. no. 19) recorded in her diary after visiting Renoir in his studio in the rue de la Rochefoucauld:

> He is working on some delightful guitar studies: a woman in a
> white chiffon dress which is held in position with pink bows leaning
> gracefully over a big yellow guitar, with her feet on a yellow cushion;
> another canvas is of a man in a Spanish costume who seems to be
> playing lively tunes on his instrument. The whole effect is colourful,
> mellow, delicious.[1]

In essence, the genre to which this painting belongs is that of the romantic costume picture, but it is carried out in Renoir's classicizing style of the 1890s. The intimate theme of a figure playing a musical instrument has a long tradition in French painting. We think of Greuze's *Guitarist* in the Musée des Beaux-Arts, Nantes, and

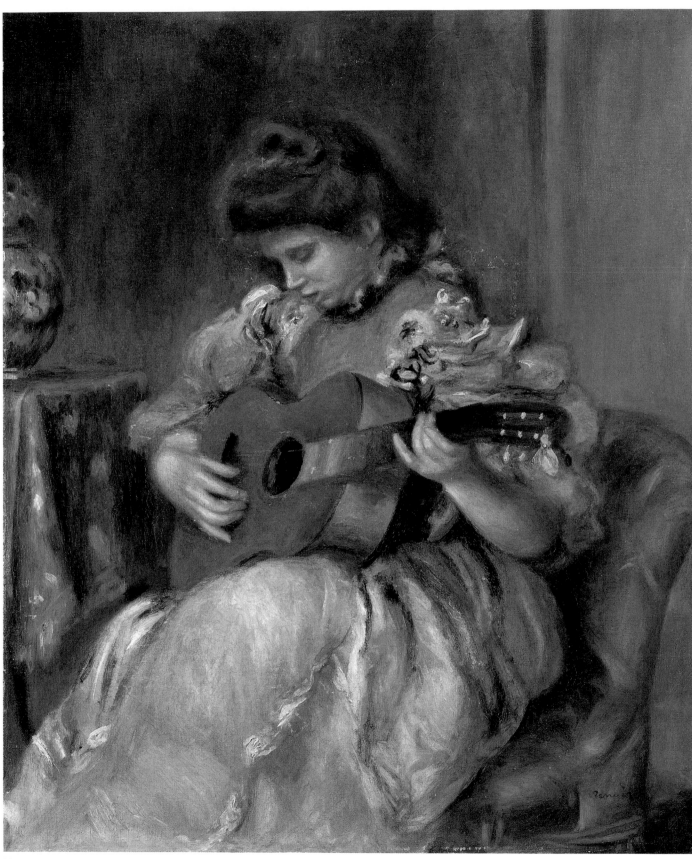

23.

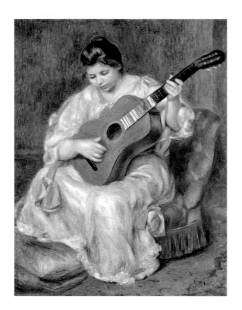

Figure 41
Pierre-Auguste Renoir. *Woman Playing the Guitar*, 1896–97. Oil on canvas, 31⅞ x 25⅝ in. (81 x 65 cm). Musée des Beaux-Arts, Lyons

Figure 42
Camille Corot. *Girl with Mandolin*, 1860–65. Oil on canvas, 20¼ x 14½ in. (51.4 x 36.8 cm). The Saint Louis Art Museum, Purchase

Figure 43
Édouard Manet. *The Spanish Singer*, 1860. Oil on canvas, 58 x 45 in. (147.3 x 114.3 cm). The Metropolitan Museum of Art, New York, Gift of William Church Osborn, 1949 (49.58.2)

23. PIERRE-AUGUSTE RENOIR
Woman with a Guitar, ca. 1896–97
Oil on canvas, 25½ x 21 in. (64.8 x 53.3 cm)
Signed (lower right) *Renoir*

PROVENANCE Galerie Durand-Ruel, Paris (stock no. 4670), purchased from the artist May 23, 1898; Paul-Marie-Joseph Durand-Ruel (1831–1922), Paris (inv. no. A.I.335); his daughter-in-law Madame Joseph Durand-Ruel, née Mary Jenny Lefébure (1868–1962), Paris; her son Charles-Marie-Paul Durand-Ruel (1905–1985), Paris; purchased from him by Sam Salz, Inc., New York, January 26, 1963; purchased from that dealer by Mr. and Mrs. Philip Levin, New York, after April 1968–by August 1971; The Philip and Janice Levin Foundation, 2001.

EXHIBITIONS Paris 1899, no. 108; Munich 1912; Paris 1922b; Paris 1934, no. 44; Paris 1948a, no. 64; Limoges 1952, p. 37 (no. 46), pl. 27; London, Edinburgh 1953, no. 22.

Corot's *Girl with Mandolin* of 1860–65 (The Saint Louis Art Museum; fig. 42), in which the seated model, her instrument momentarily abandoned on her lap, is lost in thought. There are also Manet's dramatic, early *Spanish Singer* of 1860 (The Metropolitan Museum of Art, New York; fig. 43) and, later, works by Picasso, Braque, and Matisse, including the latter's painting of his wife, in Spanish male attire, playing a guitar (ca. 1902–3; Colin Collection). The exotic mood Renoir evokes here is found consistently throughout the work of his later years. While Manet, for example, began his career with a number of costume pieces and ended with scenes of contemporary urban life, Renoir largely reversed that direction, and from the 1890s or so, Parisian life disappears and models in "oriental" and Spanish costumes populate a world of idealized figures in confined or abstracted settings. The present painting combines these two concepts, the original inspiration having come from one of Paris's most famous places of entertainment but the realization somehow removing the young woman from that world into one of solitary concentration.

1. *Growing Up with the Impressionists*, entry for February 1, 1897, p. 108.

24.

Henri de Toulouse-Lautrec (1864–1901)

24. *A Country Outing*, ca. 1882

24. HENRI DE TOULOUSE-LAUTREC
A Country Outing, ca. 1882
Oil on canvas, 18⅛ x 15 in. (46 x 38 cm)
Initialed (lower left) *TL*

PROVENANCE Monsieur Rachon, Paris; F. Marion
de Gaja; Algur Hurtle Meadows (1899–1978) and
Elizabeth Boggs Meadows, née Bartholow, Texas,
probably not before 1964–by 1968; private collec-
tion, Paris, not before July 1974; Sandra Canning
Kasper, New York; purchased from that dealer by
Janice H. Levin, New York, November 22, 1989; The
Philip and Janice Levin Foundation, 2001.

EXHIBITIONS Kyoto, Tokyo 1968–69; Dallas 1974.

REFERENCE Dortu 1971, vol. 2 *(Catalogue des
peintures: Notices et reproductions, No. P.1 à No. P.515)*,
pp. 86–87 (no. P.195, ill).

The world evoked in Toulouse-Lautrec's early work is quite distinct from the subject matter for which he later became famous. He is known, of course, for his scenes of Parisian nightlife, its places of entertainment, its dance halls, bars, and brothels. This was the world into which he escaped once he had begun to lead a life more independent of his parents, Count Alphonse and Countess Adèle de Toulouse-Lautrec-Monfa. His family's ancient lineage, its several houses in and near Albi in southwestern France, and his mother's grand apartment in Paris formed the privileged backdrop to Toulouse-Lautrec's early years. Most of his numerous male relations had a passion for riding, hunting, and other country pursuits, which the young Henri followed avidly until a series of accidents stunted his already short, frail legs. By 1880, at age sixteen, he was physically deformed, and he never grew beyond about five feet in height. During his long convalescent periods in the late 1870s, he began to develop his precocious skills as a witty and observant draftsman, having inherited talent from and been encouraged by his father and two uncles, all competent amateur artists. The count came to know the equestrian painter René Princeteau (1844–1914), who gave lessons to the boy both in Paris and on visits to Albi. Carriage driving, hunting parties, the count falconing in the country, military maneuvers, and riders in the Bois de Boulogne are the subjects of some of Toulouse-Lautrec's earliest paintings (see fig. 44). They naturally reflect his familiar surroundings and, in that sense, are typical of his time and class. But his vivid, flexible line and near-caricatural approach to the figure are prophetic of future developments.

A Country Outing belongs to this early period. It shows a family in the countryside, resting between shady banks of what appears to be a sun-burnished cornfield. The casual disposition of the three figures (the woman in the center may well be Countess Adèle) and the alert, perhaps impatient little black dog (one of the earliest of several brilliant canine presences in Toulouse-Lautrec's work), as well as the sure handling of spatial recession, suggest considerable sophistication on the artist's part: the work may indeed belong a year or two later than its given date. Toulouse-Lautrec's more famous, later paintings are notable for their rapidly brushed surfaces in oil paint that had been thinned with turpentine to maximize the calligraphic effect. But even in this early painting, he has scratched into the wet paint, perhaps with the other end of his brush,

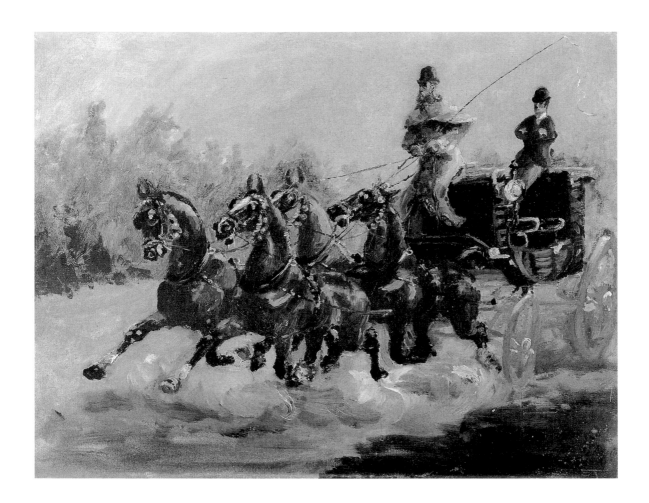

Figure 44
Henri de Toulouse-Lautrec. *Alphonse de Toulouse-Lautrec Driving His Mail-Coach to Nice,* 1880. Oil on canvas, 15⅛ x 20⅛ in. (38.5 x 51 cm). Musée du Petit-Palais, Paris (PPP 0770)

to suggest dry, burnt grasses in the foreground. What is perhaps most striking is the canvas's affinity with works made ten or fifteen years later by such painters as Pierre Bonnard and Édouard Vuillard. Both eventually became known as *intimistes* (and became friendly, too, with Toulouse-Lautrec), and something of their relaxed domesticity is found here in their friend's charming early work.

Opposite: Detail, cat. no. 24

25.

Édouard Vuillard (1868–1940)

25. *Madame Vuillard Setting the Table*, ca. 1895

25. ÉDOUARD VUILLARD
Madame Vuillard Setting the Table, ca. 1895
Oil on canvas, 12½ x 15½ in. (31.7 x 39.3 cm)
Signed (lower right) *E Vuillard*

PROVENANCE Sam Salz, Inc., New York, by January 1965; purchased from that dealer by Mr. and Mrs. Philip Levin, New York, after April 1968–by August 1971; The Philip and Janice Levin Foundation, 2001.

EXHIBITIONS Cleveland, New York 1954, possibly exhibited *hors catalogue*; Los Angeles 1965, no. 25; New York 1968c, no. 36 (as *The Breakfast*, ill.); Houston, Washington, D.C., Brooklyn 1989–90 [exh. no. 49], pp. 91, 93 (fig. 68, color).

REFERENCE To be included in vol. 1 of the catalogue raisonné of the work of Vuillard, by Guy Cogeval and Antoine Salomon, forthcoming in 2003.

The four paintings by Vuillard in this collection (cat. nos. 25 to 28) belong to the early and middle years of the artist's career. They are also representative of two of his work's major themes—the domestic interior, centered on his home life and studio; and the world of his patrons, who became his friends and whose social pursuits afforded him a contrast to (even a relief from) the comfortable security of his bachelor life with his mother. In this, the earliest of the four paintings, we are confronted with a typically side-angled view of Madame Vuillard laying the table for dinner in the family apartment in the rue Saint-Honoré, in Paris's first arrondissement. Having been widowed early—when her son Édouard was just sixteen years old—Madame Vuillard (née Marie Michaud) was left as the sole breadwinner for her three children. She worked as a corset maker and is frequently seen in her son's works sewing or embroidering amid the seamstress's usual paraphernalia. In the early years, the family also included Madame Vuillard's mother and Édouard's brother Alexandre and sister Marie, who married the painter Ker-Xavier Roussel in 1893. Thereafter, Vuillard shared a succession of Paris apartments with his mother until her death in 1928. She was at the heart of his existence, providing for his wellbeing, discussing day-to-day concerns, and supporting his work and career. The comfort of her presence is delightfully encapsulated in a brief entry in Vuillard's diary: "Dine with mother ... conscious of growing calmer, of taking peaceful pleasure in her kindly face."[1] Initially, Madame Vuillard is pictured in a number of works as being the motive force behind her household and business. Later, she is a more solitary elderly presence, easily blending with the familiar furnishings of the Vuillard apartment (as in *Woman Sweeping* of 1899–1900; The Phillips Collection, Washington, D.C.; fig. 45). Later still, she sits quietly by an open window or putters among the furniture, at the end of a long life (as in one of her son's last images of her, *The Artist's Mother in Her Apartment, Rue de Calais, Paris—Morning* of about 1922; Virginia Museum of Fine Arts, Richmond; fig. 46).

Mealtimes were a motif shared by several of the Nabi painters—from modest family gatherings (see Bonnard's *Luncheon*, cat. no. 31) to elaborate alfresco lunches in the country (as commemorated in Vuillard's great panels in the National Gallery, London, such as *Lunch at Vasouy* of 1901). Here, at the more domestic end of the scale, Madame Vuillard prepares the family dinner table in the evening. The crepuscular scene,

Figure 45
Édouard Vuillard. *Woman Sweeping*, 1899–1900. Oil on cardboard, 17⅜ x 18⅝ in. (44.1 x 47.3 cm). The Phillips Collection, Washington, D.C.

in which the patterned wallpaper and cloth form a dashed and stippled setting for the lighter figure of Madame Vuillard, is at first glance almost unreadable in its formal ambiguities. In such early works, Vuillard savored the spatial elisions that can transpire from viewing a scene from within rather than at a distance. Objects and people are haphazardly interrupted by the edges of the board or canvas; a chair takes precedence over a figure or, as here, intervenes between the viewer and the central figure. This procedure was more viable in the somewhat claustrophobic and embellished rooms of the family apartment, although it was one that Vuillard carried to an extreme in his large decorative panels of the 1890s. These, while depicting the often larger, higher rooms of his patrons' houses, are no less insistently patterned and replete with flowers and furniture.

Figure 46

Édouard Vuillard. *The Artist's Mother in Her Apartment, Rue de Calais, Paris—Morning*, ca. 1922. Oil on millboard, 17⅛ x 11¾ in. (43.4 x 29.8 cm). Virginia Museum of Fine Arts, Richmond, Collection of Mr. and Mrs. Paul Mellon (83.60)

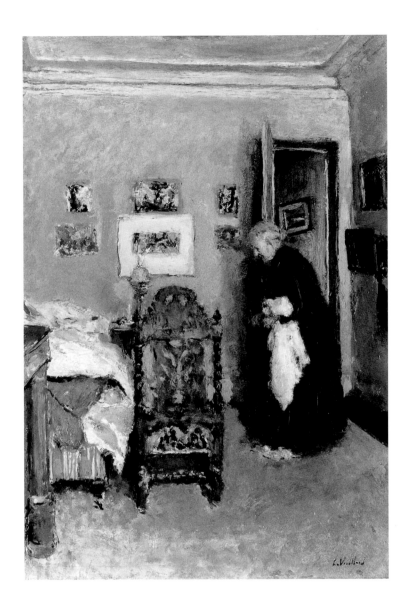

In smaller-scaled studies such as the present work, Vuillard distills a visual poetry from the most ordinary domestic material. In turning the simple preparations for dinner into something almost sacramental, he goes straight to the core of his passionate devotion to the soothing rituals of everyday life.

1. Journal entry for November 19, 1907, quoted in Belinda Thomson, *Vuillard*, exh. cat. (London, South Bank Centre, 1991), p. 18.

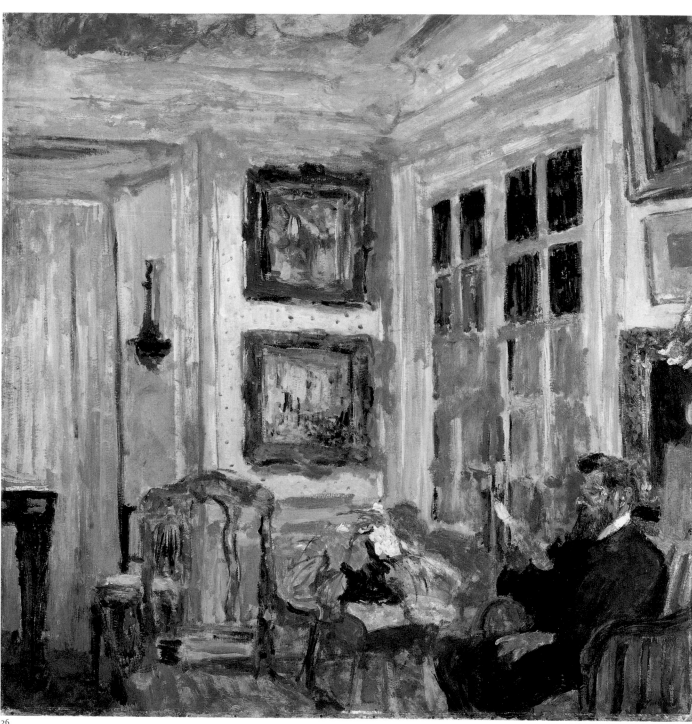

26.

Édouard Vuillard (1868–1940)

26. *Arthur Fontaine Reading in His Salon,* 1904

26. ÉDOUARD VUILLARD

Arthur Fontaine Reading in His Salon, 1904

Oil on paper laid down on canvas, 24³/₈ x 24³/₈ in. (62 x 62 cm)

Atelier stamp (lower right) *E Vuillard*

PROVENANCE Galerie René Drouin, Paris; Kocher collection; private collection; various owners; their sale, Sotheby's, New York, November 11, 1987, no. 59 (color ill.); purchased at that sale by Janice H. Levin, New York; The Philip and Janice Levin Foundation, 2001.

EXHIBITIONS Paris 1943, no. 94; Stockholm 1948, no. 8; Basel 1949a, no. 203 (as *Der Grüne Salon*). Possibly two additional, unidentified exhibitions, per labels on reverse: Galerie Georges Moos, Geneva; Stockholm 1948.

REFERENCE To be included in vol. 2 of the catalogue raisonné of the work of Vuillard, by Guy Cogeval and Antoine Salomon, forthcoming in 2003.

In the late 1890s and early in the next decade, Vuillard's social world was transformed in a way that greatly increased the range of his subject matter—new faces, new landscapes, new rooms. He and other painters in his intimate circle, such as Pierre Bonnard, Félix Vallotton, and Ker-Xavier Roussel, were taken up by a number of enlightened patrons and collectors central to the literary, artistic, and musical elite of Paris. They were well-to-do rather than very rich, from the upper bourgeoisie rather than the old aristocracy; their style of living was inflected by the social and moral freedoms of the artists they entertained and supported. In the earlier part of this period, Thadée Natanson and his wife, the former Misia Godebska, were crucial to Vuillard's social life. His stays at their country houses, first at Valvins (where Vuillard came to know the poet Stéphane Mallarmé) and then at Villeneuve-sur-Yonne, inspired some of his greatest mural decorations, and Misia, a Polish-born pianist famed for her looks, her affairs, and her marriages, drew from him some of his most poetic and rapt interiors-with-figures, in which the smell of flowers and the sound of the piano are almost as palpable as the person of Misia herself.

Among the other devoted patrons of the Nabis was Henry Lerolle (1848–1929), a musician and a painter in his own right, though of a more conservative nature than most of the artists with whom he associated. He and his wife, Madeleine (née Escudier), invited a variety of composers, writers, and painters into their substantial home at 20, avenue Duquesne, in Paris. Their guests included the composers Claude Debussy, Vincent d'Indy, and Ernest Chausson, who was Lerolle's brother-in-law and also an adventurous collector; Chausson and Lerolle were particular patrons of Maurice Denis. From an earlier generation, Renoir was a family friend who had painted Lerolle's daughters at the piano (*Yvonne and Christine Lerolle at the Piano,* ca. 1898; Walter-Guillaume Collection, Musée de l'Orangerie, Paris). Madame Lerolle's sister, Marie, was married to Arthur Fontaine (1860–1931), the subject of the present painting. Fontaine was an industrialist who had been appointed chief engineer of mines for France and, in 1899, minister of labor. He was a well-read, cultivated man, a collector and patron, a friend of writers such as Paul Claudel and André Gide (who mentions Fontaine in his *Journals*), and the founder with Maurice Denis of a short-lived periodical, *L'Occident,* established for the promotion of Western Catholic art. One of the Fontaines' closest friends was

Odilon Redon, who drew portraits of them in 1901 (that of Marie is in The Metropolitan Museum of Art, New York; fig. 47). The couple lived, not especially happily (they divorced in 1905), in the avenue de Villars, the salon of which is the setting for this painting.

In his characteristic manner, Vuillard pushes the reading figure of Fontaine, lit from the side, to the margin of the painting. There he forms a solid, concentrating presence, though dominated by the rectangles of window, furniture, and pictures on the walls. As in *Madame Vuillard Setting the Table* (see cat. no. 25), an empty chair looms in the foreground. The predominant color scheme of gray and pale lemon is subdued yet warm, set off by Fontaine's sober clothes and the dark windowpanes and enlivened by touches of stronger color—Fontaine's florid hands, the flowers on the small table, the pink blossom peeping into the painting above the sitter's head. In another canvas of 1904 with the same dimensions as this one, Vuillard shows the salon from a different

angle and includes the diminutive figures of the Fontaines below a wall filled with
Maurice Denis's large decoration *The Muses* (1893; fig. 48), his celebrated image of women
walking and reading under trees that is now in the Musée d'Orsay, Paris. In an additional painting of 1903–4, also of similar size—lending credence to the suggestion that
the Fontaines may have commissioned Vuillard to paint a suite of interiors of their
home—Madame Fontaine pauses by one of the windows, wearing a shimmering rose-
and-gold dress that picks up the glow of the sunlit room (private collection).

Vuillard remained friendly with the couple as they went their separate ways
after the divorce: she remarried and became Madame Abel Desjardins, while he continued for a while in the avenue de Villars, overseeing his gatherings of writers and
painters. Arthur Fontaine's collection was dispersed at auction in Paris in April 1932.

Édouard Vuillard (1868–1940)

27. *Woman with a Hat,* ca. 1909

27. ÉDOUARD VUILLARD

Woman with a Hat, ca. 1909

Oil on board mounted to stretcher, 17½ x
14¾ in. (44.5 x 37.4 cm)

Atelier stamp (bottom right) *E. Vuillard*

PROVENANCE With B. Grossetti, Galleria dell-
l'Annunciate, Milan; private collection, Paris, by
1946; William and Edith Meyer Goetz, Los Angeles;
sale of that collection, Christie's, New York, Novem-
ber 14, 1988, no. 11 (color ill.); purchased at that sale
by Janice H. Levin, New York; The Philip and Janice
Levin Foundation, 2001.

EXHIBITIONS Brussels 1946, no. 13 (as *Le Chapeau
blanc,* ill.); San Francisco 1959, p. [2], no. 60 (ill.).

REFERENCE To be included in vol. 2 of the cata-
logue raisonné of the work of Vuillard, by Guy
Cogeval and Antoine Salomon, forthcoming in
2003.

If Misia Natanson was the light of Vuillard's social world in the 1890s, the subject of
the present painting became the predominant figure in his life from 1900, the year they
met, until the artist's death in 1940. Lucie Hessel (née Reiss)—dark haired and dark
eyed, intelligent, amusing, and temperamental—was the wife of Joseph (Jos) Hessel,
a Belgian picture dealer. Hessel was the first director of the Galerie Bernheim-Jeune in
Paris, one of the capital's principal dealers in Impressionist and Post-Impressionist art,
alongside Paul Durand-Ruel, Georges Petit, and Ambroise Vollard. Later, he success-
fully conducted business on his own from premises in the rue de la Boétie and was
a well-known figure in the art world of Paris, as is documented, for example, in René
Gimpel's *Diary of an Art Dealer* (1963). From early in their friendship, Hessel dealt in
Vuillard's work, and the artist had several solo shows at Bernheim-Jeune; the last, of
his early work, was held in 1938 at the time of Vuillard's grand retrospective at the
Musée des Arts Décoratifs, Paris.

　　　Vuillard's relationship with Hessel's wife remains enigmatic, but it was close
enough to encourage some occasional jealousy in the two other important women in
his life—his mother and Misia Natanson. Jos Hessel's business interests and extramari-
tal affairs perhaps left Lucie Hessel with time on her hands, and in Vuillard she found
a willing accomplice for outings in the Bois de Boulogne and the Tuileries and for eve-
nings at the theater. Sophisticated and well dressed, she was an expert hostess, first in
the Hessels' apartment in the rue de Rivoli and, after 1909, in their superbly appointed
quarters in the rue de Naples (as seen in Vuillard's *Woman Reading* of 1917; Kunstmuseum
Bern; fig. 49). She was a tireless model and appears in hundreds of paintings and draw-
ings over four decades (see fig. 50). Many of these were carried out in a succession of
country and seaside houses in Normandy and Brittany, where Vuillard was a faithful
summer guest. His visits inspired him to paint decorations, beach scenes, sunlit interi-
ors, and images of family and friends, often seen relaxing out of doors. They also in-
spired him as a photographer: a Kodak supplemented his ever present sketchbook. If
the social atmosphere of the Hessels' gatherings in Paris included an element of the
beau monde, richer and grander than at the Natansons', their country house parties in the
summer were freer and more leisurely: as noted with regard to the Pourville landscape
by Renoir elsewhere in this catalogue (see cat. no. 13), Vuillard's many works from these
visits convey something of the spirit of Proust's Balbec in *À la recherche du temps perdu.*

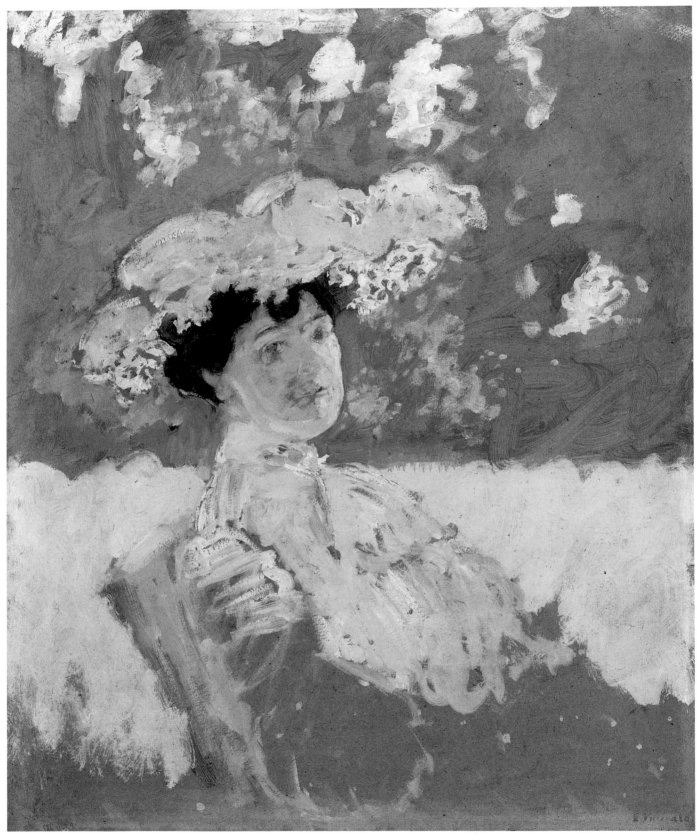

27.

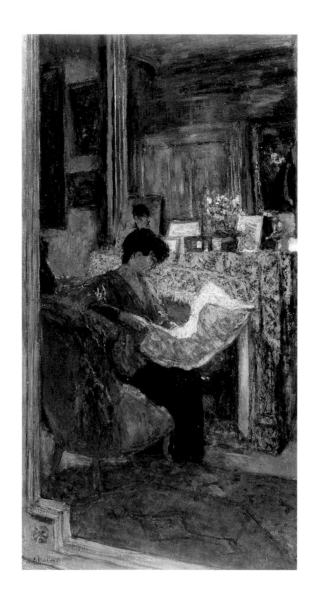

One of Vuillard's photographs, of Lucie Hessel in a pony trap with her dog,
Basto (much portrayed by Vuillard), and friends, was taken at Saint-Jacut on the
Channel coast probably in the summer of 1909 and points to a date for the present
painting.[1] In both, she wears the same broad-brimmed hat trimmed with a flounce of
white lace or tulle. The painting, sketched on Vuillard's favored support of unprimed
board, shows Lucie Hessel seated in the garden, turning momentarily toward the
viewer. Typically, Vuillard makes use of the warm brown ground to suggest the deeper
shadow across Madame Hessel's lower figure; her white blouse and hat are in half-
shade, their delicate rapidity of execution echoed in the shifting sunlight passing
through the bank of trees that borders the garden. The unfinished state of the work
obviously satisfied the artist, who signed it.

Figure 50
Édouard Vuillard. *Interior (Madame Hessel in the Garden Room)*, 1904. Charcoal on board, 21½ x 15 in. (54.6 x 38.1 cm). The Philip and Janice Levin Foundation

Figure 51

Édouard Vuillard. *Madame Hessel on a Sofa*, ca. 1900–1901. Oil on board, 21½ x 21½ in. (54.6 x 54.6 cm). Walker Art Gallery, Liverpool (WAG 6217)

The straightforward simplicity of the image (though it is not without a certain intimacy of regard) is rare in Vuillard's portrayals of Lucie Hessel. Usually, she is seen as one element—albeit an important one—of the interiors that reflected and sustained her comfortable style of life. Exceptions to this tendency include her smiling, even flirtatious likeness in a painting of 1900 in the Walker Art Gallery, Liverpool (fig. 51), and the splendidly behatted portrait of about 1905–6 that was painted on holiday at the Château Rouge, Amfreville (private collection, Saint Louis, Mo.).

1. In the forthcoming catalogue raisonné of the work of Vuillard by Guy Cogeval and Antoine Salomon, this painting is dated ca. 1902. The date published here of ca. 1909 is based on information in Belinda Thomson, *Bonnart at Le Bosquet*, exh. cat. (London, Hayward Gallery, 1994).

Édouard Vuillard (1868–1940)

28. *Model Undressing,* ca. 1902–3

The nude female figure is a minor thematic tributary diverging from the great flow of Vuillard's work. It occupies nothing like the place it does in the oeuvres of his contemporaries, such as Bonnard (Marthe at her toilette and in her bath, as discussed on p. 118) and Ker-Xavier Roussel (in his many mythologically inspired paintings and decorations). Vuillard did not have that access to the nude generally afforded by cohabitation or married life, as was the case with Bonnard and Roussel; nor was he steeped in the latter's vision of frolicsome nymphs and satyrs disporting naked in the Île-de-France. Vuillard is not known for his love affairs with women or for long hours of concentration with a nude model in his studio. Perhaps there was some strain of shyness or restraint in his nature that prevented this bachelor, living with his mother, from tackling what was, after all, a major theme of the painting of his time. There are some early attempts at the nude and a further group painted in Vuillard's studio, which was located in 1903–4 in the rue Truffaut and from 1905 in the rue de la Tour, the setting for the present work. An impressive nude on a studio sofa of about 1908–9 is in a private collection (fig. 52).

In most of Vuillard's nude studies, his model is seen in transition between more formal sittings, undressing or at a moment of rest. The nudes have little sexual charge or psychological presence. Vuillard perhaps realized that his gifts did not lie in the objective portrayal of the posed nude figure, which might lack the spontaneity and movement inherent in his most characteristic subjects. He would have agreed with his friend and contemporary Walter Sickert (1860–1942), who wrote that the nude figure should be doing something in a believable setting (even if it were one that the artist had contrived in his studio, as was usually the case with Degas, for example, or Sickert himself). Here, we see a model undressing, placing her clothes on a chair next to a red-covered sofa or daybed and about to remove her skirt. The dramatic contrast of the red rectangle and the dark shape of her skirt is tempered by the lemony wall, lit somewhat coldly from above by the studio windows behind the painter.

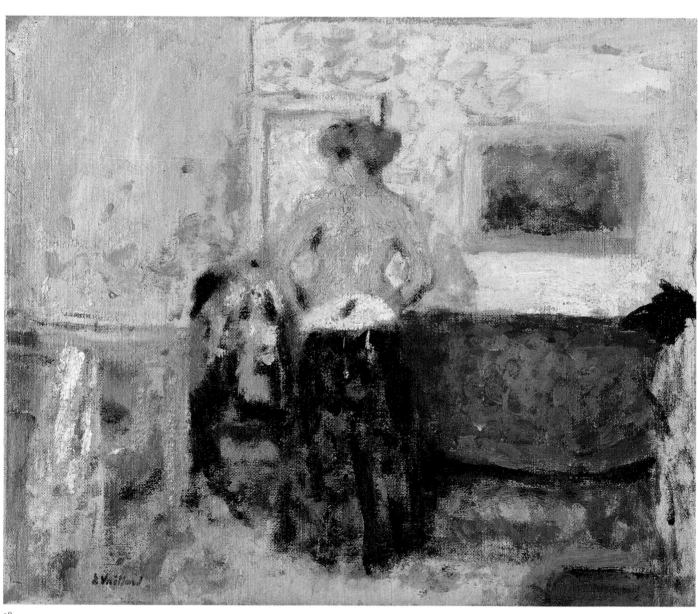

28.

28. ÉDOUARD VUILLARD
Model Undressing, ca. 1902–3
Oil on canvas, 9¼ x 10½ in. (23.5 x 26.6 cm)
Signed (lower left) *E Vuillard*

PROVENANCE Galerie Bernheim-Jeune, Paris;
P. Ebstein, Paris; Georges Renand (b. 1879), Paris, by
1937; Wildenstein and Co., New York; Mr. and Mrs.
Sydney R. Barlow, Los Angeles; their sale, Christie's,
New York, May 16, 1977, no. 18 (color ill.); purchased
at that sale by Janice H. Levin, New York; The Philip
and Janice Levin Foundation, 2001.

EXHIBITIONS Paris 1937, p. 58 (no. 7, as "*Le Modèle,*
1900"); Paris 1938, p. 15 (no. 87); Paris 1948b, no. 36.

REFERENCES Chastel 1948 (color ill. on cover);
Mercanton 1949, pl. 9 (color); to be included in
vol. 2 of the catalogue raisonné of the work of
Vuillard, by Guy Cogeval and Antoine Salomon,
forthcoming in 2003.

Figure 52
Édouard Vuillard. *Nude on a Sofa in the Artist's Studio,*
1908–9. Distemper on board laid on canvas, 54½ x
49¼ in. (138.4 x 125 cm). Private collection

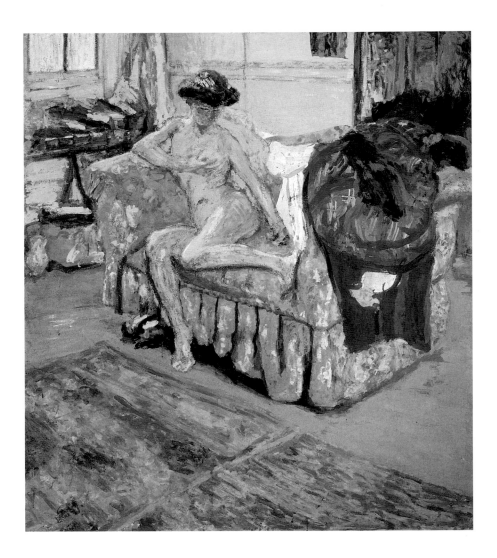

Half-dressed, the model appears more vulnerable than she would in a state
of full, professional nakedness. She turns her back to Vuillard and to the viewer before
assuming her accustomed role, not especially from bashfulness but out of a natural
decorum. Vuillard hits just the right light note, introducing neither bravura nor car-
nality. The work is in the tradition of Fragonard and Boucher, but it is given a painterly
spice that Manet might have admired.

Pierre Bonnard (1867–1947)

29. *The Young Woman*, 1901

29. PIERRE BONNARD

The Young Woman, 1901
Oil on canvas, 12¾ x 7¾ in. (32.4 x 19.6 cm)
Signed (lower right) *Bonnard*

PROVENANCE Ambroise Vollard (1867–1939), Paris; private collection, Paris; Sam Salz, Inc., New York; purchased from that dealer by Mr. and Mrs. Philip Levin, New York, December 1, 1969; The Philip and Janice Levin Foundation, 2001.

REFERENCE Dauberville and Dauberville 1965–74, vol. 1 (1888–1905), p. 248 (no. 248, as *La Jeune Fille à l'abondante chevelure*, ill.).

At first sight, this small painting is difficult to decipher. The image is grounded in Bonnard's early procedure of establishing an emphatic, interlocking pattern of light and shadow with little internal modulation or linear detail. Several influences flowed into Bonnard's practice as it evolved in the 1890s. The work of Paul Gauguin was paramount, as filtered through the theoretical and practical example of Bonnard's fellow Nabi artist Maurice Denis. Bonnard's own work as a designer in the experimental theater of Paris and his love of puppet plays; his absorption in the medium of photography, as crucial and alluring to him as it was to his great friend Édouard Vuillard; the impact of Japanese prints, with their silhouetting of figures in contrapposto, their forms cropped at the edges, and their use of aerial perspective to delineate the domestic world, particularly that of women—all of these influences fed a personal vision that fused often acute and amusing observations of life at home or in the streets of Paris with an increasing sense of impermanence and transitoriness. Direct though his observations may be—a woman crossing a street, the sudden turn of a head, a family of different ages and needs at a dining table—Bonnard invariably invests the scene with an indefinable recollection of what has gone before, of a *temps perdu*. He finds consolation for the passing of the moment by transfixing it on canvas in a vocabulary of great flexibility. This sense of the transitory is, paradoxically, a permanent characteristic of Bonnard's work of all periods.

Here, a young girl is seen in profile, her head inclined slightly toward the viewer. Her long, brown hair falls down her back and merges with her dark coat or cape, partly obscuring the lighter band of trim around its shoulders. She seems to be peering a little anxiously past the curtain of a window. It is the momentary glance, rather than any air of daydreaming, that has caught Bonnard's attention. Numerous questions arise in the viewer's mind. Is it still raining? Will the girl need her umbrella (and become the woman in the street in Bonnard's *The Cab Horse*; fig. 53)? Or is she waiting for someone to pass along the sidewalk or call at the house? Such anecdotal speculation is inviting but ultimately fruitless (although at this time Bonnard and Vuillard often gave semianecdotal titles to their works, such as *Waiting* or *The Widow's Visit*). We are not looking at some nineteenth-century storytelling painting of a young protagonist suspended in Tennysonian confinement or awaiting a visit from the

29.

Figure 53
Pierre Bonnard. *The Cab Horse,* ca. 1895. Oil on wood, 11¾ x 15¾ in. (29.7 x 40 cm). National Gallery of Art, Washington, D.C., Ailsa Mellon Bruce Collection (1970.17.4)

doctor. Bonnard's elusive, contemporary sensibility forbids such a "literary" reading. Nevertheless, a certain air of somber expectancy pervades the painting, through the very forms themselves, so sympathetically translated on so modest a scale.

No one familiar with Renoir's well-known street scene *La Place Clichy* of about 1880 (Fitzwilliam Museum, Cambridge; fig. 54) could fail to note the parallel in pose between the girl seen there in close-up profile and the girl in Bonnard's image. At the same time, the two paintings represent the world of difference that obtains between uncomplicated, Impressionist joie de vivre and Bonnard's understated anxiety.

Figure 54

Pierre-Auguste Renoir. *La Place Clichy,* ca. 1880. Oil
on canvas, 25⅝ x 21¼ in. (65 x 54 cm). Fitzwilliam
Museum, Cambridge (PD.44-1986)

Pierre Bonnard (1867–1947)

30. *Woman in a Blue Hat,* ca. 1903

30. PIERRE BONNARD
Woman in a Blue Hat, ca. 1903
Oil on canvas, 16½ x 21 in. (41.9 x 53.3 cm)
Signed (lower left) *Bonnard*

PROVENANCE The artist's family, by descent; Bernard W. Katz, United States, as of 1965; Wildenstein and Co., New York; purchased from that dealer by Mr. and Mrs. Philip Levin, New York, September 27, 1969; The Philip and Janice Levin Foundation, 2001.

REFERENCES Vaillant 1965, pp. 51 (color ill.), 225; Dauberville and Dauberville 1965–74, vol. 2 (1906–1919), p. 183 (no. 588, ill.).

The street life of the city of Paris is a major theme in Bonnard's early work, the subject of many paintings and of his captivating suite of lithographs *Quelques aspects de la vie de Paris,* published by Ambroise Vollard in 1898 (see fig. 55). His thematic precedent is to be found in paintings such as Renoir's *La Place Clichy* (fig. 54), in Degas's fractured image of Viscount Lepic and his daughters in the place de la Concorde (1875–77; State Hermitage Museum, Saint Petersburg), in Whistler's urban etchings and lithographs and Georges Seurat's *Circus Sideshow* (ca. 1887–88; The Metropolitan Museum of Art, New York). There are also easily discernible affinities with the work of Bonnard's friend Toulouse-Lautrec, above all in the relationship of performance to viewer in his paintings of Parisian nightlife and particularly his 1895 decorative panel for La Goulue's fairground booth (Musée d'Orsay, Paris; fig. 56). Bonnard was entranced by life on the sidewalk, by shopwindows, dogs, scuttling children, street performers, the shadow of an omnibus. He seizes on his subject, often disconcerting in its abridgement or in the odd angle from which he views it, and relates it, through interlocking rhythms and formal correspondences, to the tide of light that gives the overall image its buoyant movement. He rescues swift gestures and curious juxtapositions as one finds them in snapshots or film sequences. Sometimes he is witty with that characteristic visual malice found in so many French artists; at other times, as in the present painting, an inexplicable note of apprehensive isolation is touched upon when his passerby suddenly realizes that she is being observed.

The picture appears to be set in a public park or garden, with a bulwark of trees to the left and some synoptically suggested buildings to the right. A woman passes between the two spindly trees growing from the municipal gravel or paving at the left, her dark silhouette almost a reverse image of the girl who centrally confronts us, looming out of the background like a figure seen against another painting. This young Parisienne wears a wide-brimmed, dark blue hat (probably of velvet) and a striped, high-collared outdoor dress. She is not looking ahead of her, in the direction suggested by the angle of her figure, but turns her eyes to the left, beyond the viewer. She has an air of wariness, but, at the same time, she appears self-contained, not easily interrupted or intimidated. Adding to the scene's ambiguous mood is the livid light of the sky, suggesting a stormy dusk that darkens trees and buildings but just illuminates the

30.

Figure 55
Pierre Bonnard. *Street Corner (Coin de rue)*, from the portfolio *Quelques aspects de la vie de Paris*, 1898. Lithograph, sheet 16 x 21 in. (40.6 x 53.3 cm). S. P. Avery Collection, Miriam and Ira D. Wallach Division of Art, Prints and Photographs, The New York Public Library, Astor, Lenox and Tilden Foundations

Figure 56
Henri de Toulouse-Lautrec. *Panel for La Goulue's Booth at the Foire du Trône, Paris*, 1895. Oil on canvas, 9 ft. 9⅛ in. x 10 ft. 4⅛ in. (2.98 x 3.16 m). Musée d'Orsay, Paris

girl's cheek and nose. It is with slender material such as this, without emphatic narrative or a nudge to the viewer of how to respond, that Bonnard invests his acute observations with a vein of pure poetry. Here, perhaps, is a verse from a song by Francis Poulenc in all its wistful ambiguity.

Opposite: Detail, cat. no. 30

116

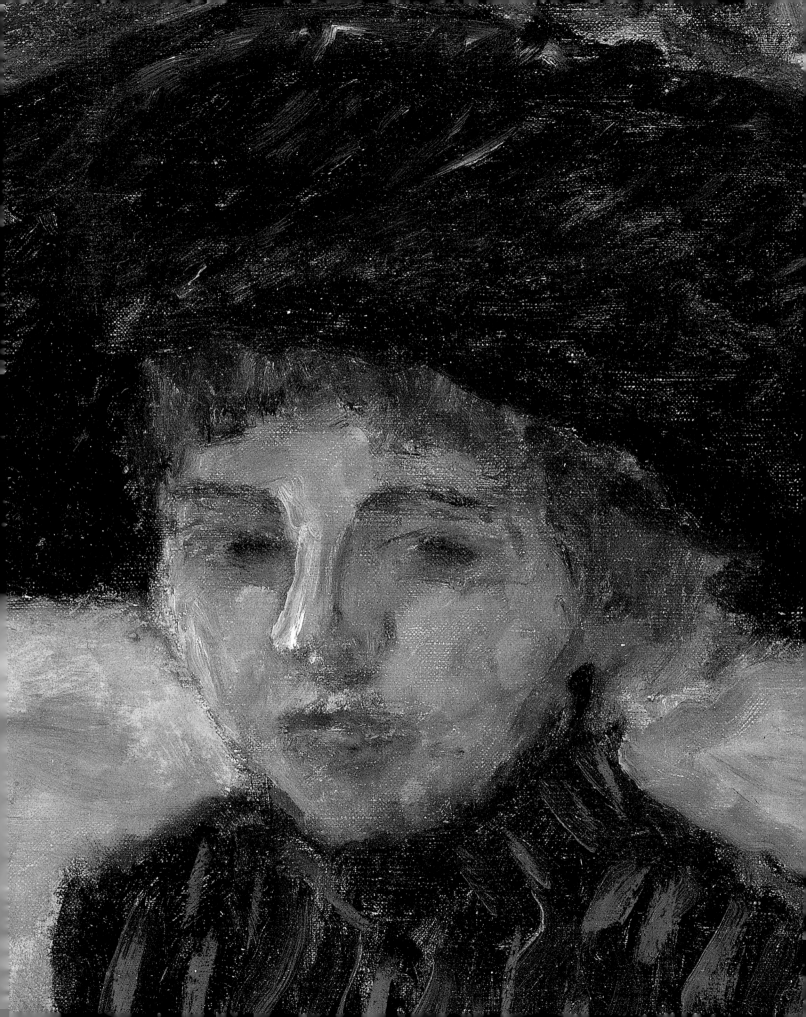

Pierre Bonnard (1867–1947)

31. *The Luncheon*, 1923

31. PIERRE BONNARD
The Luncheon, 1923
Oil on canvas, 16¼ x 24½ in. (41.3 x 62.2 cm)
Signed (upper right) *Bonnard*

PROVENANCE Galerie Bernheim-Jeune, Paris, acquired from the artist, 1923; purchased from that dealer by Knoedler and Co., 1927; repurchased from Knoedler by Galerie Bernheim-Jeune, Paris, 1930; purchased from Bernheim-Jeune by L'Art Moderne, Lucerne; Seligmann Galleries, New York; Stephen Carlton Clark (1882–1960), New York, 1931; given anonymously to the Museum of Modern Art, New York (acc. no. 453.37), 1937; deaccessioned by that institution by sale to Richard L. Feigen and Co., New York (stock no. 4913-B), April 21, 1971; purchased from that dealer by Mr. and Mrs. Philip Levin, April 21, 1971; The Philip and Janice Levin Foundation, 2001.

EXHIBITIONS Venice 1930, no. 99 (as lent by Bernheim-Jeune, Paris); New York 1934a; Boston 1938; Chicago 1938–39, no. 38; San Francisco 1939–40; New York 1940–41; New York 1944; New York 1945–47; Palm Beach 1948; Cleveland, New York 1948, pp. 99 (color ill.), 140 (no. 54); Syracuse, New York 1949; Boston 1950; New London 1950; Akron 1951; Boulder 1951; New York 1951–53; Lyons 1954, no. 61; New York 1954–55; Newport 1955; Sarasota 1956, no. 31; South Hadley 1956; Palm Beach 1957, no. 16; London 1966, p. 60 (no. 193).

REFERENCES Fage 1930, pl. 16; Barr 1948, pp. 38 (ill.), 301 (no. 74); Dauberville and Dauberville 1965–74, vol. 3 (1920–1939), p. 180 (no. 1214, ill.); Barr 1977, pp. 33 (ill.), 525 (no. 33).

Bonnard was forty-five years old when, in 1912, he purchased a small house named Ma Roulotte (My Caravan, or Trailer) in Vernonnet, a village across the river Seine from the small town of Vernon in Normandy, north of Paris. He retained accommodation and a studio in the capital but lived and worked at Ma Roulotte in the spring and summer. He shared his life with Maria Boursin (1869–1942), known as Marthe, whom he had met in 1893 and whom he married in 1925. She is, of course, best known as the nude figure lazily washing and bathing herself in innumerable paintings and drawings—a regime of ablutions that was, in fact, dictated by her increasingly precarious health. Although these and many other images of her suggest a life of chic indolence, she still managed to be an attentive housekeeper at Ma Roulotte and, later, at the Bonnards' second home in the south of France, Le Bosquet, at Le Cannet near Cannes. In Bonnard's interior views of these two houses, she is often the quietly presiding figure, a ghostly presence hovering at the edge of a room, passing across a doorway, or glimpsed, with a cat or dachshund in her lap, in a chair beyond the main motif of a painting. At other times, as here at the dining table, she is a vivid and tangible presence.

A family or group of friends at lunch or dinner is one of the key subjects of the Nabis, the loose association of painters formed in the 1890s that included Édouard Vuillard, Félix Vallotton, Maurice Denis, and Bonnard himself. The subject gave these artists the opportunity to explore several components of their aesthetic vocabulary—close interiors, overlapping figures, different light sources (windows, overhanging lamps), and, of course, still life in relation to people. Claude Monet's *The Dinner* of about 1868–69 (Foundation E. G. Bührle Collection, Zürich; fig. 57) set a precedent for these *intimiste* scenes. But where Vallotton or Paul Signac, the Pointillist contemporary of the Nabis, might introduce the sharp flavor of social or psychological observation, Bonnard and Vuillard are more concerned with gesture, odd formal relations, and the diverse coloristic feast offered by a laden table. Bonnard often goes further and introduces a personal note in his eloquent evocation of mood, frequently through the inimitable self-absorption of Marthe, with her particular demeanor expressive of a kind of fatigued delight in the French ritual of a perfectly prepared, swiftly consumed lunch.

The round table in the small dining room of Ma Roulotte (in contrast to the large, oblong table in the more spacious dining room at Le Bosquet) is the subject of

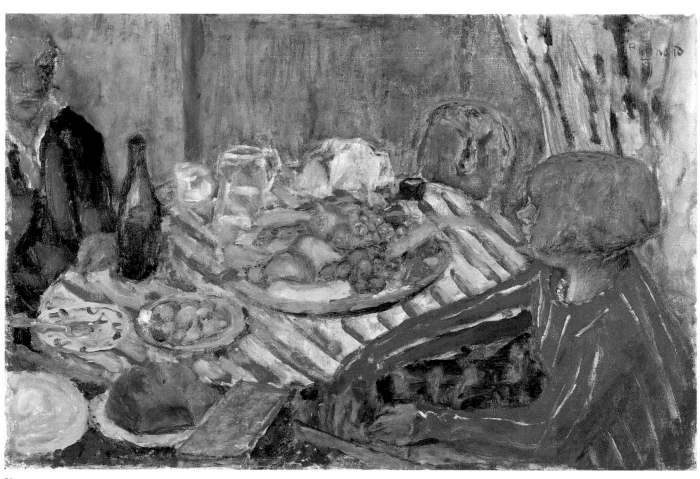

31.

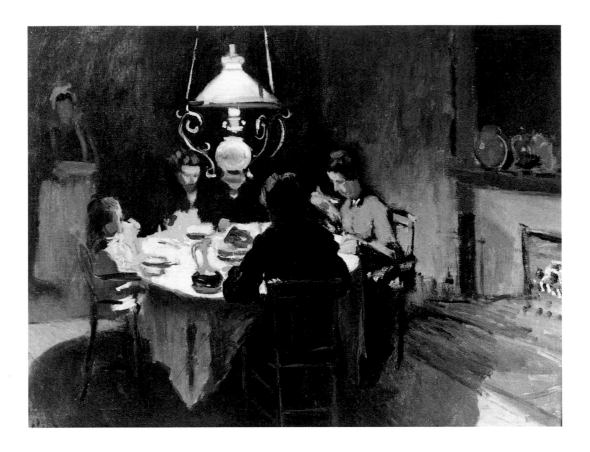

Figure 57
Claude Monet. *The Dinner*, 1868–69. Oil on canvas, 19⅞ x 25¾ in. (50.5 x 65.5 cm). Foundation E. G. Bührle Collection, Zürich

this painting, the quintessence of Bonnard in the 1920s. It is seen from above and from behind a serving table or sideboard that forms a red triangle at the lower left—the type of viewpoint often adopted by Bonnard. Marthe looks toward the subdued, casually dressed man on the far side of the table (almost certainly Bonnard himself). Her bobbed hair and striped red blouse are familiar from several other paintings of the early 1920s, especially *Woman with Dog* of 1922 (The Phillips Collection, Washington, D.C.; fig. 58). Lunch, it seems, is over: a napkin is crumpled at the table edge and the plate and spoon have been pushed aside. Should the couple have coffee here or on the veranda? What are their plans for the afternoon? So often such suggestions of day-to-day dialogue hover over the surface of Bonnard's paintings.

The picture's gently sloping direction from top left to lower right, emphasized by the striped cloth, is abruptly halted by Marthe's right arm casually poised along the table edge; the dark fall of the tablecloth glimpsed between her arms balances the red segment of side table. Such formal compression of an apparently random scene and a generally warm palette characterize Bonnard's small-format domestic interiors of the 1920s. This one was painted in the studio, almost certainly from pencil notations and studies.

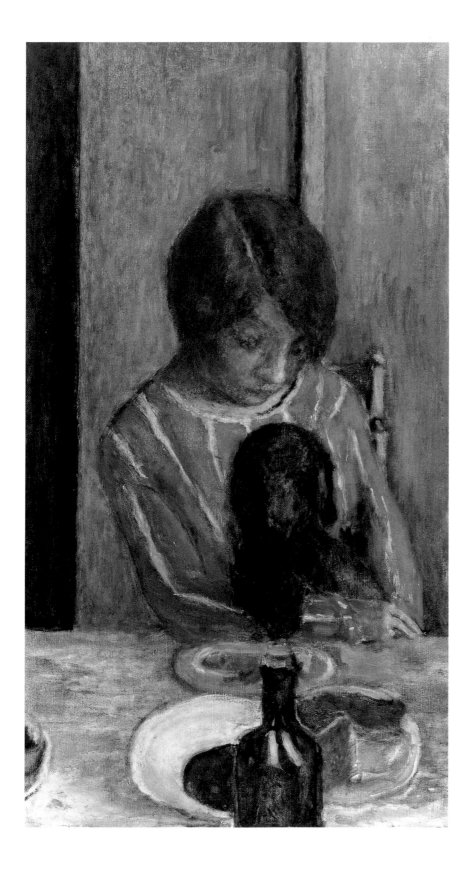

Figure 58
Pierre Bonnard. *Woman with Dog,* 1922.
Oil on canvas, 27¼ x 15⅜ in. (69.2 x 39.1 cm).
The Phillips Collection, Washington, D.C.

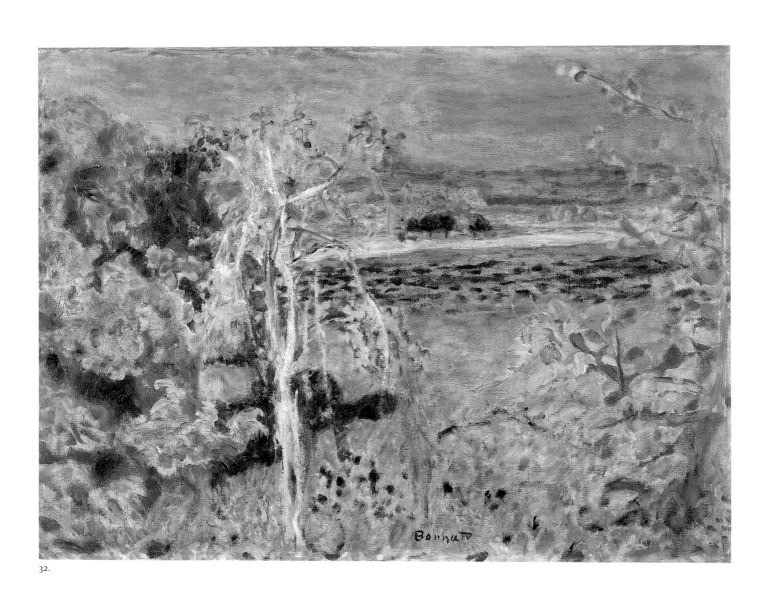

32.

Pierre Bonnard (1867–1947)

32. *The Seine at Vernon,* 1927

32. PIERRE BONNARD
The Seine at Vernon, 1927
Oil on canvas, 19¾ x 26⅞ in. (50.2 x 68.2 cm)
Signed (bottom, right of center) *Bonnard*

PROVENANCE Galerie Bernheim-Jeune, Paris,
until after 1935; Sam Salz, Inc., New York, 1948–49;
Nate B. Spingold (1886–1958) and Frances Spingold;
given by her to The Metropolitan Museum of Art,
New York (acc. no. 1959.168), 1959; deaccessioned
by that institution by sale, Sotheby's, New York,
May 18, 1983, no. 49 (color ill.); purchased at that
sale by Janice H. Levin, New York; The Philip and
Janice Levin Foundation, 2001.

EXHIBITIONS Pittsburgh 1930, no. 213; Cleveland
1931, no. 39; New York 1934b, no. 34; Palm Beach
1957, no. 23; New York 1960b, p. [1].

REFERENCES Sterling and Salinger 1955–67, vol. 3
(*XIX–XX Centuries*), p. 209 (ill.); Dauberville and
Dauberville 1965–74, vol. 3 (1920–1939), p. 297
(no. 1366, ill.).

Bonnard's country home Ma Roulotte (see cat. no. 31) was a short walk from the Seine. The modest house, with a gravel terrace to one side and a garden sloping down to the river, was distinctive for its second-floor veranda, which stretched along the width of the front and around the side of the house and was reached by a flight of wooden steps. This structure afforded wide views of the Seine as it made its way through the lush surrounding country. Behind the house, a hillside provided more panoramic views, and Bonnard could also look back down onto Ma Roulotte and its neighboring farm. (The house still exists in private ownership; both it and the nearby landscape are surprisingly unchanged.)

The Seine in this part of Normandy is associated with numerous artists— Monet, for example, Bonnard's neighbor and friend, was just a few miles away at Giverny—but its banks at Vernon and Vernonnet belong to Bonnard. He never tired of painting and drawing the view of the river from his veranda (which sometimes enters the composition, rather like a theater box or balcony from which one looks at the stage). He depicted its flow and its gleaming stillness, the changing reflection of the sky in its water, and the complement of passing barges and tugboats, animating the scene with color and puffs of smoke. Some of his small pencil drawings are miracles of succinct observation of light, air, tone, and movement.

Bonnard was essentially a painter of the human figure and of the interiors and gardens and streets in which people spend their lives. But landscape, seen through open doors and windows and beyond cultivated gardens in the countryside, permeates his work. Pure landscape is relatively rare in his painting, especially one such as this, without a vestige of people or buildings. It belongs to the later 1920s, when Bonnard worked on a series of large Normandy landscapes that are often sharply lit and in which, over the whole field of the canvas, large masses of vegetation are contrasted with wandering linear elements that take one's eye through the composition. "In every landscape," Bonnard said late in life, "there must be a certain amount of sky and earth, water and greenery, a proportion that you cannot always establish at the beginning."[1] Preliminary pencil drawings and finished canvases show the extent of Bonnard's re-creation of observed scenes.

The present work, more modest in scale than other landscapes of the later 1920s such as *Landscape in Normandy* (fig. 59), is straightforwardly composed in Bonnard's enframing manner: two outer wings of trees and foliage contain the distance like painted flats at either side of a stage (a feature seen at its most theatrical in *Earthly Paradise* of 1916–20; The Art Institute of Chicago; fig. 60). It is the sort of relaxed but carefully planned view that Bonnard inherited from the generation before him—that of Monet, Pissarro, and Sisley. One thinks particularly of Sisley along the rivers Seine and Loing near Moret-sur-Loing, viewing the water through copses and undergrowth and often introducing, as Bonnard does here, the vertical of a nearby tree trunk to offset the recession of horizontals leading toward the sky. In the Bonnard, all is early-summer freshness of variegated greens and blues, the dashes and curls of the vegetation echoed in the cobalt blue patches of the breeze-ruffled Seine.[2]

1. "Propos de Pierre Bonnard à Tériade (Le Cannet, 1942)," *Verve* 5, nos. 17–18 (August 1947), n.p.
2. A very similar composition is *Tugboat at Vernon* of 1929 (Dauberville and Dauberville 1965–74, no. 1411).

Kees van Dongen (1877–1968)

33. *The Parisienne,* 1904

Of all the artists who flocked to Paris around 1900 to form the international, polyglot École de Paris, Kees van Dongen, born in Rotterdam, was one of the most prominent and brilliant. He was quick off the mark, an alert magpie among all the aesthetic choices on offer. His earliest works, once he had installed himself in Montmartre in late 1899, record the popular view of Paris as a city of louche entertainment and fashionable boulevards, of cabarets and dance halls, with all their possibilities of encounters and assignations. He took to this side of Parisian life with the wide-eyed enthusiasm of any adventurous foreign visitor but was soon a well-known habitué of his quarter (his great height and red beard made him a conspicuous figure). His modest paternal allowance was supplemented by a variety of jobs, and his graphic talent earned him a living from the numerous illustrated newspapers and magazines of the time. He shared that activity, and source of income, with several artists, such as Frantisek Kupka and Juan Gris, who were later to make significant contributions to modernism in Paris.

At first, Van Dongen fused influences from the realist Hague School in his native Holland with the recent French illustrative tradition of Théophile-Alexandre Steinlen and Jean-Louis Forain, the example of the Nabi artists, such as Félix Vallotton, and, above all, that of Toulouse-Lautrec (who died in 1901). At the same time, there are notable affinities in his graphic style with that of the young Picasso and his Catalan friends in Paris. Van Dongen's work appeared in the magazine *Frou-Frou,* in which Picasso had published drawings in 1901, and he made regular contributions to *Gil Blas* (a Bonnard-like cover in 1902, for example), to *La Revue blanche,* and to the famous art and literary journal *L'Assiette au beurre.* For the most part, his drawings were low-life or bohemian in subject (though there were also studies of fashionable crowds at the Paris Opéra, a taste of Van Dongen's future direction) and were wittily observant rather than sharply caricatural. Alongside his illustrative work, he was painting figures and landscapes with a synoptic line and muted color range; their merit was recognized by the great dealer Ambroise Vollard, who gave the young Dutchman his first solo show in 1904.

The present work, which may have been included in the Vollard exhibition, shows all of Van Dongen's élan and obvious enjoyment of the milieu into which he had plunged. His stylishly dressed Parisienne sits across a cane chair with an air of

33.

33. KEES VAN DONGEN

The Parisienne, 1904

Oil on cardboard, 16¼ x 11½ in. (41.3 x 29.2 cm)

Signed (lower left) *van*[indistinct] *Dongen* / 04

PROVENANCE Ambroise Vollard (1867–1939),
Paris; Marquise de Galéa; S. Dinine, Paris; Jean-
Claude Bellier et Cie., Paris; purchased from that
dealer by Janice H. Levin, New York, October 9,
1979; The Philip and Janice Levin Foundation, 2001.

EXHIBITIONS Possibly Paris 1904; Paris n.d.

Figure 61

Kees Van Dongen. *Le Moulin de la Galette,* or
La Matchiche, 1904. Oil on canvas, 25⅝ x 21¼ in.
(65 x 54 cm). Musée d'Art Moderne, Troyes,
Donation Pierre et Denise Lévy

almost provocative contempt—a look both challenging and disdainful. It is a brief,
unfinished sketch, but it illustrates the coming together of Van Dongen's graphic style
and his new interest in a higher register of color, as can also be seen in a more com-
plete painting of 1904, the high-spirited *Le Moulin de la Galette* (Musée d'Art Moderne,
Troyes; fig. 61). These two elements quickly came to fruition in the following year,
when his painting was transformed under the influence of Fauvists such as Maurice
de Vlaminck and, to some extent, Matisse. With a raw, ringing palette and crude
facture, Van Dongen had arrived. From 1905 to the years just before World War I, his
portraits and figures, especially circus performers and dancers, take a distinctive place
beside the creations of Raoul Dufy, André Derain, Othon Friesz, and Vlaminck. A dec-
ade or more later, however, worldly success and a formulaic manner, particularly in
society portraits, had ensured him great social repute but a dwindling respect for his
art (even by 1910, Guillaume Apollinaire, who had admired Van Dongen's audacious
color, was complaining of his descent into vulgarity). His contribution to the Fauvist
period remains his primary claim on our attention, in spite of attempts in recent years
to upgrade his later work. Fortunately, *The Parisienne,* with its verve of handling and
quintessential subject, captures him at a perfect moment.

34.

André Derain (1880–1954)

34. *Plate of Peaches,* ca. 1903–4

34. ANDRÉ DERAIN
Plate of Peaches, ca. 1903–4
Oil on canvas, 7¼ x 9⅜ in. (18.4 x 23.8 cm)
Signed (on reverse) *Derain* [followed by
indistinct number: 9(?)]

PROVENANCE Galerie Marseille, Paris; "La Peau
de l'Ours" collection [La Peau de l'Ours was a con-
sortium of collectors of contemporary art active
for ten years (1904–14) and led by André Level; for
further information, see Guy Habasque, "Quand
on vendait La Peau de l'Ours," *L'Oeuil,* no. 15 (March
1956), pp. 16–21]; that consortium's sale, Hôtel
Drouot, Paris, March 2, 1914, no. 10; purchased at
that sale by Percy Moore Turner, London; Browse
and Darby, London, by 1980; purchased from that
dealer by Richard L. Feigen and Co., New York, May
16, 1980; purchased from that dealer by Janice H.
Levin, New York, June 5, 1980; The Philip and Janice
Levin Foundation, 2001.

EXHIBITION London 1979, no. 6 (color ill. on
cover).

REFERENCE Kellermann 1992–99, vol. 1
(1895–1914), p. 167, no. 275 (as *Nature morte aux
fruits,* ill.).

Some fruit on a plate is among the handful of canonical still-life subjects of early modernism, taking its place alongside depictions of bottles and glasses, playing cards, newspapers, and guitars or mandolins. Its immediate derivation is, of course, from the work of Paul Cézanne: in the presence of Derain's intense little painting, it is hard not to call to mind several of Cézanne's still lifes, especially the small canvas of seven apples that was once in Degas's collection (ca. 1877–78; Keynes Collection, King's College, University of Cambridge; fig. 62). Throughout his life, Derain was one of the most eclectic and learned of French painters, playing one artist's work or stylistic movement off another, absorbing and synthesizing disparate styles with a rapidity comparable to that of his friend Picasso. But there is no lack of originality: although we can detect the example of Cézanne as well as of Gauguin in this work, it is unmistakably Derain's. Even at this early stage in his career, we find his habitual gravity and seriousness of purpose.

From the fall of 1901 to September 1904 Derain's youthful development as an artist was interrupted by compulsory military service, and painting had to wait for periods of leave between the rigors and boredom of barracks life. Intellectually, however, he was by no means dormant, as is demonstrated in many letters to his close friend Maurice de Vlaminck. Derain's reaction against the transitory observations and fleeting effects of early Impressionism was already under way. He was convinced that the later work of Cézanne and Gauguin was the way forward and resolved to make paintings that were constructed and emphatic, that went beyond the quotidian and were marked by an expressive, even arbitrary, rather than naturalistic range of color. The present work relates to, though it is not a specific study for, a large and elaborate still life of 1904 (private collection, Paris), which was a tribute to Cézanne (then becoming a hero for artists of Derain's generation) as well as a projection of Derain's understanding of the work of Matisse, whom he already knew and admired.[1] The large still life contains two dishes and two compotiers holding fruit, set among an array of bottles, jugs, tureens, and plates. At a vertiginous angle on the right, a shallow dish in shadow holds two brilliantly colored peaches. This detail seems to have been developed from the present work, which shows three curvaceous peaches in a strongly lit dish that is cropped at both left and right. The fruits' interlocking forms and palpable

Figure 62

Paul Cézanne. *Still Life with Apples,* ca. 1877–78.
Oil on canvas, 7 ½ x 10 ¼ in. (19 x 26 cm). Keynes
Collection, King's College, University of Cambridge;
on loan to the Fitzwilliam Museum, Cambridge

Figure 63

André Derain. *Still Life with Apples,* ca. 1907–8. Oil
on canvas, 15 x 18⅛ in. (38 x 46 cm). Musée d'Art
Moderne, Troyes, Donation Pierre et Denise Lévy

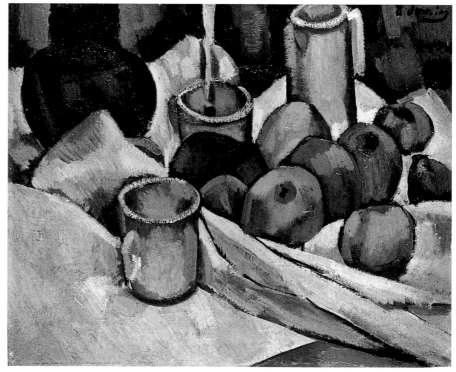

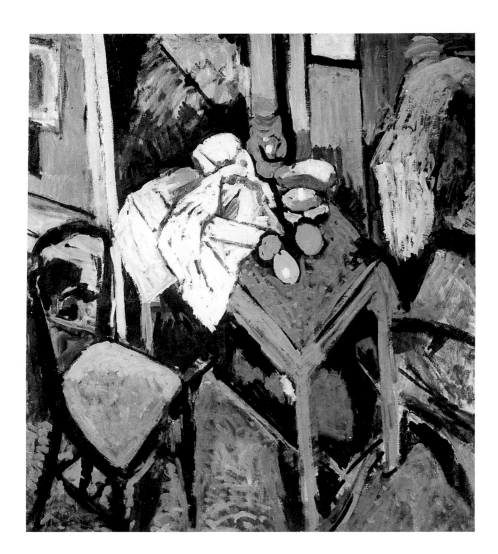

Figure 64
André Derain. *The Table*, 1904–5. Oil on canvas, 37 x
33½ in. (94 x 85 cm). Foundation E. G. Bührle
Collection, Zürich

realization are emphasized by the white dish, which, as we can see from the contours, was painted after the fruit and the segmented background, in confident brushstrokes of cool whites, blues, and grays.

The relative sobriety of this painting was soon eclipsed, however, and eighteen months later, by the time of Derain's substantial still life *The Table* of 1904–5 (Foundation E. G. Bührle Collection, Zürich; fig. 64), with its central motif of fruit, vibrant, rushing brushstrokes and electric color have replaced his earlier restraint. The stage was now set for Derain's and Matisse's triumphant Fauvist outpouring at Collioure in southwestern France in the summer of 1905.

1. Another still life of the same period, of apples and pots on a crumpled cloth, is also close to the present work in its Cézannian subject and high viewpoint (*Still Life with Apples*; Musée d'Art Moderne, Troyes; fig. 63).

Pablo Picasso (1881–1973)

35. *Head of a Jester,* cast ca. 1925 after composition of 1905

35. PABLO PICASSO
Head of a Jester, cast ca. 1925 after composition
of 1905
Bronze with black patina, h. 16½ in. (41.9 cm)
Signed (on back) *PICASSO*

PROVENANCE Ambroise Vollard (1867–1939),
Paris; purchased from that dealer by Monsieur
Martini, Paris, ca. 1925; acquired from him by
Galerie de l'Elysée (proprietor Alex Maguy), Paris,
ca. 1955; Mr. and Mrs. O. Roy Chalk, by October 5,
1963; their sale, Christie's, New York, May 16, 1990,
p. 110 (no. 39); purchased at that sale by Janice H.
Levin, New York; The Philip and Janice Levin
Foundation, 2001.

REFERENCES Other casts: Zervos 1932–78, vol. 1
(*Works from 1895 to 1906*), pp. 148 (ill.), xliii (no. 322);
Kahnweiler 1948, pp. [2] (as *Harlequin*), [9] (no. 2),
fig. 2; Penrose 1967, pp. 52 (ill.), 221 (no. 5); Johnson
1976, pp. 165 (no. 5), 202 (figs. 27, 28); Spies 1971,
pp. 17–18, [35] (fig. 4), 301 (no. 4); Spies 2000, pp. 23–
24, [27] (pl. 4, color), 334 (nn. 63–65), 335 (nn. 74–77),
346 (fig. 4), 394 (no. 4).

Head of a Jester is one of the earliest and most obviously traditional of Picasso's sculptures: modeled in clay and later cast in bronze, it takes the familiar head-and-shoulders format of the European portrait bust. The features of the man portrayed were originally based on those of the poet Max Jacob, one of Picasso's intimate friends during his early years in Paris. Although the likeness was transformed as Picasso worked on the head, the suggestion remains of Jacob as one of the entertainers in Picasso's circle of friends (the role of court jester-in-chief went to another poet, Guillaume Apollinaire). It is recorded that Picasso and Jacob attended a performance of the famous Cirque Médrano one day in 1905 and that Picasso began the bust that evening with some clay he had to hand in his studio. The work was finished, it seems, in the studio of Paco Durrio, a sculptor and jewelry maker from the Basque region whom Picasso had met in 1900, the year of his first visit to the French capital. The initial likeness to Jacob was subsumed in a more generalized male physiognomy, but it is interesting to note a definite resemblance between the jester and the red-suited figure in the painting *Acrobat and Young Harlequin* (Barnes Foundation, Merion, Pa.; fig. 65), also of 1905. The acrobat of the title is almost certainly a jester, wearing the same typical pointed hat as is found in the sculpture. All through 1905 Picasso was obsessed with strolling players—*saltimbanques*—and with circus performers such as acrobats and strongmen. In a series of works, he evolved an almost idealized troupe of such characters, in some measure akin to Gauguin's groups of Tahitian figures in the outdoors, themselves partly indebted to Puvis de Chavannes. Picasso emphasizes the strength and grace of his players but rarely constructs any narrative situation. They are eternally trapped in a melancholy that is both pervasive and inexplicable—so much so that the poet Rainer Maria Rilke, inspired by the *Family of Saltimbanques* of 1905 (National Gallery of Art, Washington, D.C.; fig. 66), began the fifth of his *Duino* elegies with "But tell, who *are* they, these wanderers, even more transient than we ourselves...." The often dusty and pale colors of this period of Picasso's work—grays, pinks, and powder blues, with touches of subdued red—add immeasurably to the plangent atmosphere. The bronze sculpture, lacking color and modeled in a lively, Rodinesque manner, makes a more direct impression of playful intelligence.

Picasso's early sculptural output is slender as compared with his creative outpouring in this medium from the late 1920s onward. *Head of a Jester* and a few other

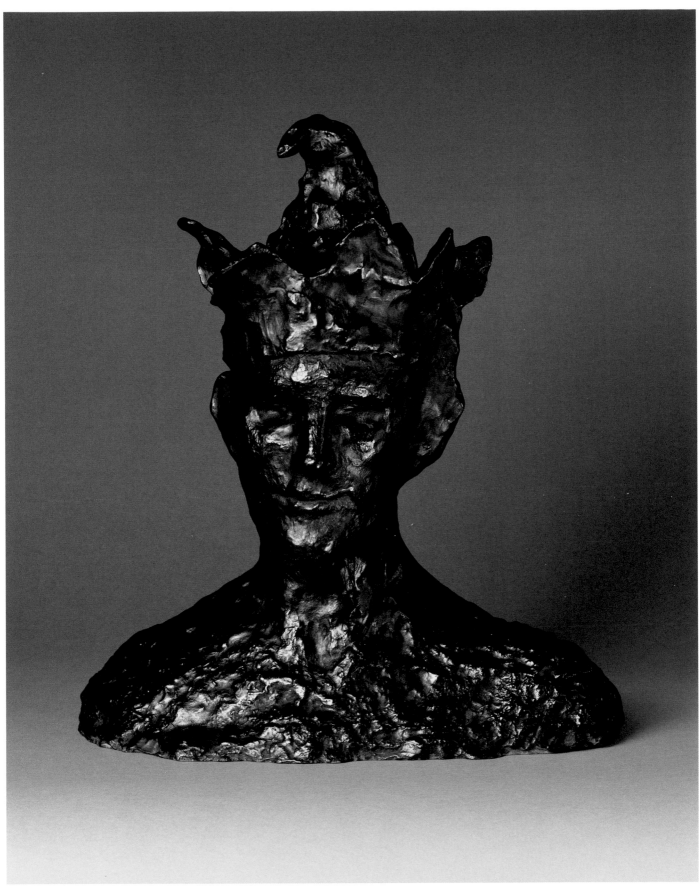

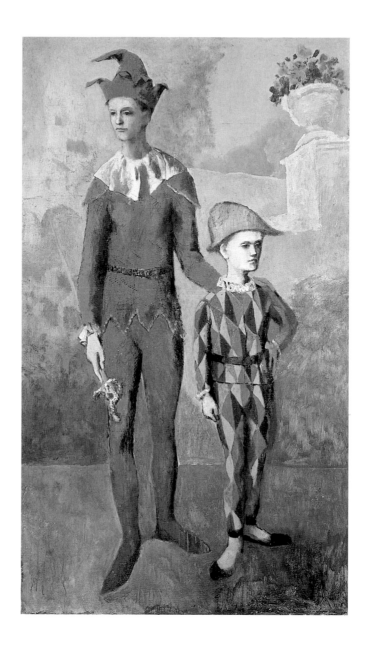

early heads and figures are precious records of the first stirrings of the artist's passion for working in three dimensions. As early as 1902 he had made a drawing of a woman in the shape of a jug, almost certainly inspired by Gauguin's figurative ceramic vessels. The present work belongs to a small group of busts that also includes a head-and-shoulders portrait of Alice Derain (wife of the painter) and another of Picasso's lover Fernande Olivier.

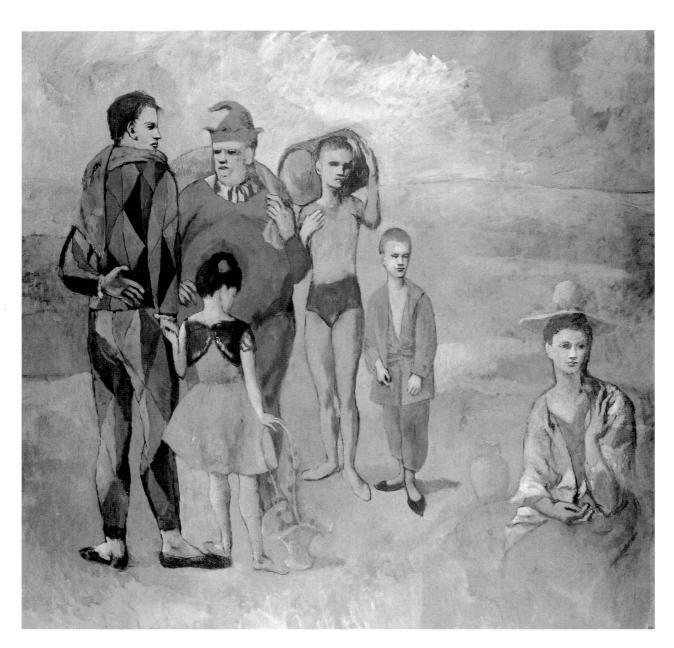

Figure 66

Pablo Picasso. *Family of Saltimbanques*, 1905.

Oil on canvas, 83¾ x 90⅜ in. (212.8 x 229.6 cm).

National Gallery of Art, Washington, D.C.,

Chester Dale Collection (1963.10.190)

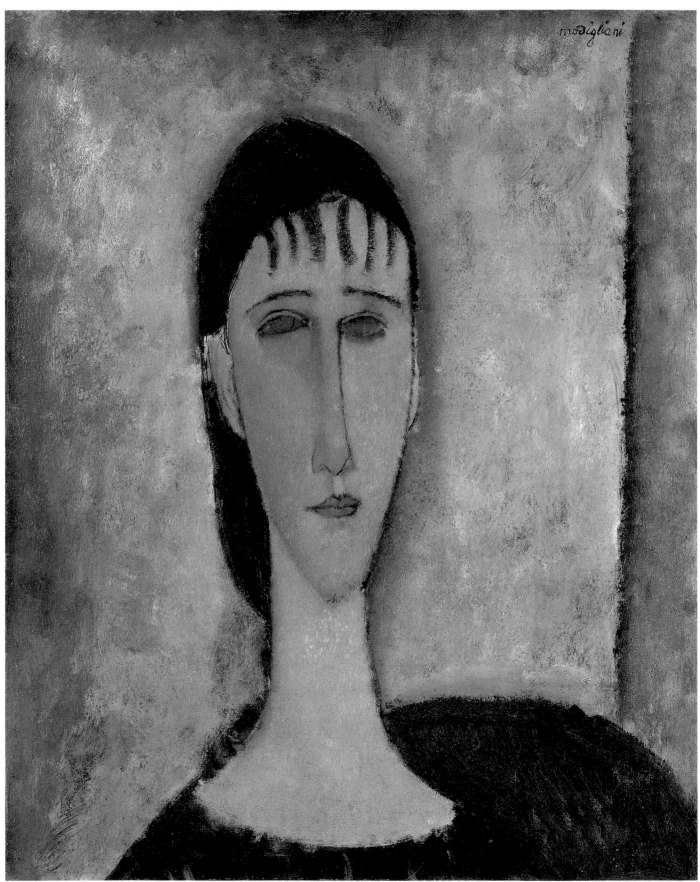

36.

Amedeo Modigliani (1884–1920)

36. *Head of a Woman,* ca. 1918

36. AMEDEO MODIGLIANI
Head of a Woman, ca. 1918
Oil on canvas, 21½ x 17 in. (54.5 x 43.2 cm)
Signed (upper right) *Modigliani*

PROVENANCE Léopold Zborowski, Paris, almost
certainly purchased from the artist's estate; pur-
chased from that dealer by Alex Reid and Lefevre,
London (stock no. 224/28), October 18, 1928; pur-
chased from that dealer by Gordon Small, March 5,
1929; Gordon Small Charitable Trust; that trust's
sale, Christie's, London, June 27, 1978, no. 54 (color
ill.), for £88,000; Marion O. Hoffman Trust; that
trust's sale, Sotheby's, New York, May 15, 1984,
no. 47 (color ill.); purchased at that sale by Janice H.
Levin, New York; The Philip and Janice Levin
Foundation, 2001.

EXHIBITIONS London 1929, no. 20; Edinburgh
1937, p. 11 (no. 9); London 1943, no. 16; Edinburgh
1961; Edinburgh 1969, no. 41 (color ill. on cover).

REFERENCE Lanthemann 1970, pp. 125 (no. 257),
228 (fig. 257).

If Modigliani's work had not existed, the course of twentieth-century art would have been no different. But if Modigliani himself had not existed, then Hollywood would have had to invent him. As painter, sculptor, and draftsman, he made a unique contribution to art, and his work is universally recognized by the curvilinear, elongated style of his portraits and female nudes (though it does not, in fact, inform all of his works). The elegance of his drawing, as we know from his imitators, can easily subside into facile repetition. But Modigliani's racehorse sensitivity, and the tension under which he worked, have ensured that his handful of masterpieces have retained their absorbing personal allure. His refinement is nearer to that of the early Sienese masters (sculptors as well as painters) and the Virgins of Duccio that he studied in his native Italy than to the streamlined Art Deco of the 1920s, a movement that appropriated much from his stylizations. He was affected by the various manifestations of Fauvism and Cubism current during his years in Paris (from his arrival there in 1906 to his death in 1920), but he did not contribute to them directly and belonged to no group. The singularity of his work and the personal excesses of his life have placed him beside such colorful contemporaries as Maurice Utrillo, Chaim Soutine, Georges Rouault, and even the particularly flavorsome charms of Fujita. But his immense popularity for the thirty or forty years after his death led to his being overrated, much faked, and, in books and films, mythologized. At present, however, he is perhaps underrated—a situation not helped by the number of dubious works attributed to him in both salesrooms and museums.

The essentials of Modigliani's style in portraiture were already established in his sculpture of 1910–11, when he was influenced by, among others, Constantin Brancusi. The head is elongated; the eyes are almond-shaped and sharply cut at the corners and the bridge of the nose; the mouth is invariably small and pinched, but not thin; the hair is smoothly simplified; the facial features are positioned around a long, magisterial nose. The head is poised on an equally exaggerated, cylindrical neck carried out with minimal modeling. In his painting, this particular configuration reaches its mannerist apogee in his last three years. Before that, there is a surprising variety, and Modigliani, it should be noted, also painted broad and rounded heads and bulky torsos, as in his portraits of such fellow artists as Henri Laurens, Soutine, and Diego Rivera. All these earlier works are executed in a lively, brushy, dabbed and spotted

style that gradually resolved, in about 1917, into a smoother, more regular application of paint and a fine differentiation of touch and brushwork. For Modigliani, the portraits of Cézanne remained a compositional touchstone in their characteristically tilted frontality and their simplicity of setting.

In spite of an increasingly self-destructive lifestyle in his last two or three years, Modigliani remained highly productive and by no means repetitive. Much of his penultimate year of work, from the spring of 1918 to May 1919, was spent in the south of France. He was not alone—his lover Jeanne Hébuterne was with him (and gave birth to their daughter in November)—and he had the companionship as well of Léopold Zborowski, the poet and dealer who was his friend and protector, and Zborowski's wife, Anna. There were also visitors such as Soutine, who was himself painting superbly in Cagnes, the hilltop village close to the Mediterranean where Modigliani had spent his first months before moving on to nearby Nice.

The model for the present portrait has not been identified, but some circumstantial and visual evidence points to Anna Zborowska (née Hanka Cirowska). It is well known that she was one of Modigliani's favorite and most patient models, particularly in 1917–18 (a near-full-length portrait of her from 1917 is in the Museum of Modern Art, New York). The Zborowskis were with Modigliani in the south of France for a considerable period, and early labels on the back of this portrait are inscribed "Nice 1918." Another portrait of Anna from about the same time, in the Nasjonalgalleriet, Oslo, is strikingly close to the present work, notably in the hairstyle (with the same six-part fringe), the dark, sober neckline of the dress, and the chalky, subdued background (see fig. 67). Both paintings are suffused with the model's tranquil hauteur, even a wary tolerance (Anna Zborowska's devotion to Modigliani was not quite as self-sacrificing as was her husband's). But such an identification can only remain a suggestion. Whoever the model, the modestly scaled portrait is self-contained and hieratic—an effect emphasized by the eyes (paler than in the named portraits of Anna), which give little away. The fringe alone adds a note of contemporaneity and detail to an otherwise timeless image. The vertical band of wall at the right—a Cézannian tic in Modigliani's work—suggests the confined position of the model and the artist's proximity to her and exemplifies the spare simplicity of Modigliani's final phase.

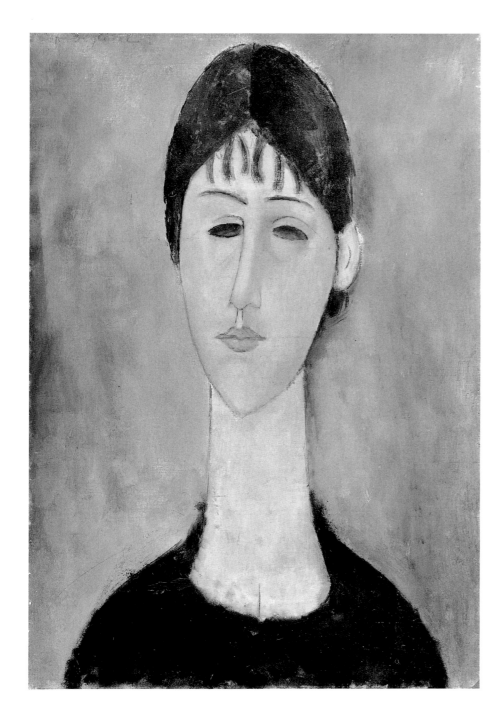

Figure 67
Amedeo Modigliani. *Portrait of Madame Zborowska,*
ca. 1918. Oil on canvas, 21⅝ x 15 in. (55 x 38 cm).
Nasjonalgalleriet, Oslo (NG.M.02128)

Alberto Giacometti (1901–1966)

37. *Bust of Diego,* cast ca. 1981 after composition of 1954

37. ALBERTO GIACOMETTI

Bust of Diego, cast ca. 1981 after composition of 1954
Patinated bronze, h. 10½ in. (26.7 cm)
Signed and numbered (on base) *A. Giacometti 8/8;*
foundry mark (on back) *Susse Fondeur / Paris;*
foundry stamp (on interior) *SUSSE FONDEUR /
PARIS / CIRE PERDUE*

PROVENANCE Possibly Galerie Maeght, Paris;
sale, Sotheby's, New York, November 13, 1996,
no. 320 (color ill.); purchased at that sale by Janice
H. Levin, New York; The Philip and Janice Levin
Foundation, 2001.

REFERENCES Other casts: The Hague 1986, pp. 98
(fig. 26, color), 117 (no. 26); Malmö 1994–95, pp. 116
(ill.), 222; Lugano 1995, p. 26 (no. 5, color ill.);
Munich 1997, p. 145 (no. 87, color ill.); Frankfurt
1998–99, pp. 60 (fig. 35), 330 (no. 35); Bologna 1999,
pp. 99 (fig. 25), 143 (no. 25); Norwich, Lausanne
2001–2, pp. 87, 88 (fig. 47, color), 89 (fig. 48, color),
154 (nos. 47, 48).

That the two most recent works in the Janice H. Levin Collection—though separated by over three decades—are by Modigliani and Giacometti accidentally reveals some interesting parallels between the two artists. Although extraordinarily different in character and manner, both were Italian-speaking residents of Paris, for whom French was a second language; both were sculptors first and painters second; both led legendary lives; and both developed a particular style in their realization of the human figure that is recognized around the world. The two works illustrated here and on page 136 are head-and-shoulders portraits, the Modigliani striving toward a sculptural definition through a series of interlocking curves, and the Giacometti assuming over its surface a painterly re-creation of form. Both achieve a vivid human presence without an overly detailed psychological reading, and both have, in their distinct ways, an elegance that has become representative of their respective periods.

In his early teens, before World War I, Alberto Giacometti made what appears to have been his first portrait of his younger brother Diego (1902–1985), modeled in plasticine. But it was not until about twenty-five years later that Diego again posed for his brother. By then they were constant companions, living in Paris at 46, rue Hippolyte-Maindron, just south of Montparnasse station. This ramshackle abode remained Giacometti's studio and living quarters until his death, although he still regarded the family house in Stampa, in southern Switzerland, as "home." In the 1930s Diego had collaborated with his brother on articles of interior design—vases, lampstands, furniture—for the decorator Jean-Michel Frank and on some remarkable modern jewelry for the couturiere Elsa Schiaparelli. Thereafter, Diego helped his brother with much of the practical side of his sculpture, by making armatures for plaster models and seeing works through the bronze-casting process. He also sat for him on a regular basis, for sculpted heads, drawings, and paintings—some in close-up, some as a seated figure in the studio (as in the paintings *Diego Seated* of 1948 and *Diego* of 1950, both of which are in the Sainsbury Centre for Visual Arts, University of East Anglia, Norwich [see fig. 68]; and in the 1964–65 bronze *Diego Seated,* an example of which is in the Louisiana Museum of Modern Art, Humlebæk, Denmark).

Diego was remarkable-looking. A photograph taken in 1952 of the two brothers (along with Alberto's wife, Annette) in the Paris studio shows Diego's comparatively

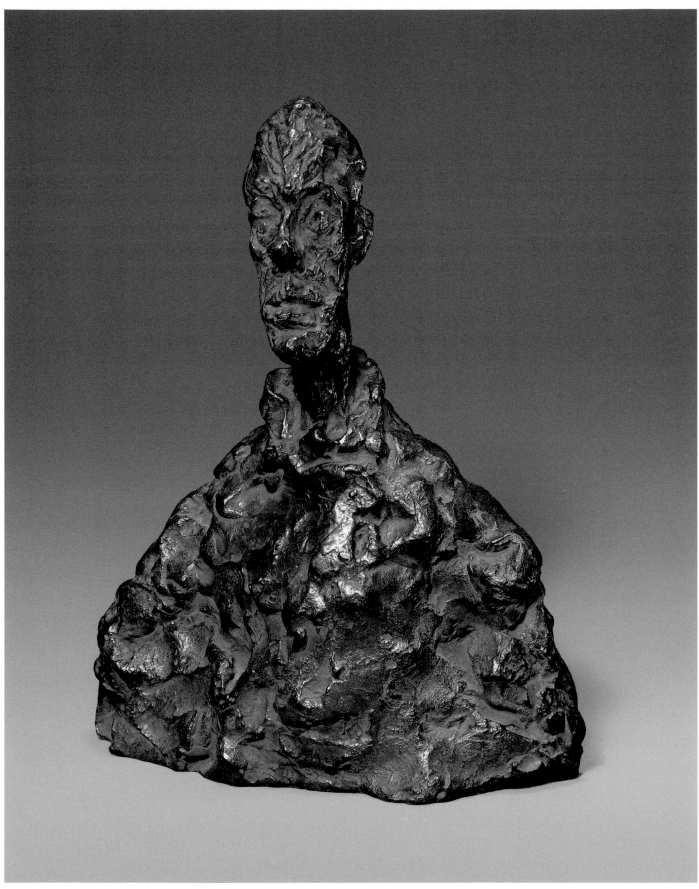

long head and full brow, emphasized by his already thinning hair; deep sockets frame
his dark eyes, with heavy pockets underneath. He was also a little taller than his older
brother, but the two shared handsome, if highly defined, features. Although achieving
a likeness was important to Giacometti in his portraiture, with Diego as model there were
none of the constraints that a commission would involve. The first images of him
from the postwar years were paintings, but, as the critic David Sylvester has written,

142

Giacometti "had resumed modelling from life in 1953, when he began to make a practice, at the end of Diego's sittings for paintings, of working from him on a bust for a while, and he was soon giving whole sessions to this."[1] For the busts of 1953 and 1954, Diego posed wearing a round-necked blouson, which gives him an almost monklike appearance; his thin neck and narrow head compound this ascetic presence. In this example, the modeling of the whole is energetic and highly tactile, with the protuberances and cavities of Giacometti's method particularly evident in the bubbling surface of the chest and shoulders, freed from any detailed verisimilitude. This somewhat scrofulous impression hardly encourages touch or intimate involvement; at the same time, the soulful dignity of the features has its appeal. As with the portrait head by Modigliani, the bust of Diego continues to show the influence of Cézanne (hugely admired by Giacometti), especially in the slight inclination of the head and the constant adjustments to the surface. In later portraits of Diego and other regular models, Giacometti's struggle to find a style often supplants his vivid sense of the human being in front of him, but in the present work he maintains an equilibrium that places it among his finest late achievements.

1. David Sylvester, *Looking at Giacometti* (London, 1994), p. 153.

Bibliography

LITERATURE AND EXHIBITIONS

Adhémar 1950. Hélène Adhémar. *Monet: Peintures.* Paris, 1950.

Akron 1951. "Painting and Sculpture from the Museum of Modern Art Collection." Akron [Ohio] Art Institute, 1951.

Amsterdam 1938. "Honderd Jaar Fransche Kunst." Amsterdam, Stedelijk Museum, July 2–September 25, 1938.

Angoulvent 1933. Monique Angoulvent. *Berthe Morisot.* Paris, [1933].

Anon. 1956. Anonymous. "Accessions of American and Canadian Museums, July–September, 1955." *The Art Quarterly* 19, no. 1 (spring 1956), pp. 72–79.

Anon. 1994. Anonymous. "Nouveaux musées, nouvelles salles." *Gazette des beaux-arts,* 6th ser., 123, no. 1502 (March 1994), pp. 90–98.

Barnes and de Mazia 1935. Albert C[oombs] Barnes and Violette de Mazia. *The Art of Renoir.* New York, 1935.

Barr 1948. Alfred H[amilton] Barr, Jr. *Painting and Sculpture in the Museum of Modern Art.* New York, 1948.

Barr 1977. Alfred H[amilton] Barr, Jr. *Painting and Sculpture in the Museum of Modern Art, 1929-1967.* New York, 1977.

Basel 1949a. *Édouard Vuillard.* Kunsthalle Basel, March 26–May 1, 1949. Exh. cat. Basel, 1949.

Basel 1949b. *Impressionisten, Monet, Pissarro, Sisley, Vorläufer und Zeitgenossen.* Kunsthalle Basel, September 3–November 20, 1949. Exh. cat. Basel, 1949.

Bataille and Wildenstein 1961. Marie-Louise Bataille and Georges Wildenstein. *Berthe Morisot: Catalogue des peintures, pastels et aquarelles.* Paris, 1961.

Berlin 1905. "Austellung VIII." Berlin, Paul Cassirer, 1905.

Berlin 1928. *Claude Monet, 1840–1926: Gedächtnis-Ausstellung.* Berlin, Galerien Thannhauser, February [15]–March 1928. Exh. cat. Berlin, 1928.

Bern 1957. "C. Pissarro." Bern, Kunstmuseum, January 19–March 10, 1957.

Bernheim-Jeune 1989. Messrs. Bernheim-Jeune. *Renoir's Atelier.* Forewords by Albert André and Marc Elder. Rev. English-language ed. San Francisco, 1989. French ed., *L'Atelier de Renoir.* Paris, 1931.

Berson 1996. Ruth Berson, ed. *The New Painting: Impressionism 1874–1886.* Vol. 2, *Documentation: Exhibited Works.* San Francisco, 1996.

Bologna 1999. *Alberto Giacometti: Disegni, sculture e opere grafiche.* Bologna, Museo Morandi, June 25–September 6, 1999. Exh. cat. by Marilena Pasquali and Lorenza Selleri. Milan, 1999.

Boston 1938. Exhibition. Boston, Museum of Fine Arts, 1938.

Boston 1950. "Group Exhibition." Boston, School of the Museum of Fine Arts, 1950.

Boston, New York, San Francisco, Minneapolis 1960-61. *Berthe Morisot: Drawings, Pastels, Watercolors, Paintings.* Boston, Museum of Fine Arts, October 10–November 8, 1960; New York, Charles E. Slatkin Galleries, November 12–December 10, 1960; San Francisco, California Palace of the Legion of Honor, December 20, 1960–January 18, 1961; Minneapolis Institute of Fine Arts, January 25–February 23, 1961. Exh. cat. by Elizabeth Mongan et al. New York, 1960.

Boulder 1951. "Fine Arts Painting Summer Exhibition." University of Colorado, Boulder, 1951.

Breeskin 1970. Adelyn Dohme Breeskin. *Mary Cassatt: A Catalogue Raisonné of the Oils, Pastels, Watercolors, and Drawings.* Washington, D.C., 1970.

Brettell 1990. Richard R. Brettell. *Pissarro and Pontoise: The Painter in a Landscape.* New Haven and London, 1990.

Brussels 1946. *Vuillard (1868–1940).* Brussels, Palais des Beaux-Arts, 1946. Exh. cat. preface by Claude Roger-Marx. Brussels, 1946.

Callen 1971. Anthea Callen. "Jean-Baptiste Faure, 1830–1914: A Study of a Patron and Collector of the Impressionists and Their Contemporaries, with a Catalogue of His Collection." Master's thesis, University of Leicester, 1971.

Chastel 1948. André Chastel. *Vuillard peintures, 1890–1930.* Paris, 1948.

Chicago 1938-39. "Paintings by Bonnard and Vuillard." The Art Institute of Chicago, December 15, 1938–January 15, 1939.

Chicago 1975. *Paintings by Monet.* The Art Institute of Chicago, March 15–May 11, 1975. Exh. cat. edited by Susan Wise. Essays by André Masson, Grace Seiberling, and J. Patrice Marandel; foreword by John Maxon. Chicago, 1975.

Chicago 1995. *Claude Monet: 1840–1926.* The Art Institute of Chicago, July 22–November 26, 1995. Exh. cat. by Charles F. Stuckey with Sophia Shaw. Chicago and New York, 1995.

Clairet et al. 1997. Alain Clairet, Delphine Montalant, Yves Rouart et al. *Berthe Morisot, 1841–1895: Catalogue raisonné de l'oeuvre peint.* Montolivet, France, 1997.

Cleveland 1931. "Exhibition of the Foreign Section of the Twenty-ninth Carnegie International." Cleveland Museum of Art, 1931.

Cleveland, New York 1948. *Pierre Bonnard.* Cleveland Museum of Art, March–April 1948; New York, The Museum of Modern Art, May–September 1948. Exh. cat. by John Rewald. New York, 1948.

Cleveland, New York 1954. *Édouard Vuillard.* Cleveland Museum of Art, January 26–March 14, 1954; New York, The Museum of Modern Art, April 7–June 6, 1954. Exh. cat. by Andrew Carnduff Ritchie. New York, 1954.

Copenhagen 1914. *Fransk Malerkunst fra det 19nde Aarhundredi.* Copenhagen, Statens Museum for Kunst, May 15–June 30, 1914. Exh. cat. Copenhagen, 1914.

Copenhagen 1949. "Berthe Morisot, Malerier, Akvareller og Tegningen." Copenhagen, Ny Carlsberg Glyptotek, August 20–September 18, 1949.

Dallas 1974. "The Collection of Mr. and Mrs. Algur H. Meadows." Dallas Museum of Fine Arts, June 5–July 7, 1974.

Dauberville and Dauberville 1965-74. Jean Dauberville and Henry Dauberville. *Bonnard: Catalogue raisonné de l'oeuvre peint.* 4 vols. Paris, 1965-74.

Daulte 1959a. François Daulte. *Alfred Sisley: Catalogue raisonné de l'oeuvre peint.* Preface by Charles Durand-Ruel. Lausanne, 1959.

Daulte 1959b. François Daulte. "L'Art français des XIX^{ème} et XX^{ème} siècles dans les collections suisses." *Le Jardin des arts,* no. 54 (April 1959), pp. 368–75.

Daulte 1959c. François Daulte. "Dans le sillage impressionniste." *Connaissance des arts,* no. 86 (April 1959), pp. 78–83.

Daulte 1971. François Daulte. *Auguste Renoir: Catalogue raisonné de l'oeuvre peint.* Vol. 1, *Figures, 1860–1890.* Foreword by Jean Renoir; preface by Charles Durand-Ruel. Lausanne, 1971.

Dieppe 1957. "Exposition Berthe Morisot." Musée de Dieppe, July 5– September 30, 1957.

Dortu 1971. M. G. Dortu. *Toulouse-Lautrec et son oeuvre.* 6 vols. New York, 1971.

Drucker 1944. Michel Drucker. *Renoir.* Paris, 1944.

Duret 1904. Théodore Duret. "Claude Monet und der Impressionismus." *Kunst und Künstler,* no. 2 (March 1904), pp. 232–45.

Duret 1906. Théodore Duret. *Histoire des peintres impressionnistes.* Paris, 1906.

Duret 1924. Théodore Duret. *Renoir.* Paris, 1924.

Edinburgh 1937. *Modigliani/Negro Art.* Edinburgh, [Whylock and Reid,] 1937. Exh. cat. essay by Adolphe Basler. Edinburgh, 1937.

Opposite: Detail, cat. no. 4
(Claude Monet, *The Artist's Garden in Argenteuil*)

Edinburgh 1961. Exhibition. Edinburgh, Scottish National Gallery of Modern Art, 1961.

Edinburgh 1969. *Modern Art from Scottish Houses.* Edinburgh (Charlotte Square), Scottish Arts Council, 1969. Exh. cat. Edinburgh, 1969.

Fage 1930. André Fage. *Le Collectionneur de peintures modernes.* Collection des Collectionneurs, 1st ser. Paris, 1930.

Ferrara, Madrid, Lyons 2002–3. *Alfred Sisley: Poetà dell'impressionismo.* Ferrara, Palazzo dei Diamanti, February 17–May 19, 2002; Madrid, Museo Thyssen-Bornemisza, June 8–September 15, 2002; Lyons, Musée des Beaux-Arts, October 9, 2002– January 6, 2003. Exh. cat. edited by MaryAnne Stevens and Ann Dumas. Ferrara, [2002].

Florence, Verona 1986. *Degas scultore.* Florence, Palazzo Strozzi, April 16–June 15, 1986; Verona, Palazzo Forti, June 27–September 7, 1986. Exh. cat. by Ettore Camesasca et al. Milan, 1986.

Fort Lauderdale 2000. *Camille Pissaro and His Descendants.* Fort Lauderdale, Museum of Art, January 29– April 30, 2000. Exh. cat. by David S. Stern, Talma Zakai-Kanner et al. Fort Lauderdale, 2000.

Fosca 1970. François Fosca. *Renoir.* New York, [1970].

Frankfurt 1998–99. *Alberto Giacometti: Werke und Schriften.* Frankfurt, Schirn Kunsthalle, October 6, 1998–January 3, 1999. Exh. cat. by Christoph Vitali et al. Frankfurt, 1998.

Frost 1944. Rosamund Frost. *Pierre Auguste Renoir.* New York, 1944.

Geffroy 1922. Gustave Geffroy. *Claude Monet: Sa vie, son temps, son oeuvre.* Paris, 1922.

Geneva 1951. "Exposition Berthe Morisot." Geneva, Galerie Motte, June 12–30, 1951.

Gordon and Forge 1983. Robert Gordon and Andrew Forge. *Monet.* New York, 1983.

The Hague 1957. "The Ragnar Moltzau Collection." Haags Gemeentemuseum, 1957.

The Hague 1986. *Alberto Giacometti, 1901–1966: Beelden, Schilderijen, Tekeningen, Grafiek.* Haags Gemeentemuseum, March 1–May 12, 1986. Exh. cat. by Mariette Josephus Jitta. The Hague, 1986.

Higonnet 1992. Anne Higonnet. *Berthe Morisot's Images of Women.* Cambridge, Mass., 1992.

Houston, Washington, D.C., Brooklyn 1989–90. *The Intimate Interiors of Édouard Vuillard.* Houston, Museum of Fine Arts, November 18, 1989–January 29, 1990; Washington, D.C., The Phillips Collection, February 17–April 29, 1990; The Brooklyn Museum, May 18–July 30, 1990. Exh. cat. by Elizabeth Wynne Easton. Houston and Washington, D.C., 1990.

Huisman 1962. Philippe Huisman. *Morisot-Charmes.* Lausanne, 1962.

Jean-Aubry and Schmit 1968. G[eorges] Jean-Aubry and Robert Schmit. *Eugène Boudin.* Translated by Caroline Tisdall. Greenwich, Conn., 1968. French ed. Neuchâtel, 1968.

Johnson 1976. Ron Johnson. *The Early Sculpture of Picasso, 1901–1914.* New York, 1976.

Kahnweiler 1948. Daniel-Henry Kahnweiler. *Les Sculptures de Picasso.* Photographs by Brassaï. Paris, 1948.

Kellermann 1992–99. Michel Kellermann. *André Derain: Catalogue raisonné de l'oeuvre peint.* 3 vols. Paris, 1992–99.

Kyoto, Tokyo 1968–69. "The Collection of Mr. and Mrs. Algur H. Meadows." Kyoto, National Museum of Modern Art, 1968; Tokyo, National Museum of Western Art, 1969.

Lanthemann 1970. J. Lanthemann. *Modigliani, 1884–1920, Catalogue raisonné: Sa vie, son oeuvre complet, son art.* Barcelona, 1970.

Lecomte 1892. Georges Lecomte. *L'Art impressionniste.* Paris, 1892.

Lemoisne 1946–49. Paul-André Lemoisne. *Degas et son oeuvre.* 4 vols. Paris, 1946–49. Reprint, New York and London, 1984.

Liège 1909. "Salon international." Liège, 1909.

Lille, Martigny 2002. *Berthe Morisot, 1841–1895.* Lille, Palais des Beaux-Arts, March 10–June 9, 2002; Martigny, Switzerland, Fondation Pierre Gianadda, June 20– November 19, 2002. Exh. cat. by Sylvie Patin, Sylvie Patry, and Hughes Wilhelm. Paris, 2002.

Limoges 1952. *Hommage à Berthe Morisot et à Pierre-Auguste Renoir.* Limoges, Musée Municipale, July 19–October 10, 1952. Exh. cat. Limoges, 1952.

London 1905. "Pictures by Boudin, Manet, Pissarro, Cézanne, Monet, Renoir, Degas, Morisot, Sisley, Exhibited by Messrs. Durand-Ruel and Sons of Paris." London, Grafton Galleries, January–February 1905.

London 1914. "Art français." London, Grosvenor Galleries, ca. June 1914.

London 1929. "Modigliani." London, Alex Reid and Lefevre, 1929.

London 1930. "Berthe Morisot." London, Leicester Galleries, March–April 1930.

London 1936. "Berthe Morisot, Madame Eugène Manet." London, M. Knoedler and Co., May–June 1936.

London 1943. "Picasso and His Contemporaries." London, Alex Reid and Lefevre, March–April 1943.

London 1950a. "Berthe Morisot: An Exhibition of Paintings and Drawings." London, Arts Council of Great Britain, 1950.

London 1950b. "Landscape in French Art." London, Royal Academy of Arts, December 1949–March 1950.

London 1966. *Pierre Bonnard.* London, Royal Academy of Arts, January 6–March 6, 1966. Exh. cat. London, 1966.

London 1979. *British and French Paintings.* London, Browse and Darby, March 13–April 19, 1980. Exh. cat. London, 1980.

London, Edinburgh 1953. *Renoir [An Exhibition Sponsored by the Edinburgh Festival Society and Arranged Jointly with the Arts Council of Great Britain].* London, Tate Gallery, September 25–October 25, 1953; Edinburgh, Royal Scottish Academy, 1953. Exh. cat. London, 1953.

London, Paris, Baltimore 1992–93. *Alfred Sisley.* London, Royal Academy of Arts, July 3–October 18, 1992; Paris, Musée d'Orsay, October 28, 1992–January 31, 1993; Baltimore, Walters Art Gallery, March 14–June 13, 1993. Exh. cat. edited by MaryAnne Stevens. With contributions by Isabelle Cahn et al. New Haven and London, 1992. French ed. Paris, 1992.

Longstreet 1964. Stephen Longstreet. *The Drawings of Degas.* Los Angeles, 1964.

Los Angeles 1965. "Years of Ferment." U[niversity of] C[alifornia at] L[os] A[ngeles] Art Galleries, January 24–August 22, 1965.

Loyrette 1991. Henri Loyrette. *Degas.* Paris, 1991.

Lugano 1995. *Alberto Giacometti: La collezione di un amatore.* Lugano, Galleria Pieter Coray, September–November 1995. Exh. cat. preface by James Lord. Milan, 1995.

Lyons 1954. *Bonnard.* Musée de Lyon, 1954. Exh. cat. Lyons, 1954.

Malingue 1943. Maurice Malingue. *Claude Monet.* Monaco, 1943.

Malmö 1994–95. *Alberto Giacometti: Skulpterer, teckningar, målningar.* Malmö Konsthall, October 29, 1994–January 22, 1995. Exh. cat. by Sune Nordgren. Malmö, 1994.

Manchester 1907–8. *Modern French Paintings.* Manchester, City Art Gallery, December 1907–January 1908. Exh. cat. introduction by J. Ernest Phythian. [Manchester, 1907.]

Meier-Graefe 1929. Julius Meier-Graefe. *Renoir.* Leipzig, 1929.

Mercanton 1949. Jacques Mercanton. *Vuillard et le goût du bonheur.* Paris, 1949.

Mulhouse 1931. "Exposition rétrospective Eugène Boudin, Jongkind, Pissarro." Mulhouse, France, Maison d'Art Alsacienne, 1931.

Munich 1912. Exhibition. Munich, Thannhauser Gallery, 1912.

Munich 1997. *Alberto Giacometti.* Munich, Kunsthalle der Hypo-Kulturstiftung, April 17–June 29, 1997. Exh. cat. by Rudolf Koella, Wieland Schmied, and Jean-Louis Prat. Munich, 1997.

New Haven 1956. Exhibition. New Haven, Yale University Art Gallery, 1956.

New London 1950. "From Delacroix to the Neo-Impressionists." New London, Conn., Lyman Allyn Art Museum, Connecticut College, 1950.

New York 1921. Exhibition. New York, possibly Durand-Ruel, 1921.

New York 1923. "Camille Pissarro." New York, Durand-Ruel, 1923.

New York 1934a. Exhibition. New York, Cooper Union Museum, 1934.

New York 1934b. "Paintings by Bonnard." New York, Wildenstein and Co., March 1–24, 1934.

New York 1940–41. "Twentieth-Century Paintings." New York, The Museum of Modern Art, and other venues, February 1940–July 1941.

New York 1941. *Renoir. [Centennial Loan Exhibition, 1841–1941. For the Benefit of the French Relief Committee.]* New York, Duveen Galleries, November 8–December 6, 1941. Exh. cat. New York, 1941.

New York 1944. "From Corot to Picasso." New York, American-British Art Center, 1944.

New York 1945–47. "Objects as Subjects." New York, The Museum of Modern Art, and other venues, October 1945–June 1947.

New York 1946–47. *Nine Selected Paintings by Renoir.* New York, Durand-Ruel, December 26, 1946–January 11, 1947. Exh. cat. New York, 1946.

New York 1950. *[A Loan Exhibition of] Renoir [for the Benefit of the New York Infirmary].* New York, Wildenstein and Co., March 23–April 29, 1950. Exh. cat. by Daniel Wildenstein. New York, 1950.

146

New York 1951–53. "Still Life." New York, The Museum of Modern Art, and other venues, 1951–53.

New York 1953. *Collectors' Choices: Masterpieces of French Art from New York Private Collections.* New York, Paul Rosenberg and Co., March 17–April 18, 1953. Exh. cat. New York, 1953.

New York 1954–55. "Twenty-fifth Anniversary Exhibition." New York, The Museum of Modern Art, October 1954–January 1955.

New York 1958a. *Renoir. Loan Exhibition. [For the Benefit of the Citizens' Committee for the Children of New York City, Inc.]* New York, Wildenstein and Co., April 8–May 10, 1958. Exh. cat. preface by Jean Renoir; chronology by John Rewald. New York, 1958.

New York 1958b. "Summer Loan Exhibition." New York, The Metropolitan Museum of Art, July 2–September 1, 1958. Exh. checklist. New York, 1958.

New York 1960a. *Loan Exhibition of Paintings: Berthe Morisot.* New York, Wildenstein and Co., November–December 1960. Exh. cat. New York, 1960.

New York 1960b. *The Nate and Frances Spingold Collection.* New York, The Metropolitan Museum of Art, [March 23–June 19,] 1960. Exh. cat. New York, 1960.

New York 1960c. "Summer Loan Exhibition." New York, The Metropolitan Museum of Art, July 6–September 6, 1960.

New York 1961. "Summer Loan Exhibition." New York, The Metropolitan Museum of Art, July 1–August 21, 1961. Exh. checklist. New York, 1961.

New York 1966. "Summer Loan Exhibition: Paintings, Drawings, and Sculpture from Private Collections." New York, The Metropolitan Museum of Art, July 8–September 6, 1966.

New York 1968a. *New York Collects.* New York, The Metropolitan Museum of Art, July 3–September 2, 1968. Exh. cat. preface by Thomas P[earsall] F[ield] Hoving. [New York, 1968.]

New York 1968b. *New York Collects.* New York, The Metropolitan Museum of Art, July 3–September 2, 1968. Exh. cat. preface by Philippe de Montebello. [New York, 1968.]

New York 1968c. *Van Gogh, Gauguin, and Their Circle.* New York, Christie's, January 14–30, 1968. Exh. cat. preface by John Richardson. New York, 1968.

New York 1969. *Renoir [A Loan Exhibition for the Benefit of the American Association of Museums].* New York, Wildenstein and Co., March 27–May 3, 1969. Exh. cat. by François Daulte, Charles Durand-Ruel, and John Rewald. New York, 1969.

New York 1971. "Summer Loan 1971. Paintings from New York Collections: Collection of Mr. and Mrs. Philip J. Levin." New York, The Metropolitan Museum of Art, July 13–September 7, 1971. Exh. checklist preface by Thomas Hoving. [New York, 1971.]

New York 1978. *Edgar Degas. [For the Benefit of Lenox Hill Hospital, New York.]* New York, Acquavella Galleries, November 1–December 3, 1978. Exh. cat. essay by Theodore Reff. New York, 1978.

New York 1982. "Claude Monet." New York, William Beadleston Gallery, October 29–November 20, 1982.

New York 1999–2000. *French Landscape: The Modern Vision, 1880–1920.* New York, The Museum of Modern Art, October 27, 1999–March 14, 2000. Exh. cat. by Magdalena Dabrowski. New York, 1999.

Newport 1955. Exhibition in conjunction with the Washington-Rochambeau Celebration. Newport, R.I., The Preservation Society, 1955.

Norwich, Lausanne 2001–2. *Alberto Giacometti in Postwar Paris.* Norwich, Sainsbury Centre for Visual Arts, University of East Anglia, October 2–December 9, 2001; Lausanne, Fondation de l'Hermitage, February 1–May 12, 2002. Exh. cat. by Michael Peppiatt. New Haven and London, 2001.

Ottawa, Chicago, Fort Worth 1997–98. *Renoir's Portraits: Impressions of an Age.* Ottawa, National Gallery of Canada, June 27–September 14, 1997; The Art Institute of Chicago, October 17, 1997–January 4, 1998; Fort Worth, Kimbell Art Museum, February 8–April 26, 1998. Exh. cat. by Colin B. Bailey et al. New Haven, London, and Ottawa, 1997.

Palm Beach 1948. "The School of Paris." Palm Beach, Fla., Society of the Four Arts, 1948.

Palm Beach 1957. "Loan Exhibition of Works by Pierre Bonnard." Palm Beach, Fla., Society of the Four Arts, January 4–27, 1957.

Paris n.d. "Van Dongen." Paris, Galerie Pétridès, before 1979.

Paris 1883. Possibly "Oeuvres de Claude Monet." Paris, Galerie Durand-Ruel, March 1–25, 1883.

Paris 1889. "Exposition E. Boudin." Paris, Galerie Durand-Ruel, July–August 1889.

Paris 1892. "Exposition P. A. Renoir." Paris, Galerie Durand-Ruel, May 1892.

Paris 1896. *Berthe Morisot (Madame Eugène Manet): Exposition de son oeuvre.* Paris, Galerie Durand-Ruel, March 5–23, 1896. Exh. cat. preface by Stéphane Mallarmé. Paris, 1896.

Paris 1899. "Exposition de tableaux de Monet, Pissarro, Renoir, et Sisley." Paris, Galerie Durand-Ruel, April 6 or 10–May 1899.

Paris 1904. Exhibition. Paris, Ambroise Vollard, 1904.

Paris 1907. "Salon d'Automne: Berthe Morisot." Paris, Grand Palais, 1907.

Paris 1908. "Paysages par Cl. Monet et Renoir." Paris, Galerie Durand-Ruel, May 18–June 6, 1908.

Paris 1912a. Exhibition. Paris, Galerie Durand-Ruel, 1912.

Paris 1912b. "Exposition d'art moderne." Paris, Manzi, Joyant et Cie., June–July 1912.

Paris 1914. "Tableaux par Alfred Sisley." Paris, Galerie Durand-Ruel, April 16–May 2, 1914.

Paris 1920. "Tableaux, pastels, dessins par Renoir." Paris, Galerie Durand-Ruel, November 29–December 18, 1920.

Paris 1922a. "Exposition d'oeuvres de grands maîtres du XIXème siècle." Paris, Galerie Paul Rosenberg, May 3–June 3, 1922.

Paris 1922b. "La Musique et la danse." Paris, Galerie Charpentier, 1922.

Paris 1924. "Cl. Monet [Organisée au profit des victimes de la catastrophe du Japon]." Paris, Galerie Georges Petit, January 4–18, 1924.

Paris 1928. "Claude Monet." Paris, Galerie Durand-Ruel, January 6–19, 1928.

Paris 1929. "Exposition des oeuvres de Berthe Morisot." Paris, Galerie Bernheim-Jeune, May 6–24, 1929.

Paris 1931. *Degas: Portraitiste, sculpteur.* Paris, Musée de l'Orangerie, July 19–October 1, 1931. Exh. cat. Paris, 1931.

Paris 1933a. *Exposition Renoir, 1841–1919.* Paris, Musée de l'Orangerie, second half of 1933. Exh. cat. by Charles Sterling; preface by Paul Jamot. Paris, 1933.

Paris 1933b. *Exposition Renoir, 1841–1919: Album de soixante-quatre reproductions.* 2nd rev. ed. of Paris 1933a, with plates only. Paris, 1933.

Paris 1933c. "Paysages par Claude Monet, Camille Pissarro, Renoir et Sisley." Paris, Galerie Durand-Ruel, January 14–31, 1933.

Paris 1934. "Quelques oeuvres importantes de Corot à Van Gogh." Paris, Galerie Durand-Ruel, May–June 1934.

Paris 1937. "Les Maîtres de l'art indépendant, 1895–1937." Paris, Petit Palais, June–October 1937.

Paris 1938. *Exposition E. Vuillard.* Paris (Pavillon de Marsan, Palais du Louvre), Musée des Arts Décoratifs, May–July 1938. Exh. cat. Paris, 1938.

Paris 1940–41. "Centenaire Monet-Rodin." Paris, Musée de l'Orangerie, December 7, 1940–March 18, 1941.

Paris 1941. "Berthe Morisot." Paris, Musée de l'Orangerie, summer 1941.

Paris 1943. "Le Portrait français." Paris, Galerie Drovin, June–July 1943.

Paris 1948a. "Les Peintres et la musique." Paris, Galerie Durand-Ruel, May 1948.

Paris 1948b. "Vuillard." Paris, Galerie Charpentier, 1948.

Paris 1950. Crédit Municipal sale.

Paris 1952. Exhibition. Paris, Petit Palais, 1952.

Paris 1956. "Camille Pissarro." Paris, Galerie Durand-Ruel, 1956.

Paris 1958. "Exposition Renoir." Paris, Galerie Durand-Ruel, May–October 1958.

Paris 1959a. "De Géricault à Matisse: Chefs-d'oeuvre français des collections suisses." Paris, Petit Palais, March–May 1959.

Paris 1959b. "Exposition Claude Monet, 1840–1926." Paris, Galerie Durand-Ruel, May 22–September 30, 1959.

Paris 1961. *Berthe Morisot.* Paris, Musée Jacquemart-André, spring 1961. Exh. cat. Paris, 1961.

Paris 1962. "Camille Pissarro." Paris, Galerie Durand-Ruel, May 29–September 28, 1962.

Paris 1965. *Eugène Boudin, 1824–1898.* Paris, Galerie Schmit, May 5–26, 1965. Exh. cat. by Robert Schmit. Paris, 1965.

Paris 1970. *Claude Monet.* Paris, Galerie Durand-Ruel, January 24–February 28, 1970. Exh. cat. Paris, 1970.

Paris, Ottawa, New York 1988–89. *Degas.* Paris, Grand Palais, February 9–May 16, 1988; Ottawa, National Gallery of Canada, June 16–August 28, 1988; New York, The Metropolitan Museum of Art, September 27, 1988–January 8, 1989. Exh. cat. by Jean Sutherland Boggs et al. New York and Ottawa, 1988. French ed. Paris, 1988.

Penrose 1967. Roland Penrose. *The Sculpture of Picasso.* [Issued in conjunction with the exhibition held at the Museum of Modern Art, New York, October 11, 1967–January 1, 1968.] Chronology by Alicia Legg. New York, 1967.

Perruchot 1964. H. Perruchot. *La Vie de Renoir.* Paris, 1964.

Pingeot 1991. Anne Pingeot. *Degas: Sculptures.* Photographs by Frank Horvat. Paris, 1991.

Pissarro and Venturi 1989. Ludovic Rodo Pissarro and Lionello Venturi. *Camille Pissarro: Son art—son oeuvre.* 2 vols. Paris, 1939. Reprint, San Francisco, 1989.

Pittsburgh 1930. "Twenty-ninth International Exhibition of Paintings." Pittsburgh, Carnegie Institute, 1930.

Rewald 1944. John Rewald. *Degas: Works in Sculpture, A Complete Catalogue.* Translated by John Coleman and Neal Moulton. New York, 1944.

Rewald 1956. John Rewald. *Degas Sculpture: The Complete Works.* Photographs by Leonard von Matt. New York, 1956.

Rewald 1973. John Rewald. *The History of Impressionism.* 4th rev. ed. New York, 1973.

Roslyn Harbor, Princeton 1992–93. *Twentieth-Century Master Watercolors: Drawings and Sculpture from the Nowinski Collection.* Roslyn Harbor, N.Y., Nassau County Museum of Art, May 10–August 9, 1992; Princeton University Museum of Art, February 28–April 11, 1993. Exh. cat. by Constance Schwartz, Ronnie Meyerson et al. Roslyn Harbor, N.Y., 1992.

Rouart 1954. Denis Rouart. *Berthe Morisot.* Paris, 1954.

Rouart 1985. Denis Rouart. *Renoir.* Rev. ed. Geneva, 1985.

Russoli and Minervino 1970. Franco Russoli and Fiorella Minervino. *L'opera completa di Degas.* Milan, 1970.

Saint Louis, Philadelphia, Minneapolis 1967. *Drawings by Degas.* Saint Louis, City Art Museum, January 20–February 26, 1967; Philadelphia Museum of Art, March 10–April 30, 1967; The Minneapolis Society of Fine Arts, May 18–June 25, 1967. Exh. cat. by Jean Sutherland Boggs. Saint Louis, 1966.

San Francisco 1939–40. "Golden Gate International Exposition." San Francisco, Treasure Island, 1939–40.

San Francisco 1959. *The Collection of Mr. and Mrs. William Goetz.* San Francisco, California Palace of the Legion of Honor, April 18–May 31, 1959. Exh. cat. introduction by Thomas Carr Crowe. San Francisco, 1959.

Sarasota 1956. *The Art of Eating: A Loan Exhibition.* Sarasota, Fla., The John and Mable Ringling Museum, January 29–March 7, 1956. Exh. cat. introduction by A. Everett Austin, Jr. Sarasota, Fla., 1956.

Scheffler 1931. Karl Scheffler. "Die Sammlung Max Silberberg." *Kunst und Künstler,* no. 30 (October–December 1931), pp. 2–20.

Schmit 1973. Robert Schmit. *Eugène Boudin, 1824–1898.* 3 vols. Paris, 1973.

Schmit 1984. Robert Schmit. *Eugène Boudin, 1824–1898: Premier supplément.* Paris, 1984.

Schneider 1967. B. F. Schneider. *Renoir.* New York, 1967.

Schoeller and Dieterle 1948. André Schoeller and Jean Dieterle. *Corot: Premier supplément à "L'Oeuvre de Corot" par A. Robaut et Moreau-Nélaton.* Paris, 1948.

South Hadley 1956. *French and American Impressionism.* South Hadley, Mass., Mount Holyoke College Art Museum, 1956.

Spies 1971. Werner Spies. *Sculpture by Picasso, with a Catalogue of the Works.* Translated by J. Maxwell Brownjohn. New York, 1971.

Spies 2000. Werner Spies. *Picasso: The Sculptures. [Catalogue Raisonné of the Sculptures in Collaboration with Christine Piot.]* [Issued on the occasion of the exhibition "Picasso Sculpteur," held at the Centre Georges Pompidou, Paris, June 7–September 25, 2000.] Translated by Melissa Thorson Hause and Margie Mounier. Stuttgart, 2000.

Sterling and Salinger 1955–67. Charles Sterling and Margaretta Salinger. *French Paintings: A Catalogue of The Metropolitan Museum of Art.* 3 vols. New York, 1955–67.

Stockholm 1948. "Vuillard." Stockholm, Galerie d'Art Latin, fall 1948.

Syracuse, New York 1949. *Impressionism.* Syracuse, N.Y., and New York, 1949.

Thieme-Becker 1934. Ulrich Thieme and Felix Becker, eds. *Algemeines Lexicon der Bildenden Künstler.* 37 vols. Leipzig, 1907–50.

Tinterow 1992. Entries by G[ary] T[interow] in *The Metropolitan Museum of Art Bulletin* 50, no. 2 (fall 1992; "Recent Acquisitions: A Selection, 1991–1992").

Toronto, Montreal, New York, Toledo, Washington, D.C., San Francisco, Portland 1952–54. *Berthe Morisot and Her Circle.* Art Gallery of Toronto; Montreal Museum of Fine Arts; New York, The Metropolitan Museum of Art; Toledo [Ohio] Museum of Art; The Phillips Collection, Washington, D.C.; San Francisco, California Palace of the Legion of Honor; Portland [Ore.] Art Museum; 1952–54. Exh. cat. Toronto, 1952.

Tucker 1982. Paul Hayes Tucker. *Monet at Argenteuil.* New Haven and London, 1982.

Tucker 1995. Paul Hayes Tucker. *Claude Monet: Life and Art.* New Haven and London, 1995.

Vaillant 1965. Annette Vaillant. *Bonnard ou le bonheur de voir [Dialogue sur Pierre Bonnard entre Jean Cassou et Raymond Cogniat].* Commentaries by Hans R. Hahnloser. Neuchâtel, 1965.

Venice 1930. "XVIIᵉ Exposition internationale des beaux-arts." Venice, 1930.

Venice 1938. "Impressionisti XXI Biennale." Venice, 1938.

Vevey 1958. *De Monet à Chagall: Collection Rosensaft.* Vevey, Switzerland, Musée Jenisch, June 28–September 14, 1958. Exh. cat. introduction by François Daulte. Vevey, Switzerland, 1958.

Vevey 1961. *Berthe Morisot.* Vevey, Switzerland, Musée Jenisch, June 24–September 3, 1961. Exh. cat. Vevey, Switzerland, 1961.

Vienna 1910. "Monet-Manet." Vienna, Miethke, May 1910.

Vollard 1918. Ambroise Vollard. *Tableaux, pastels, et dessins de Pierre-Auguste Renoir.* 2 vols. Paris, 1918.

Vollard 1919. Ambroise Vollard. *La Vie et l'oeuvre de Pierre-Auguste Renoir.* Paris, 1919.

Washington, D.C., 1991. *Art for the Nation: Gifts in Honor of the Fiftieth Anniversary of the National Gallery of Art.* Washington, D.C., National Gallery of Art, 1991. Exh. cat. edited by Frances P. Smyth. Washington, D.C., 1991.

Washington, D.C., Fort Worth, South Hadley 1987–88. *Berthe Morisot, Impressionist.* Washington, D.C., National Gallery of Art, September 6–November 29, 1987; Fort Worth, Kimbell Art Museum, December 12, 1987–February 21, 1988; South Hadley, Mass., Mount Holyoke College Art Museum, March 14–May 9, 1988. Exh. cat. by Charles F. Stuckey and William P. Scott. New York, 1987.

Washington, D.C., Hartford 2000. *The Impressionists at Argenteuil.* Washington, D.C., National Gallery of Art, May 28–August 20, 2000; Hartford, Wadsworth Atheneum Museum of Art, September 6–December 3, 2000. Exh. cat. by Paul Hayes Tucker. Washington, D.C., 2000.

Weimar 1905. "Cl. Monet." Weimar, Grossherzogliches Museum, April–May 1905.

White 1969. Barbara Ehrlich White. "Renoir's Trip to Italy." *The Art Bulletin* 51, no. 4 (December 1969), pp. 333–51.

Wildenstein 1974–91. Daniel Wildenstein. *Claude Monet: Biographie et catalogue raisonné.* 5 vols. Paris, 1979–91.

Wildenstein 1996. Daniel Wildenstein. *Claude Monet: Catalogue raisonné.* 4 vols. 2nd rev. ed. Cologne and Paris, [1996].

Wilenski 1940. R[eginald] H[oward] Wilenski. *Modern French Painters.* New York, 1940.

Zervos 1932–78. Christian Zervos. *Pablo Picasso.* 33 vols. Paris and New York, 1932–78.

Zürich 1917. "Französische Kunst des XIX und XX Jahrhunderts." Zürich, Kunsthaus, 1917.

Index

Photograph Credits

Photographs were in most cases provided by the owners of the works and are reproduced by their permission; their courtesy is gratefully acknowledged. Photography of works in the exhibition is by Bruce Schwarz of the Photograph Studio, The Metropolitan Museum of Art, New York.

Cat. nos. 25, 26 (with detail), 27, 28, 29, 30 (with detail on p. 2), 31, 32, 33, 34, 37 © 2002 Artists Rights Society (ARS), New York/ADAGP, Paris. Cat. no. 35 © 2002 Estate of Pablo Picasso/Artists Rights Society (ARS), New York.

Figs. 1, 2, 3: photo © 2002, courtesy of Sotheby's, Inc. Fig. 5: photo © 2002 Board of Trustees, National Gallery of Art, Washington. Fig. 13: photo by Martin Bühler. Fig. 16: Réunion des Musées Nationaux/Art Resource, NY. Fig. 17: Réunion des Musées Nationaux/Art Resource, NY; photo by C. Jean. Fig. 27: Réunion des Musées Nationaux/Art Resource, NY; photo by Hervé Lewandowski. Fig. 29: Document Archives Durand-Ruel; courtesy of Mme Caroline Durand-Ruel Godfroy. Fig. 32: photo © 2002 Board of Trustees, National Gallery of Art, Washington. Fig. 36: Giraudon/Bridgeman Art Library. Fig. 38: photo by Catherine Lancien/Carole Loisel, © Musées de la Ville de Rouen. Fig. 41: Réunion des Musées Nationaux/Art Resource, NY; photo by Claude Gaspari. Fig. 44: photo by Pierrain, © Photothèque des musées de la ville de Paris. Fig. 45: © 2002 Artists Rights Society (ARS), New York/ADAGP, Paris. Fig. 46: © 2002 Artists Rights Society (ARS), New York/ADAGP, Paris; photo by Wen Hwa Ts'ao, © Virginia Museum of Fine Arts. Fig. 48: © 2002 Artists Rights Society (ARS), New York/ADAGP, Paris; Réunion des Musées Nationaux/Art Resource, NY; photo by H. Lewandowski. Figs. 49, 50: © 2002 Artists Rights Society (ARS), New York/ADAGP, Paris. Fig. 51: © 2002 Artists Rights Society (ARS), New York/ADAGP, Paris; photo © Board of Trustees of the National Museums and Galleries on Merseyside. Fig. 52: © 2002 Artists Rights Society (ARS), New York/ADAGP, Paris; photo courtesy of Hall & Knight (USA) Ltd. Fig. 53: © 2002 Artists Rights Society (ARS), New York/ADAGP, Paris; photo © 2002 Board of Trustees, National Gallery of Art, Washington. Fig. 55: © 2002 Artists Rights Society (ARS), New York/ADAGP, Paris. Fig. 56: Réunion des Musées Nationaux/Art Resource, NY. Figs. 58, 59: © 2002 Artists Rights Society (ARS), New York/ADAGP, Paris. Fig. 60: © 2002 Artists Rights Society (ARS), New York/ADAGP, Paris; photo by Greg Williams, © 2002 The Art Institute of Chicago. Figs. 61, 63: © 2002 Artists Rights Society (ARS), New York/ADAGP, Paris; photo by Daniel Le Nevé. Fig. 62: photo by André Godin. Fig. 64: © 2002 Artists Rights Society (ARS), New York/ADAGP, Paris. Fig. 65: © 2002 Estate of Pablo Picasso/Artists Rights Society (ARS), New York. Fig. 66: © 2002 Estate of Pablo Picasso/Artists Rights Society (ARS), New York; photo © 2002 Board of Trustees, National Gallery of Art, Washington. Fig. 67: photo by J. Lathion, © 2002 Nasjonalgalleriet. Fig. 68: © 2002 Artists Rights Society (ARS), New York/ADAGP, Paris; photo by James Austin